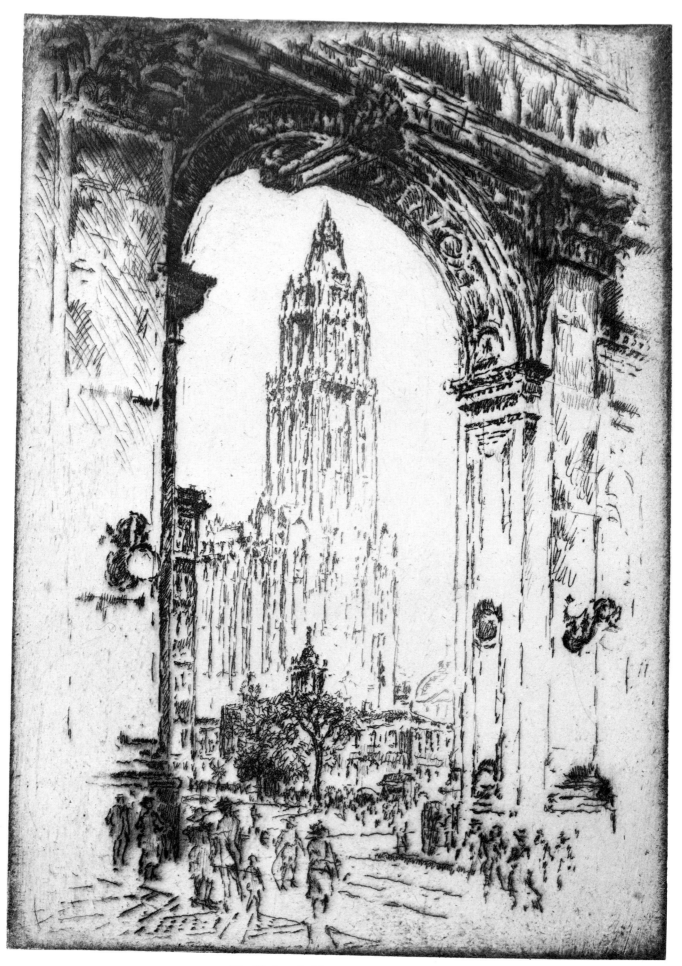

The Woolworth, Through the Arch. 1921.

Pennell's NEW YORK ETCHINGS
90 Prints

by
Joseph Pennell

Selection & Text by
Edward Bryant
Professor of Fine Arts
Director, The Picker Art Gallery, Colgate University

Published in cooperation with
The Picker Art Gallery of Colgate University by
Dover Publications, Inc.
New York

Published in Canada by General Publishing Company, Ltd., 30 Lesmill Road, Don Mills, Toronto, Ontario.
Published in the United Kingdom by Constable and Company, Ltd., 10 Orange Street, London WC2H 7EG.

Pennell's New York Etchings: 90 Prints is a new work, first published by Dover Publications, Inc., in 1980, in cooperation with The Picker Art Gallery of Colgate University, Hamilton, N.Y.

Book design by Richard Oriolo

International Standard Book Number: 0-486-23913-6
Library of Congress Catalog Card Number: 80-66802

Manufactured in the United States of America
Dover Publications, Inc.
180 Varick Street
New York, N.Y. 10014

Acknowledgments

Joseph Pennell's New York City was preoccupied with becoming and remaining foremost. To suggest in this book its epic growth, there were included in the captions, along with identification of buildings and locales, many "tour-guide" statistics concerning the first, the largest, the tallest, how many stories, feet, etc. All of this, of course, involved research that would not have been possible without the assistance of others. Therefore, it is with much gratitude that I wish to thank the following persons and institutions who were so helpful while I was doing research for this book: Long Island Historical Society, Brooklyn; Steven Miller, Curator of Prints and Photographs, Museum of the City of New York; New-York Historical Society; New York Public Library; New York City Municipal Archives; Alan D. Frazer, Curator/Registrar, New Jersey Historical Society, Newark, N.J.; Jersey City Museum; Railroad Museum of Pennsylvania, Strasburg, Pa.; Everett Needham Case Library, Colgate University, Hamilton, N.Y.; Cornell Club of New York; Dorothy A. Ellison, Con Edison, New York; and Theodore Conrad, Jersey City, N.J. They all provided helpful information, clues and solutions to many riddles in identifying locations and structures in the prints. The works listed in the bibliography, especially those by I. N. Phelps Stokes, John A. Kouwenhoven, Harmon H. Goldstone and Martha Dalrymple, Paul Goldberger, and the Federal Writers' Project, have been indispensable references in writing about New York City. Thanks are also due to Linda Murray, Susan Smith and Leslie Ann Eliet, at The Picker Art Gallery, Colgate University, for so much typing and retyping; and to my wife Tamara for reading and otherwise helping in what at times surely seemed a thankless task. Finally, a special thank-you to Mrs. Persis Judd for sparking this project through her generous gift to Colgate University of the Orrin G. Judd Collection of Joseph Pennell prints.

E. B.

Preface

Joseph Pennell* loved New York City. For him it was man's greatest achievement. He was captivated by its skyscrapers (that new architectural form purely modern and innately American), the grandeur of their groupings, the awesome magnificence of man's labor on such a grand scale and the city's ever-pulsing energies. Here to be etched and drawn and painted was the embodiment of the modern spirit capable of creating a great age. Inspired, Pennell compiled a remarkable record of New York City during the first quarter of the twentieth century, infusing his work with that vital spirit, while at the same time describing with amazing fidelity buildings and places. All the more valuable now that they are records of a past reality, the 90 etchings reproduced in this book will introduce you to the City florescent through the vision and sensibilities of a remarkable artist.

These etchings, selected from The Picker Art Gallery of Colgate University, were collected by the distinguished lawyer and judge Orrin G. Judd (1906–1976). After study at Colgate University (A.B., 1926), the Sorbonne in Paris and Harvard Law School, Judd returned to his native Brooklyn to begin his career as a law clerk to U.S. Circuit Judge Learned Hand (1930). He engaged in the private practice of law in New York City with Davies, Auerbach, Cornell and Hardy (1931–43) and was a member of the firm of Goldstein, Judd and Gurfein (1946–64, 1965–68). He was State Solicitor General (1943–46) under Governor Thomas E. Dewey. He was Surrogate of Kings County (1964). Appointed U.S. District Judge in 1968, Judd issued several well-known decisions: affirmation of the right of public-school children to remain seated during the Pledge of Allegiance, the cleanup of Willowbrook State School for the Mentally Retarded, and the 1973 order to halt U.S. bombings in Cambodia.

Judge Judd believed that New York City was the most wonderful place in the world. Relating directly each day to the great metropolis which Joseph Pennell had drawn and etched with similar sentiment, he began collecting Pennell etchings of Manhattan and Brooklyn during the 1930s. While Surrogate he had 50 Pennells framed and hung in his office at the Kings County Court House. The collection of 95 etchings that he assembled is today important both for its artistic qualities and as an historical record of New York City, since the subjects are places now completely or largely transformed. Judge Judd had always thought his etchings would eventually go to his alma mater. In 1977, the Orrin G. Judd Collection of Etchings by Joseph Pennell was presented to the Colgate University Art Collection as a memorial to him by his widow, Persis D. Judd, and their children, Pi, Betsy, Orrin D. and John.

E. B.

*Pennell is pronounced with the stress on the first syllable.

As the steamer moves up the bay on the left the Great Goddess greets you, a composition in color and form, with the city beyond, finer than any in any world that ever existed, finer than Claude ever imagined, or Turner ever dreamed. Why did not Whistler see it? Piling up higher and higher right before you is New York; and what does it remind you of? San Gimignano of the Beautiful Towers away off in Tuscany, only here are not eleven, but eleven times eleven, not low mean brick piles, but noble palaces crowned with gold, with green, with rose; and over them the waving, fluttering plume of steam, the emblem of New York. To the right, filmy and lace-like by day, are the great bridges; by night a pattern of stars that Hiroshige never knew. You land in streets that are Florence glorified. You emerge in squares more noble than Seville. Golden statues are about you, triumphal arches make splendid frames for endless vistas; and it is all new and all untouched, all to be done, and save for the work of a few of us, and we are Americans, all undone. The Unbelievable City, the city that has been built since I grew up, the city beautiful, built by men I know, built for people I know. The city that inspires me, that I love. (Joseph Pennell, ''The Pictorial Possibilities of Work,'' p. 111).

*See the Bibliography at the end of this volume for the full bibliographical data on all books and articles referred to in the text.

Introduction

Joseph Pennell's discovery for himself of the new New York, *the* city of the new century, was a profound experience which would affect his art for the remaining 22 years of his life and bring to fruition the most creative aspects of his distinguished career.

Arriving in New York in the third week of August 1904 aboard the steamer *Teutonic*, on his way to St. Louis as Chairman of the Jury on Illustration and Engraving at the Louisiana Purchase Universal Exposition, Pennell was captivated by the magnificent, moving spectacle of a grand city which was surely man's greatest achievement. Twenty years an expatriate, he was visiting his homeland as an artist respected on both sides of the Atlantic and considered in importance among American printmakers next to Whistler, his friend and mentor (who had died the year before).

Previously, Pennell had made two other brief trips home since he and his bride Elizabeth Robins left in 1884 to settle in London. But both times before, he had passed quickly through New York, uninterested in sightseeing. There were no special sights for the sophisticated world traveler in 1891, when he returned to settle his father's estate in Philadelphia. Nor had New York changed much by 1893, when he was on his way to the World's Columbian Exposition in Chicago. There was nothing to compare to the French and English cathedral towns, to Florence and Rome, to Paris and London, or to Granada and Cordova—not even those two grand hotels, the Waldorf and the New Netherland, just completed by William Waldorf Astor, for three million dollars each. Indifferent, Pennell had written back to the painter John McLure Hamilton in London: "Philadelphia and London are good enough for me—and I have no more ambition to see my native land."

But now he was enraptured by the marvelous cosmopolis that had mushroomed during the eleven intervening years, its skyline a soaring fantasy and its interior a cauldron of machine-age dynamism. On his return trip from St. Louis to London, Pennell remained in New York for more than a month, working prodigiously until mid-November in that city's special autumn light to create his first New York series of the metropolis and its skyscrapers. An immodest, hurried note to his wife began, "It is so beautiful I must go out and make more immortal works."

Altogether Pennell produced at least 28 etchings and a series of lithographs for The Society of Iconophiles, an exclusive-membership organization founded in 1894 to visually document the appearance of New York. In these works there was a revitalizing quality, a new vision. Now, replacing the detached picturesqueness of those foreign remains of Europe's great past, his subjects announced the forceful realities of a new epoch reaching its synthesis of energies at a new place. The esthetic of Whistler's "art for art's sake" was no longer adequate to express this modern dynamism. Pennell would work again and again in New York, fascinated by its vitality, in 1908, 1915, and from 1918 until his death in Brooklyn in 1926. In the resulting vivid, valuable, expressive documentation of New York City during its greatest period of growth, he would find the most perfect realization of his grand theme, "The Wonder of Work."

The New York to which Pennell returned in 1904 had changed spectacularly since he was there in 1893. It was no longer the city looking back to a proud past of New Amsterdam, the Revolution, and that brief year when it was capital of the new Republic. It was now the dynamic city of the future, of perpetual youth; continually building and tearing down, repudiating and replacing the past; always in the process of becoming and never completing itself. Since the Civil War, New York had increasingly expanded in financial, commercial and industrial dominance. As the major port and a nationally important railway hub, it was the gateway to the nation and the industries of the world. The United States was taking the world out of Europe's control. In its explosive growth, now both vertically and horizontally, this metropolis was fast becoming the world's center. Its skyline of skyscrapers was the symbol for the golden age of free enterprise and capitalist expansion, and as much as the Statue of Liberty, emblematic proof of the validity of the American Dream. It was a city the entire country and the world should be proud of. It claimed the tallest, the biggest, the first, the greatest, the most.

Perhaps better than any other artist, Pennell expressed this optimistic vitality; the raw faith of a modernistic "pantheism" in an age in which the machine replaced nature; the sentimental ethical esthetics of Progress; and that mass materialistic dynamism within which the individual was lost in the rush of traffic, insignificant among his own preponderant monuments. Pennell was not interested in the sociology of the city, as were Jacob Riis and Lewis Hine. Nor was he interested, as were John Sloan and George Luks, in the human comedy. He was an artist of buildings. He discerned art in the skyscrapers of his contemporaries and, as someone remarked, "made Architecture of the New York buildings." With chauvinistic pride, he used the building and unbuilding of New York as the paradigm of a new ethos.

In 1894 the 19-story Manhattan Life Insurance Company Building exceeded in height by 60 feet the tip of the steeple of Richard Upjohn's Trinity Church, which for 48 years had been the highest point (284 feet) in Manhattan. By the turn of the century, office buildings that high or higher were common in lower Manhattan—American Surety (21 stories), American Tract Society (23 stories), Commercial Cable (21 stories). In 1897 the St. Paul Building (25 stories, 310 feet high) won for New York from Chicago the distinction of having the world's tallest building. That fall the nearby Park Row Building topped that claim at 382 feet. With the invention of efficient electric elevators and caisson foundations, and the use of steel-skeleton construction, the skyscraper—America's unique contribution to architectural form—could tower higher and higher. By 1915 there were seven towers over 400 feet high in Manhattan. In 1908 the Singer Building rose 612 feet, the tallest building in the world; in 1909 the Metropolitan Life Insurance Company tower went up to 700 feet; in 1913 the Woolworth Building, 792 feet high, became the world's tallest building (not to be exceeded in height until the Chrysler Building in 1930).

Only a fraction of the buildings in Manhattan during this time were towers (in 1913 only five percent were from 18 to 22 stories; and two percent from 23 to 55 stories), making them all the more impressive on the ever-changing skyline.

When Joseph Pennell executed his first New York series in 1904, he had already produced 300 etchings in an oeuvre that would finally total close to 900 intaglio prints, around 625 lithographs and unknown quantities of drawings, watercolors and oil paintings (Wuerth, *Catalogue of the Etchings* and *Catalogue of the Lithographs*).* Before settling abroad in 1884, he had produced almost 50 prints. These all involved man-made structures, for he was from the beginning a specialist in buildings. In 1881, at twenty-four, his first of countless commissions for *The Century* (at that time *Scribner's*) magazine, "A Day in the Mash," consisted of etchings of an industrial landscape of old canal boats and an oil refinery. He had etched a series of Philadelphia buildings; illustrated articles on the Creoles of Louisiana showing the Cabildo in New Orleans and other architecture; and in 1882–83 he was in Florence, Pisa, Lucca, Pistoia, Siena and San Gimignano, illustrating a series of articles on Tuscan cities by William Dean Howells.

In the 20 years between 1884 and 1904, his London plates, his Spanish series and his illustrations for Mrs. Schuyler Van Rensselaer's text on *English Cathedrals* and for Elizabeth Robins Pennell's *French Cathedrals*, were the training ground for his later "cathedrals of commerce." ("After all, who is there who can do architecture like Pennell?" exclaimed Richard Watson Gilder, editor at *Century*.) After Winchester, Salisbury, Amiens, Rouen, Beauvais and Toledo, what new challenges were there in Ernest Flagg, Cass Gilbert and Henry J. Hardenbergh?

From the beginning, even during childhood, Joseph Pennell's interest in drawing, with architecture as the primary subject, was reinforced and amplified by a variety of persons. Born July 4, 1857, into a Philadelphia family of long Quaker lineage, he was a nervous, detached child who preferred drawing to playing with other children. Close to his father, a shipping clerk for the Cope Brothers firm, which owned the Liverpool packet ships, Joseph spent much time

*Improper storage by a London warehouse from 1917 to 1922 resulted in the unfortunate loss of a large quantity of Pennell's work, an estimated two thirds of his entire production up to that time.

with Larkin Pennell in a second-story office overlooking Walnut Street Wharf, perched on a high stool at a window, drawing the ships and nearby buildings. Later he claimed that it was not the influence of Japanese prints but the experience of those office windows that accounted for the elevated viewpoint in so many of his pictures.

Moving with his family in 1870 to Germantown, he attended the Friends' Select School. There a drawing master, James R. Lambdin, a Philadelphia painter, stressed drawing from memory. He awarded Joseph first prize for the best drawing made out of doors during summer vacation (a pencil rendering of a house neighboring the Pennells'). A lecturer at the Friends' School, W. H. Goodman, was a student of Gothic architectural refinements.

Upon graduating in 1876, Pennell applied for admission to the Pennsylvania Academy of the Fine Arts, under Thomas Eakins the most rigorous art school in the country, but was rejected. Nineteen years old and wanting to be on his own, he took a seven-dollar-a-week job as clerk for a coal company and attended night classes at the Pennsylvania School of Industrial Art. His friend Edward L. Tinker, the author, wrote: "It was probably some 'perversity' of the romantic, impractical Welsh-Irish blood in his veins that made him, from the first, worship beauty with the same veneration which his sober Quaker relatives accorded to their God, and determined him to become an artist" (Tinker, *Dictionary of American Biography*).

One teacher, Charles M. Burns, an architect who was interested in etching, took a group of students to sketch shipyards and coal wharves. Earlier, Larkin Pennell had taken his son to the oil regions of Pennsylvania and the coal towns of Tamaqua, Mahanoy City and Mauch Chunk, where Joseph did drawings of the industrial landscape which would be an influence on his later "Wonder of Work" theme.

Through a fellow student, Pennell met Stephen Ferris, an etcher and a collector who taught him about etching and introduced him to the work of the modern Spaniards Mariano Fortuny, Martin Rico, Daniel Vierge, Antonio Fabres and Antonio Casanova y Estorach, now little known but influential on that generation of illustrators. Their special qualities of brilliant sunlight flooding over form would have a lasting effect.

In 1879, through Burns, at the moment of Pennell's dismissal from the School of Industrial Art (for leading a student rebellion against teaching "too much mechanical art and too little industrial art"), Pennell gained admission to the Pennsylvania Academy. Things did not work out well between Eakins and the stubborn young Pennell, who could not easily take the exacting criticism of his teacher.

He left the Academy in 1880 and rented his own studio to launch his career as an illustrator with two drawings of a house for ten dollars each, and within two years, more securely, with his series of Philadelphia etchings and his first commission for *The Century*. Mrs. Pennell claims in her biography of her husband that it was on the ferry crossing the Hudson to sell his idea for the "Mash" series that he discovered the "Unbelievable City" which would "haunt him through the years until, at last, he settled down before it to record phase after phase of its inexhaustible beauty" (E. R. Pennell, *Life*, I, p. 41).

In 1880, Joseph Pennell was invited to participate in founding the Philadelphia Society of Etchers. Through the collection of etchings of one of its most distinguished members, James L. Claghorn, President of the Pennsylvania Academy of the Fine Arts, Pennell became deeply influenced by Whistler and Seymour Haden. It was Claghorn who in 1882 proudly introduced the New York dealer Frederick Keppel

to Pennell's etchings as "original work by one of our own boys." That was the year that the surgeon and etcher Haden, Whistler's brother-in-law, spoke in Philadelphia on the occasion of the etching society's international exhibition. Later, as expatriates, the Pennells would get to know Whistler and his circle intimately, and in 1908 would together publish a monumental, definitive Whistler biography.

During the time the Pennells lived abroad, they traveled and wrote extensively. He not only illustrated their own books and articles, but works by such notable writers as George Bernard Shaw, H. G. Wells, Henry James, Edmund Gosse, Andrew Lang, F. Marion Crawford and others. In London, living first in Bloomsbury and then at Adelphi Terrace, they met most of the leading literary and artistic persons of the day: Whistler, Robert Louis Stevenson, Theodore Duret, George Moore, Walter Crane, Henry James and Philip Hamerton. Shaw turned over his place as art critic on *The Star* to Pennell, who introduced Aubrey Beardsley to the art world. Pennell's whiplash tongue and his positivistic, unsoftened criticism made him a controversial person, respected for his firm beliefs.

He was for several years a lecturer on illustration at the Slade School of Art, University College, London, and at the Royal College of South Kensington. Pennell won the First Class gold medal at the 1900 Paris Exposition, another at Dresden in 1902, the Grand Prix at the 1904 St. Louis Exposition, the Grand Prix at Milan in 1906, and during his career medals at exhibitions in Paris, Brussels, Amsterdam, Leipzig, Rome, Florence, Barcelona, Philadelphia, Chicago, San Francisco and Buffalo.

His work entered the collections of the British Museum, the South Kensington Museum and the Guildhall Gallery, London; the Luxembourg Museum, Paris; the Uffizi Gallery, Florence; the Modern Gallery, Venice; the Modern Gallery, Rome; the Berlin National Gallery; and museums in Dresden, Budapest, Munich, Melbourne, Perth and Adelaide.

Joseph Pennell's work is inevitably associated with Whistler, in his estimation the greatest artist of modern times, "the master who will endure." Often it was regarded as imitative, and indeed his early work was. But now with a fresher look, one sees in Pennell's development the growth of an individual creative personality, forceful and provocative, especially in the New York series and those prints and drawings illustrating "The Wonder of Work."

Pennell did not actually study under Whistler, but he did in 1893 at Whistler's invitation help him bite and print a set of plates in Paris; and, of course, during his close association with Whistler, he observed his working techniques and thoroughly discussed his ideas about art. He claimed that technically he learned everything from Whistler. There is a lot to that, but Pennell's art is also soundly based on a knowledge of the traditions and history of the graphic arts, as can be clearly seen in his thorough technical treatises on etching and lithography, and his personal collection of prints. As well as Whistler, one should also consider the formative effect of his other hero, Rembrandt, along with Charles Méryon, Piranesi, Canaletto and other *vedutisti*.

Like Whistler, Pennell drew directly onto the prepared copper plate, using it like a sketchbook, rather than making a drawing to copy or transfer later in reverse onto the plate. This practice of Pennell's, of course, gives a mirror-image reversal of the subject in the printing process, causing the orientation of a scene to be quite confusing. In this, following the precedent of Rembrandt and Seymour Haden, as well as

Whistler's, Pennell felt that the artistic qualities of the print, the vivid, spontaneous deftness gained through working in direct response to the subject, outweighed the inconvenience of having to look at the print in a mirror to see the scene correctly oriented. (There are exceptions: for example, the series of etchings for the Brooklyn Edison Company in 1923.)

Pennell's dealer, Frederick Keppel, left a record of the artist's approach:

> To see Mr. Pennell at work etching a plate is a thing to remember. He loves to depict the towering buildings of crowded streets. Most etchers of such subjects would make a preliminary sketch on the spot and afterwards toil laboriously over the copper plate in the retirement of their studios; but Mr. Pennell takes a far more direct course, and one which would disconcert almost any other artist. He chooses his place in the crowded street, and stands there quite undisturbed by the rush of passers-by or by the idlers who stand and stare at him or at his work. Taking quick glances at the scene he is depicting, he rapidly draws his lines with the etching needle upon the copper plate which he holds in his other hand, and what to me seems an astonishing *tour de force*, he never hesitates one instant in selecting the exact spot on the plate where he is about to draw some vital line of the picture, each line of it being a "learned stroke" (in which one stroke in the right place tells more than ten in the wrong) such as Seymour Haden insists upon" (Keppel, *Joseph Pennell*, pp. 36–39).

Like Haden, Pennell felt that to achieve freshness and unity in a print the artist should know exactly what he wants to do and then proceed to execute it immediately. "An etching which occupies the artist for, say, three days, is in fact the work of three different men" (quoted in Keppel, *Pennell*, p. 32). Related to this impressionist aim to achieve impromptu spontaneity, and related also to Whistler, are the use of unexpected vantage points, giving a fresh aspect even to the familiar; and the preference for interpretive mass effects rather than descriptive detail. Frequently Pennell's views (e.g., "Trinity Church, from the River," Plate 1) in not being equally "completed" to the edges, are reminiscent of Whistler's "Japanese method of drawing" in which the artist begins with the chief point of interest and works outward, expanding the composition of elements peripherally, so that at any time in its making the picture is complete.

Pennell had his own ideas about drawing architecture:

> To draw a building well, it is not absolutely necessary to be able to put it up ... one should give the most impressive view of a building, not the most commonplace; ... one should give the building its due relation to the others which surround it, or to the landscape in which it is placed.
>
> I have tried to do something also in the drawings of architecture among other things, and some ten years spent among the great masterpieces of that art gave me some idea of it.... When possible the drawings were made on the spot. I have tried assistants ... I used photographs and the camera lucida; but it dawned upon me soon that if I wanted to do good work I must do it all myself, and do it all from nature.... I gave up all help and aids, I forgot perspective, and like other discoverers, discovered that the perspective I invented was known to the Italian primitives and used by Dürer. It is simply this, they never used any side vanishing lines. We have become accurate, we think, but we do not give the bigness, the feeling of things as the old men did. You cannot make a skyscraper dignified if you make it by the laws of modern perspective. You must forget them (Pennell, *Pen Drawing*, pp. 304–07).

Like Whistler, Joseph Pennell printed his own etchings. There were some exceptions: his 1904 New York plates were left in Manhattan with Kimmel and Voight to pull the edition, after he had tried and proofed them (Keppel was to

stock the set, and *The Century* was to run six of them). As his wife observed: "To him printing was an essential part of the art of etching. Only the artist knows what is in his plate, and only he can get it out of the plate into the print.... But the artist, while printing, is forever seeing something more in his plate, forever working on it, striving for perfection" (introduction to Wuerth, *Catalogue of Etchings*, p. xii). In a letter of 1907 to Hans Singer, a critic writing for *International Studio*, Pennell wrote:

> I think there is just as much in the printing of a copper plate as in the drawing and biting of it by the artist.... of course [a master printer] can follow a model you set him perfectly—but then the charm of etching-printing is that you don't follow a model—when you do it yourself you have an idea of what you want and maybe you get that—but as soon as you have got it—you see something else and go for that, and with a result ... that when I have done 25 I am just about where I would like to have started ... it is all to me a series of experiments (E. R. Pennell, *Life*, II, p. 35).

Pennell was constantly experimenting with new tools, different grounds and their preparation, acids and inks, and paper. He was a master printer who insisted on the most suitable materials and tools. His favorite etching tool was the Whistler needle, a small, well-balanced, delicate needle, with a point at each end. In his late prints he used a dental tool shaped to his purpose.

Again like Whistler, Pennell sought out in all his travels old papers, in Italy, France and Holland, in bookshops and junk stores, tearing out flyleaves to build up an abundant collection. "A paper which is old does take ink very much better than modern papers ... a paper that has the beautiful tone of time on it, and the beautiful watermarks that some of those old masters put on it, is something, when you can find it, you want to treasure" (Pennell, *The Graphic Arts*, p. 215).

Prior to around 1907, Pennell would often trim the edges of his prints right down to the platemark, with only a bit of the margin left for the signature, a device also used by Whistler. Since they were using old papers which were expensive and often with ragged edges or a hole, by doing this it was possible at times to get two sheets out of one or to place the plate lopsided on a defective sheet. Although the trimmed prints are less well protected, as there is no margin to lift them by, they lie flatter than untrimmed ones.

Joseph Pennell was among the first artists at the beginning of this century to recognize in the industrial and commercial environment a subject matter expressive of the new modern age. He saw in the Wonder of Work a power and grandeur which was "the apotheosis of America":

> Work today is the greatest thing in the world, and the artist who best records it will be best remembered.... The man with the greatest imagination is the man with the greatest information about his own surroundings, which he uses so skillfully that we call the result imagination, and this is the way the greatest art in the world has been created.... And art which shows life and work will never die, for such art is everlasting, undying, "The Science of the Beautiful" (Pennell, "The Wonder of Work," pp. 775, 778).

No longer is the Church the great patron of art. Artists today do not seek commissions from popes and princes, but from captains of industry and politicians. While in other days popes and princes built churches and palaces which are still the wonder of the world, today Commerce and Industry are doing work equally impressive....

The mills and docks and canals and bridges of the present are more mighty, more pictorial, and more practical than any similar works of the past; they are the true temples of the present. Our mills are as well worth painting as medieval churches; Minneapolis is as fine as Albi ... Bartholdi's Statue of Liberty in New York Harbor is far more dignified than the legendary Colossus of Rhodes. Can the Pont du Gard be compared with the bridge between Scranton and Binghamton? And how do the skyscrapers of New York compare with those of Florence and Genoa, where this structural idea had its origin?

These are works of utility, but a utility of the present, which has grown out of the utility of the past, in which tradition has been carried on by architects and engineers who have built these mills and bridges and canals and docks for use—and yet made them pictorial, for all great work is great art (Pennell, "The Wonder of Work in the Northwest," p. 591).

Pennell was fascinated by the dynamics of the Machine Age, capable of vast structural wonders on a scale never seen before. Yet he stood with one foot in each century at that moment when nineteenth-century values were evolving into their radical twentieth-century distensions. With a style bound to the past he sought artistic truth in the realities of the future. He responded enthusiastically, but with an esthetic that accepted the proofs of Progress as ethical enrichments of subject matter.

He was an illustrator, in the best sense of the word, of these modern monuments, using an essentially impressionist style. In giving the subject immediate and primary value, he was distinctly apart from Whistler, who emphasized artistic arrangement and refinement, subordinating to that aim any contextual relationships. "I was always an illustrator," Pennell said. While by no means merely a topographical etcher, he did not seek beyond pictorial description for a formal language, which, as the Cubists and Futurists were contemporaneously discovering, could combine new values and new forms. Instead, he was bound to a reaffirming attitude of sentimental optimism, which to us now all the more expresses the values of that seemingly so distant era of unabated effulgence and exploitation prior to World War I. "He was friendly to those forms of beauty which veil the uglier aspects of the visible world" (editorial, *New York Times*, Apr. 24, 1926, p. 16).

Although Pennell claimed to have had an interest in the Wonder of Work from childhood, his first use of the term appeared in 1909 in a letter to John Van Dyke, author of *The New New York* (1909), for which Pennell did the illustrations. In addition to New York City, his art of work led him to seek out his subjects in Birmingham and Sheffield in England, France, Belgium, Germany, Chicago, San Francisco, the Northwest and elsewhere in the United States. He found inspiration in past art for this theme in Rembrandt, Claude's harbors, Canaletto's Venice, Piranesi's prisons, Courbet, Millet, Ford Madox Brown and the Belgian sculptor Constantin Meunier.

For Pennell the greatest work of modern times was the Panama Canal. It was very important to him in 1912 to go to the Isthmus while the Canal was in the process of being built, to draw under construction the great locks at Gatun, Pedro Miguel and Miraflores, and the Gaillard Cut; to draw the steam shovels, cranes and engines, the bare walls of the cavernous locks, the gigantic gates and the army of laborers. Without this activity, with the Canal completed, there would no longer exist that great Wonder of Work, only its product. Pennell's interest in the Wonder of Work within Nature herself found expression upon his return from Panama by way of San Francisco and the Grand Canyon and Yosemite.

Contrasts between ancient and modern Wonders of Work intrigued him. He drew the building of the Monument to Victor Emmanuel II in confrontation to the Roman Forum, and the rebuilding of the Campanile in Venice. He went to

Greece to see "what remained of her glory, to see if the greatest work of the past impressed me as much as the greatest work of the present—and to try to find out which was the greater—the more inspiring" (E. R. Pennell, *Life*, II, p. 118). He made etchings from the Pentelicon quarry, which had provided marble for the Parthenon, and the ancient Greek quarry in Agrigento in Sicily. The grandeur of nature versus the grandeur of man was expressed in the theater at Taormina in contrast with the majestic cliffs of the Mediterranean. He claimed that having seen the Grand Canyon, one of Nature's compositions, he knew how marvelous were the architectural compositions of the Greeks.

World War I provided Pennell with an extraordinary Wonder of Work subject—up to then the greatest amount of industrial energy ever expended. In his posters of war work in England and later in the United States, he wanted to impress people with the enormous expenditure of both labor and lives, hoping to contribute toward the deterrence of wars.

In his New York series grandiose themes are developed out of the contrasts between small and large, old and new, rags and riches, the sacred and the profane, man's spirituality amid the transience of his products, the succession of kings among the skyscrapers, shipping, transportation and that endless tearing down and rebuilding.

In June 1921, after installing their valuable collection of Whistleriana in the Print Division of the Library of Congress, Joseph and Elizabeth Pennell moved to Brooklyn Heights. In their native Philadelphia they had felt like foreigners after returning there before the end of World War I. Joseph was a controversialist, irascible and contumacious, and that had never helped him make friends easily. "Always right, even when he was wrong," he had left Philadelphia bitter about an unhappy incident in which the University of Pennsylvania, after voting to confer upon him an honorary degree, had decided for some reason to deny him the award. Feeling homeless in his own country, he sought in Brooklyn Heights a replacement for the Adelphi Terrace flat with its grand view of the Thames and the Waterloo Bridge, which in 1917—himself shattered by the war—he had been so saddened to give up. His search ended in an apartment high up in the massive 12-story Hotel Margaret (95–97 Columbia Heights, northeast corner of Orange Street) at the northern end of Brooklyn Heights. From large bay windows his rooms commanded an unexcelled view of the Manhattan skyline and New York Harbor from the Brooklyn Bridge almost to Staten Island.

Brooklyn Heights, isolated on a high bluff overlooking the East River, in the nineteenth century had been a wealthy district inhabited by an upper crust of merchants and bankers who built fine brownstone mansions for their families and enjoyed the comfortable seclusion of a beautiful location which was only minutes away by ferry from the Manhattan business district. That quiet isolation was inevitably broken by the city's expansion, which brought increased accessibility and real-estate speculation. The Brooklyn Bridge opened in 1883; the IRT Subway Tunnel in 1908 and the BMT tunnel in 1913 bound together the two boroughs even more irrevocably than the Greater New York Charter of 1897; the advent of the motor car was another decisive factor. Brooklyn Heights became a desirable commuter suburb. The wealthy moved out to more exclusive areas; their brownstones were converted into apartment and rooming houses. Large hotels went up: the Touraine, Standish Arms, Bossert and the Hotel St. George—with more than a thousand rooms the largest in Brooklyn. The Margaret, built in 1889 (Frank Freeman, architect), was one of the first.

When the Pennells moved to the Heights there still remained much of the character of its dignified and aristocratic past. Its quiet tree-lined streets and old houses had a secure respectability and charm that were an acceptable substitute for their Buckingham Street flat, and the view even surpassed that from the London Embankment.

Fifteen minutes away by subway in Manhattan, on Sixth Avenue at 28th street, was Mouquin's, the old French restaurant, which reminded them of their favorite haunts in London and on the Continent. There, in an atmosphere of red velvet, leather seats against the wall, marble-topped tables, and mirrors; French waiters, good food and wine; modest prices and a minimum of pretense; they met with artists, architects and writers—John Flannagan, Paul Bartlett, Ernest Lawson, Childe Hassam, W. A. Rogers, Walter Griffin—and Joseph could carry on his conversational tournaments with friends. Hamilton Easter Field, editor and publisher of *The Arts*, was a neighbor on the Heights until his death in 1922.

During this Brooklyn period, even in his sixties, Pennell continued to be very productive. "Work is my hobby," he once told someone. Other than his prints, he executed a group of watercolors from his windows which were published in 1926 as *The Great New York*. As well as subjects in the great metropolis across the river, his etchings included a Brooklyn Heights series, etched in the streets below. He taught at the Art Students League; wrote art criticism for the *Brooklyn Eagle;* made a lecture tour through the Southern states; and wrote an extensive autobiography, *The Adventures of an Illustrator*.

There also were honors that indicated continued respectful recognition as an artist. Pennell was elected to the American Academy of Arts and Letters and to the National Institute of Arts and Letters. He was chosen to travel to Brussels to represent the American Academy at the 150th anniversary of the Royal Belgian Academy. He was made a member of the Royal Antwerp Academy. He was invited to serve on the New York Advisory Committee of the 1926 Philadelphia Sesquicentennial.

Joseph Pennell died on April 23, 1926, after a week's bout with pneumonia. According to his arrangements, after his wife's death in 1938, the Library of Congress received the Pennell Collection and the Pennell Fund. These include the most complete collection of his own prints, plates, drawings, books and papers; his Whistler collection; prints by important nineteenth- and twentieth-century artists; and an endowment for the acquisition of prints produced during the last hundred years by artists of any nationality (U.S. Library of Congress, *American Prints*, p. xii).*

*Other major collections of Pennell's New York prints are at the New York Public Library and the Brooklyn Museum.

Pennell's
NEW YORK
ETCHINGS

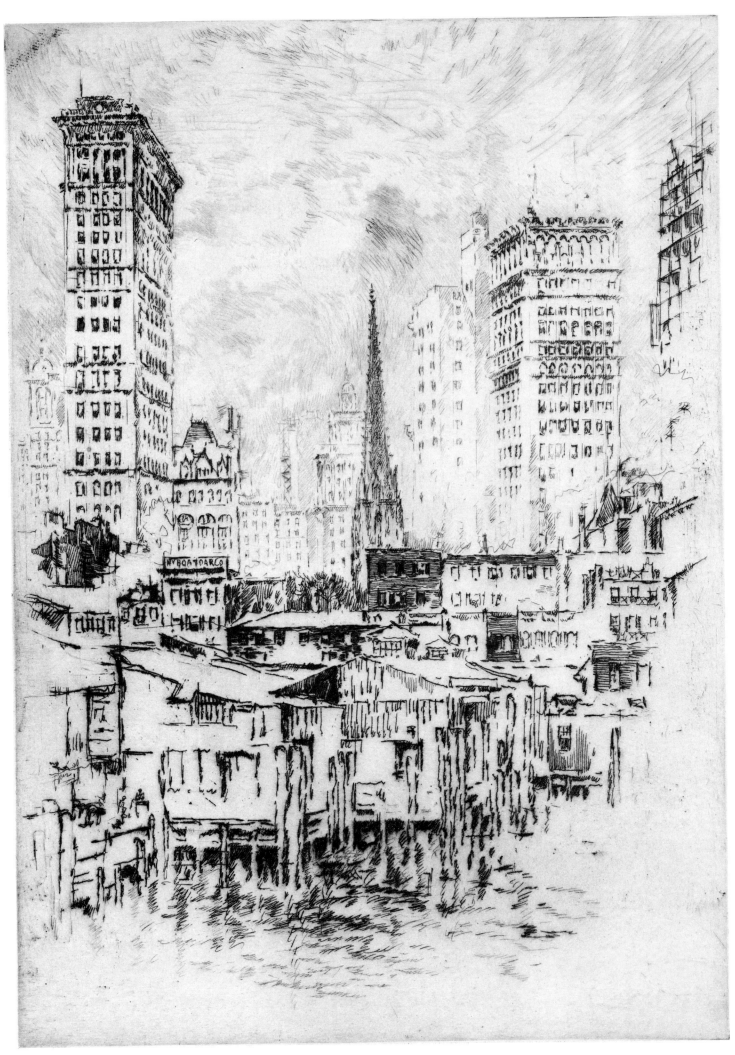

1. Trinity Church, from the River. 1904.

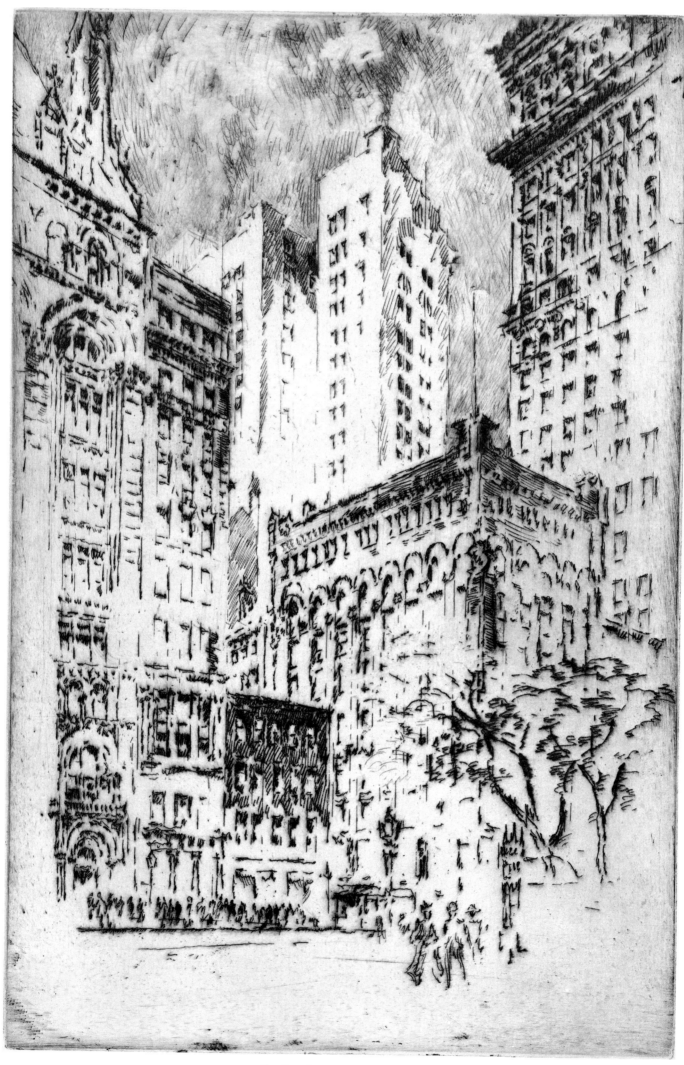

2. Four-Story House. 1904.

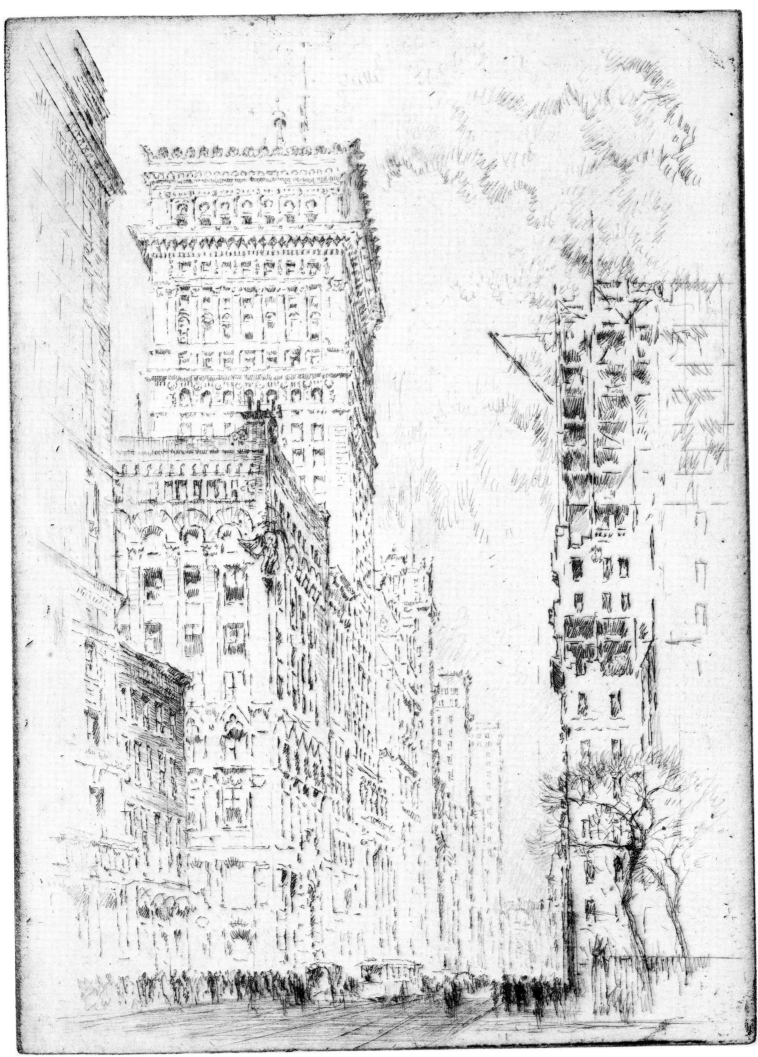

3. The Golden Cornice, I. 1904.

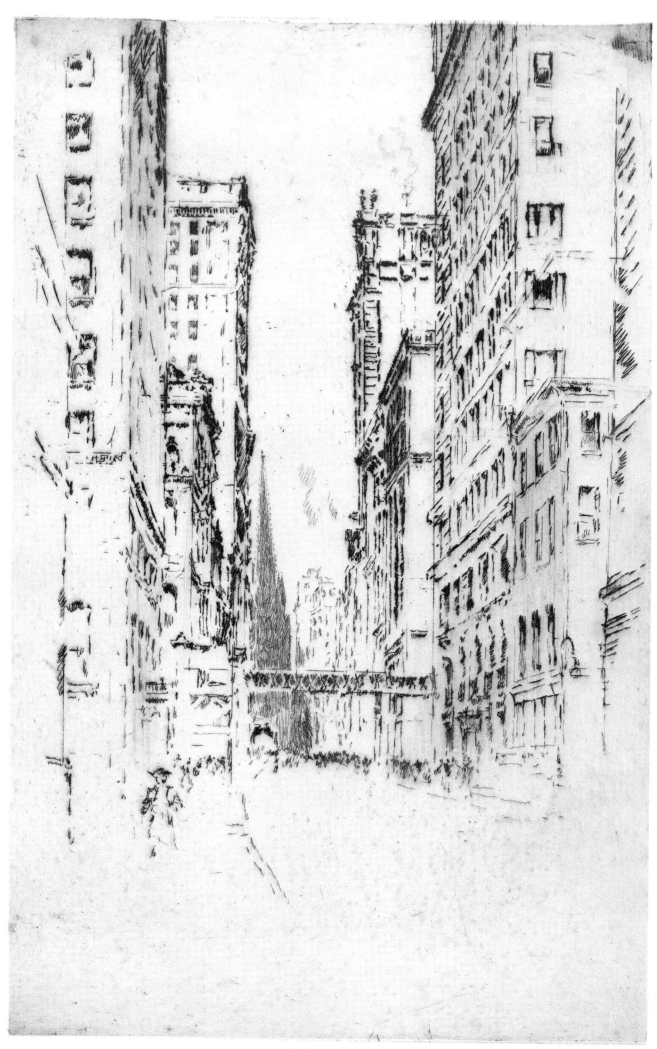

4. Wall Street. 1904.

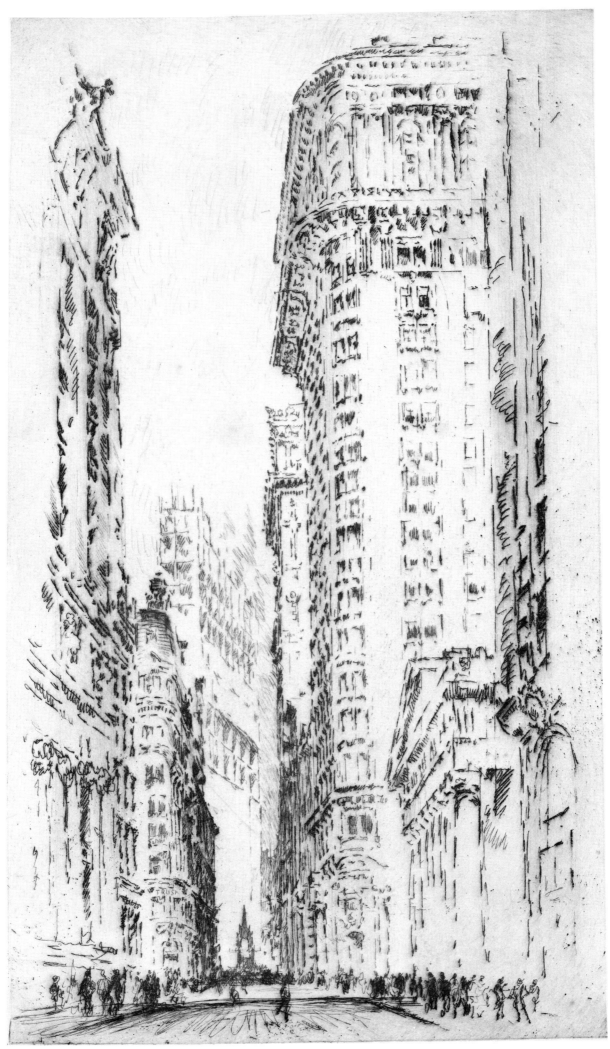

5. The Shrine. 1904.

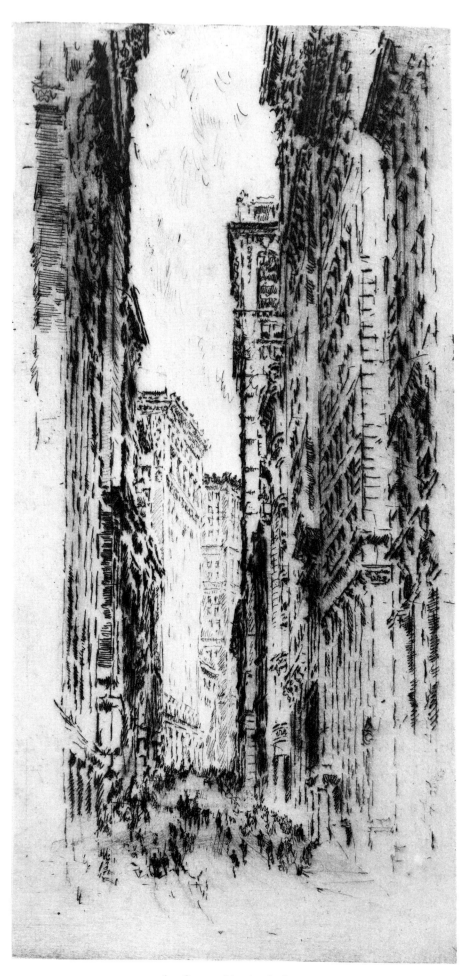

6. Canyon, No. 1. 1904.

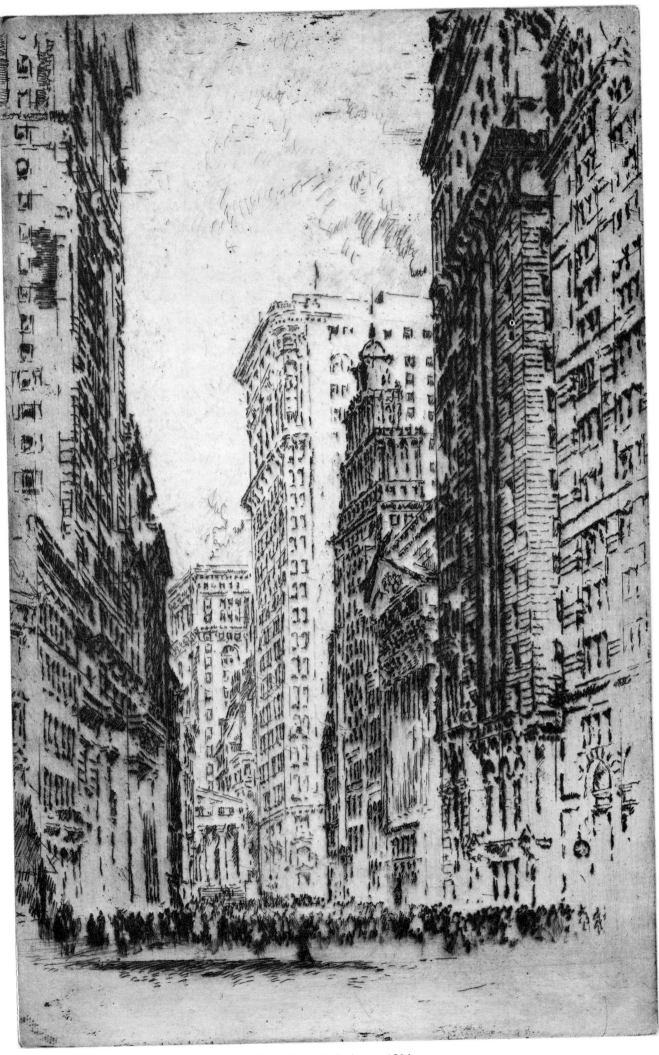

7. The Stock Exchange. 1904.

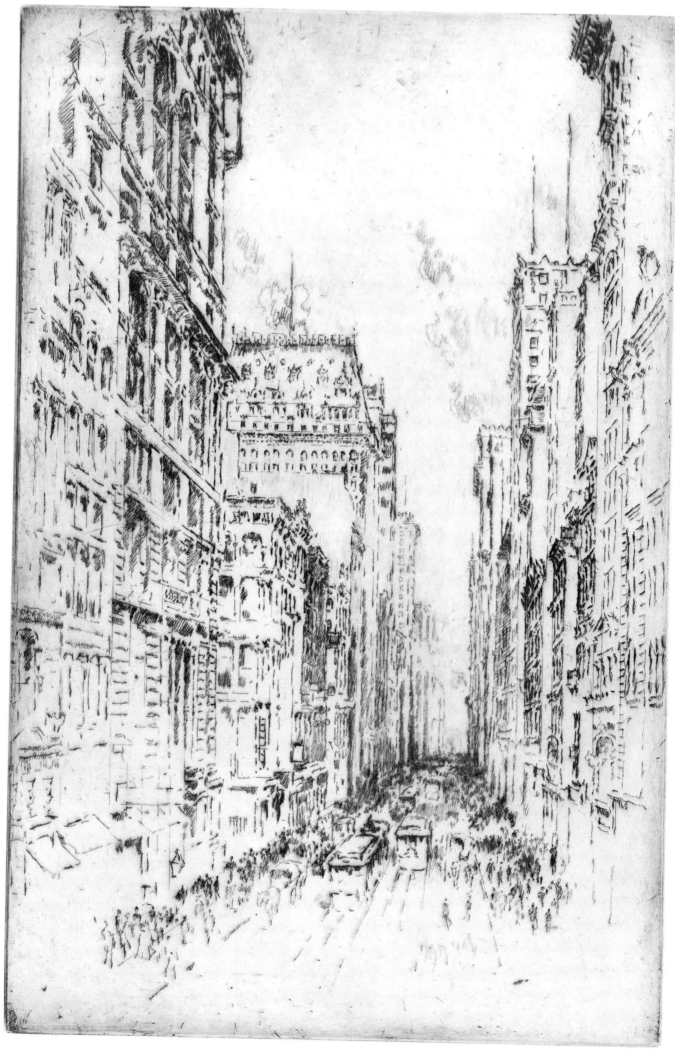

8. Lower Broadway. 1904.

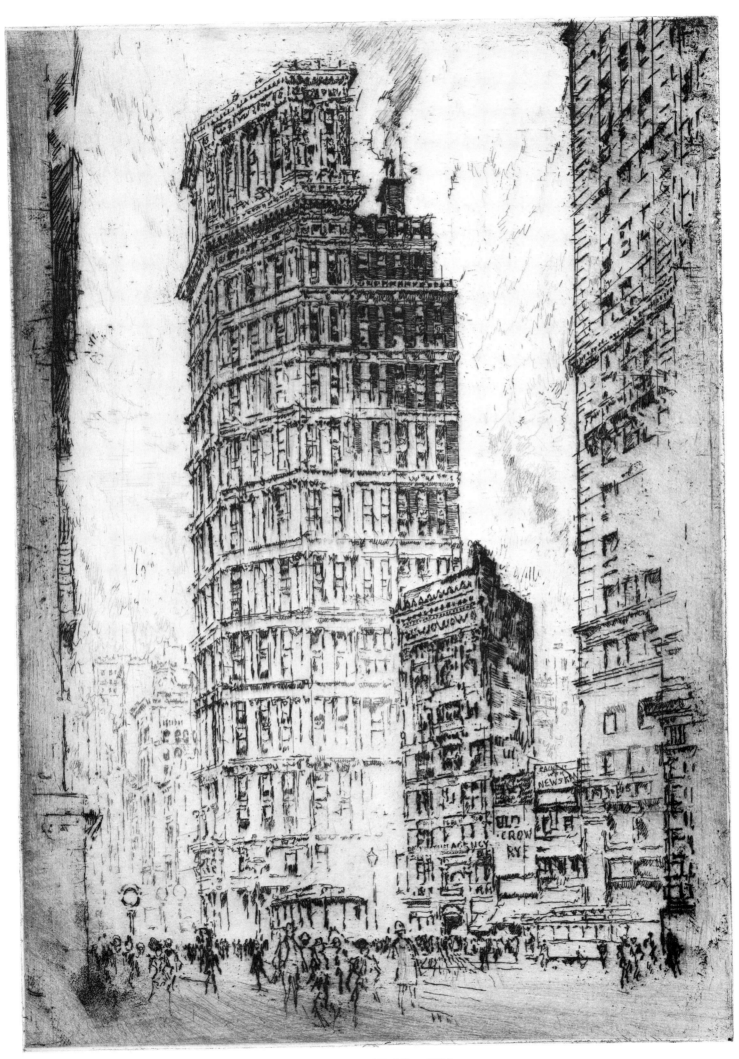

9. St. Paul Building. 1904.

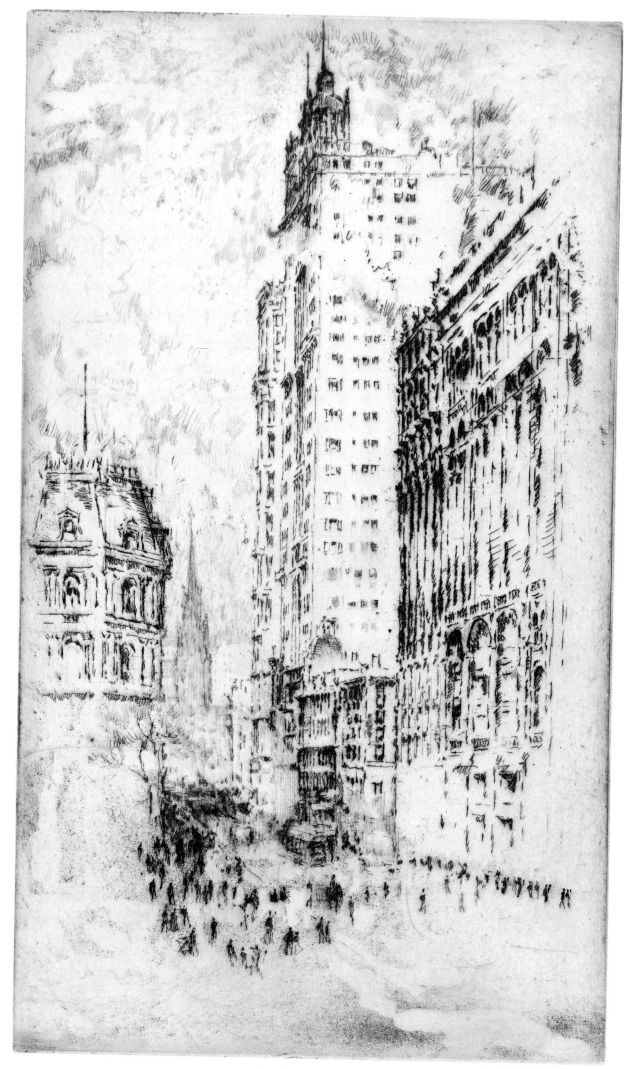

10. Park Row. 1904.

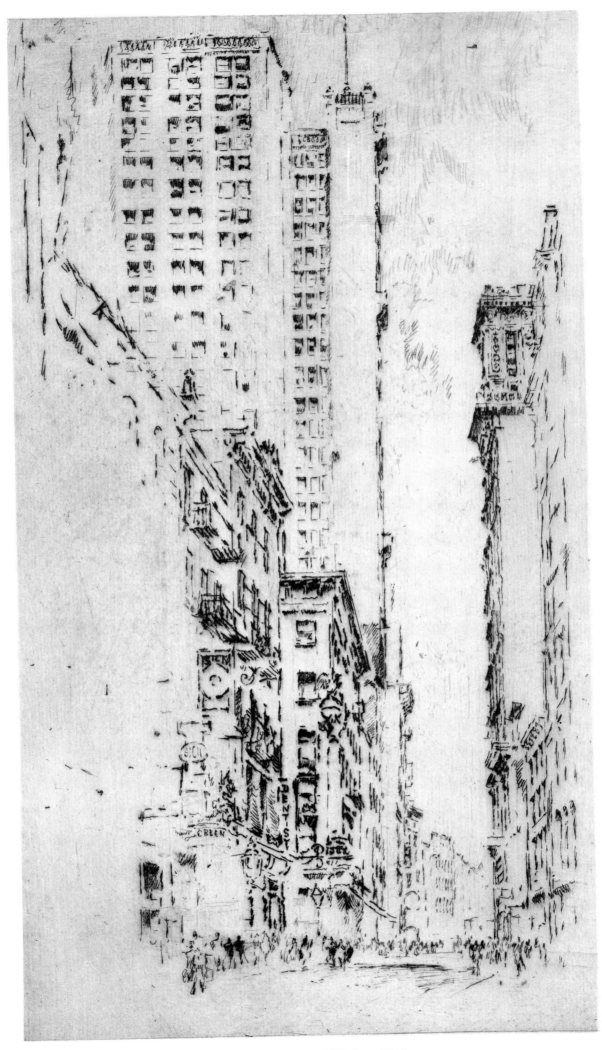

11. The Thousand Windows. 1904.

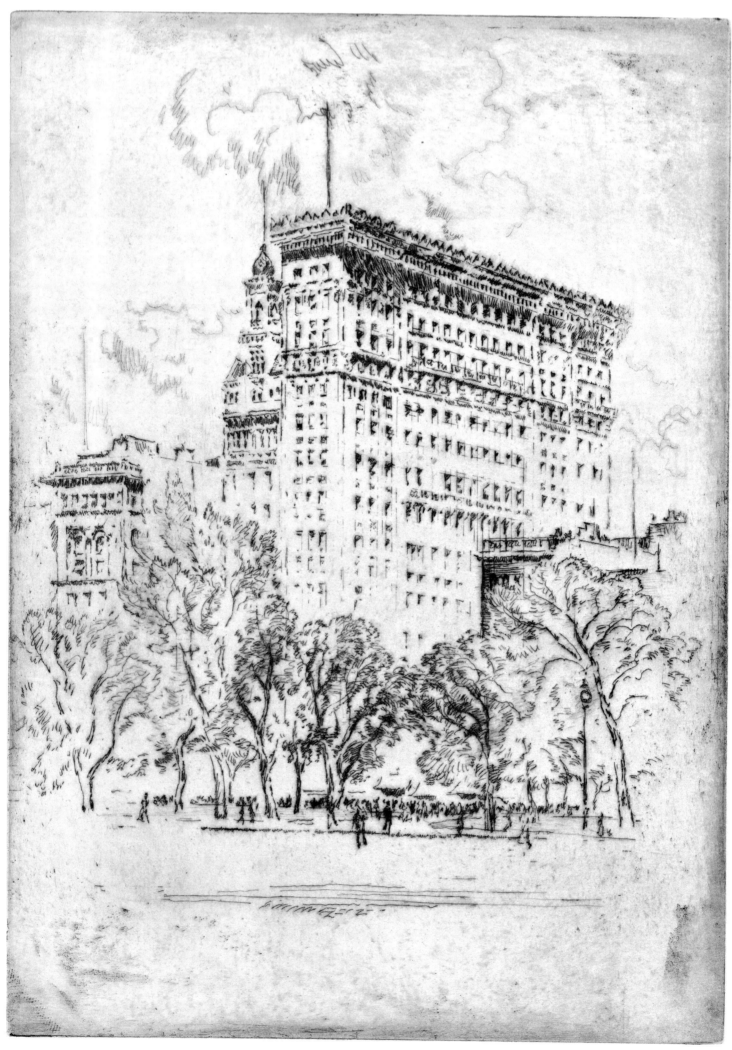

12. Union Square and Bank of Metropolis. 1904.

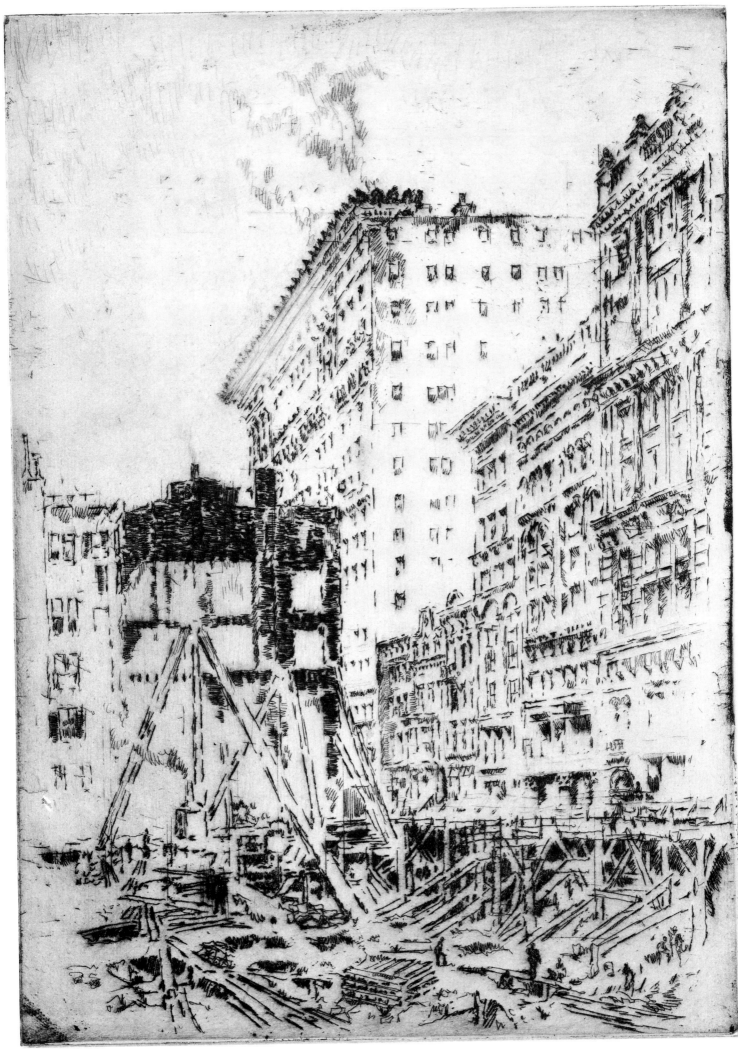

13. Hole in the Ground. 1904.

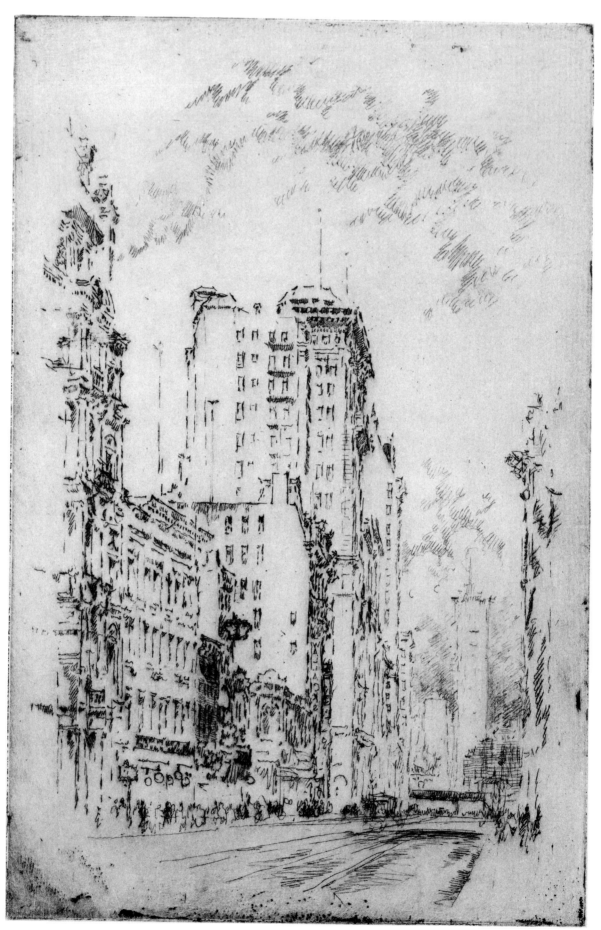

14. Broadway North from Gilsey House to Times Tower. 1904.

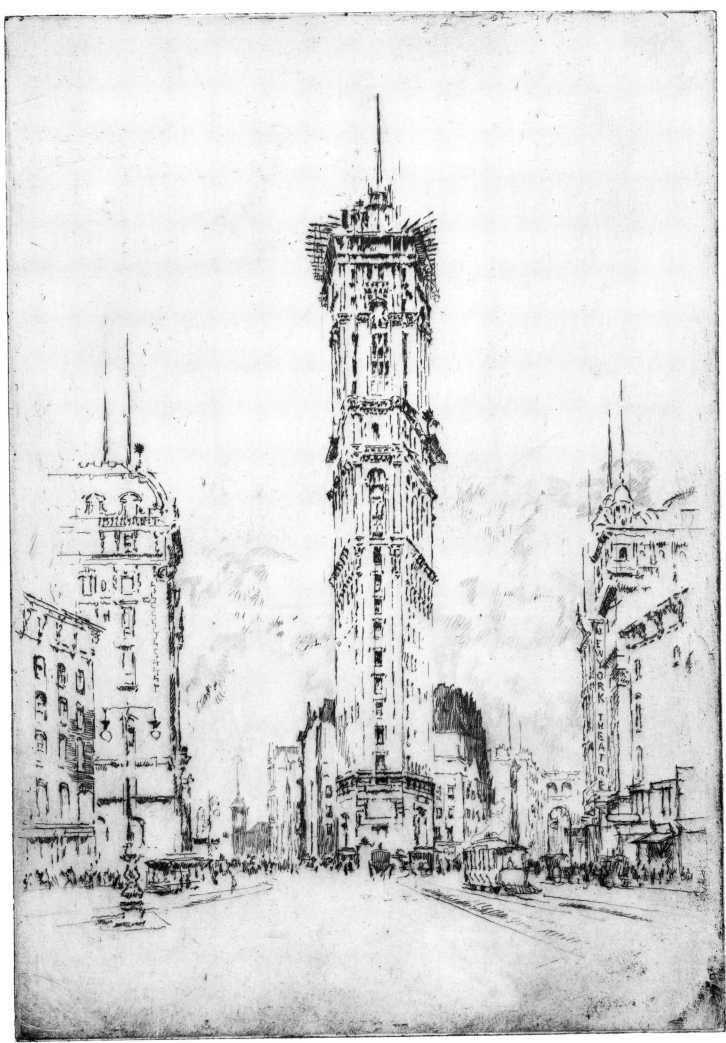

15. The Times Building. 1904.

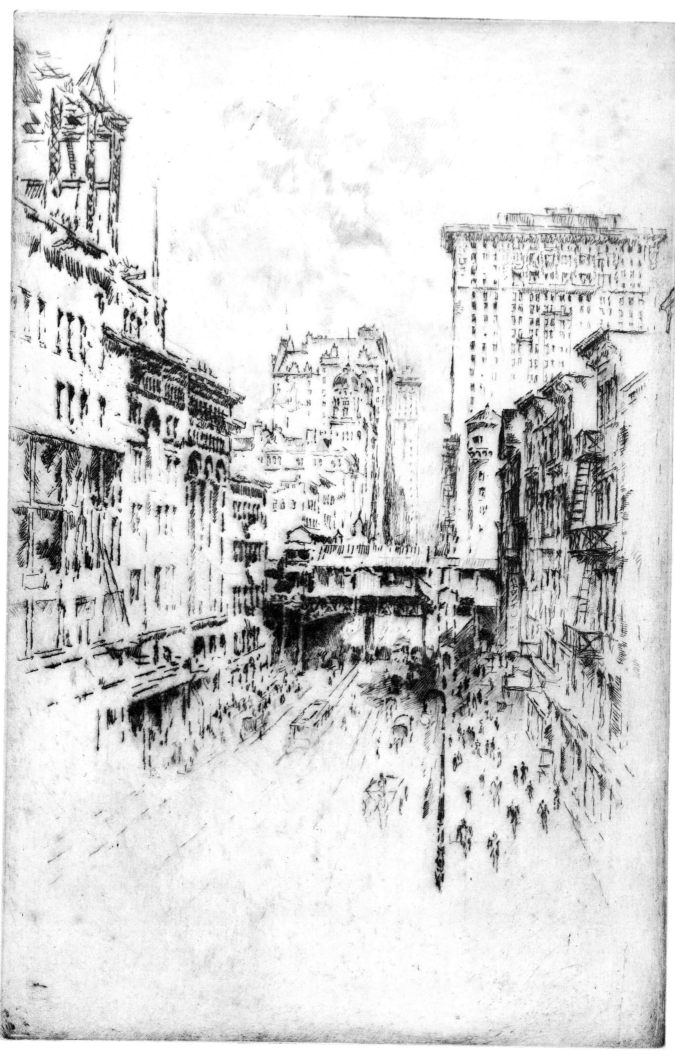

16. Forty-Second Street. 1904.

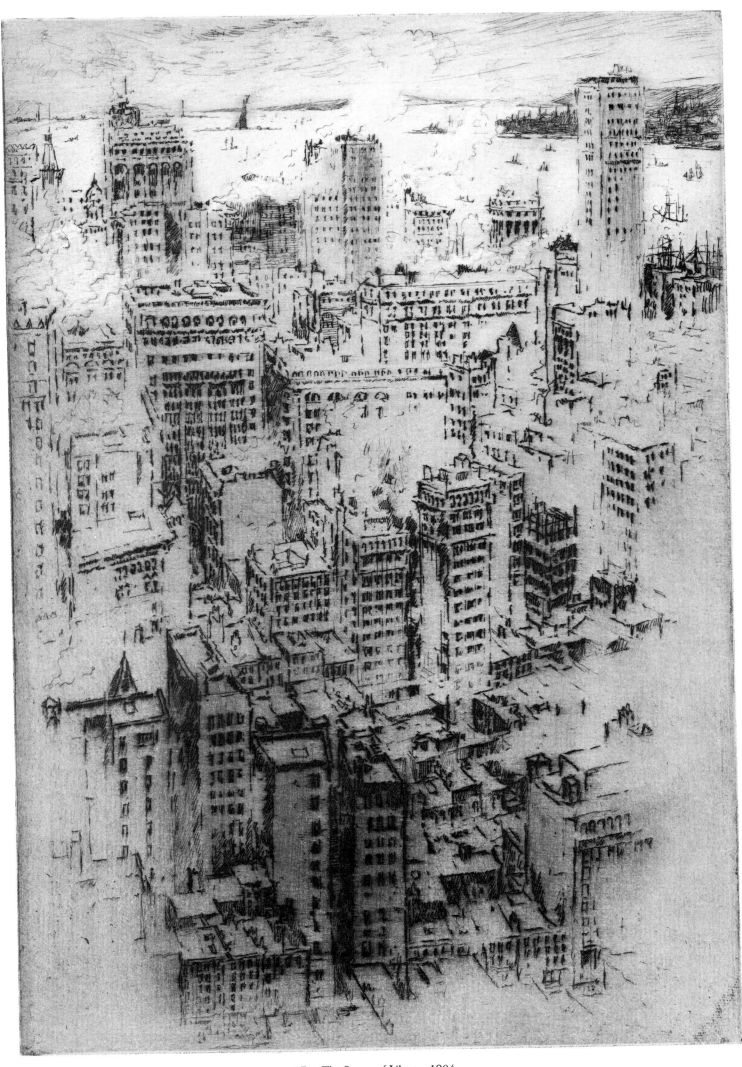

17. The Statue of Liberty. 1904.

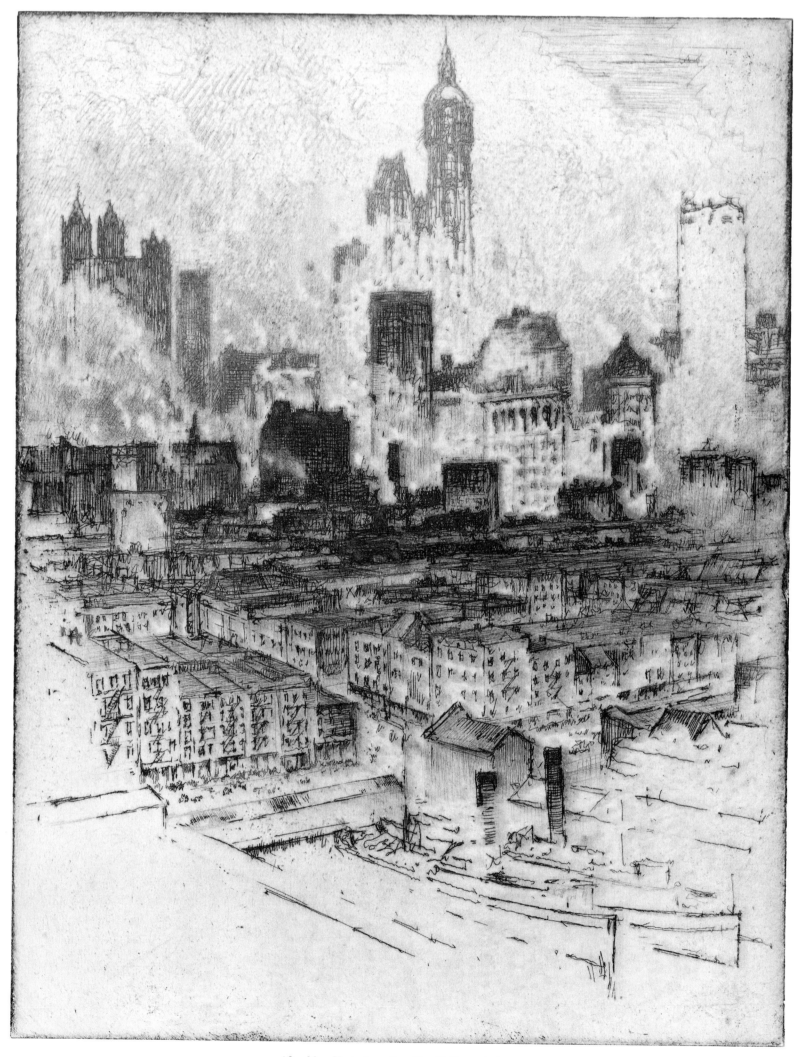

18. New York, from Brooklyn Bridge. 1908.

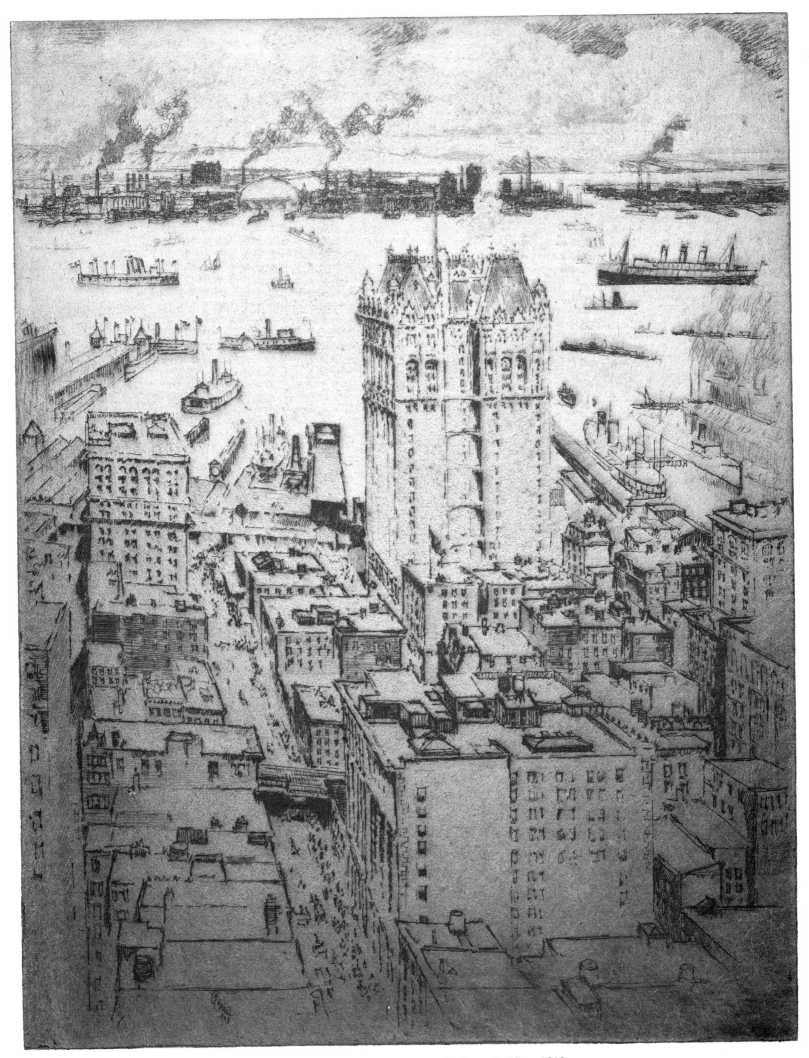

19. The West Street Building, from the Singer Building. 1908.

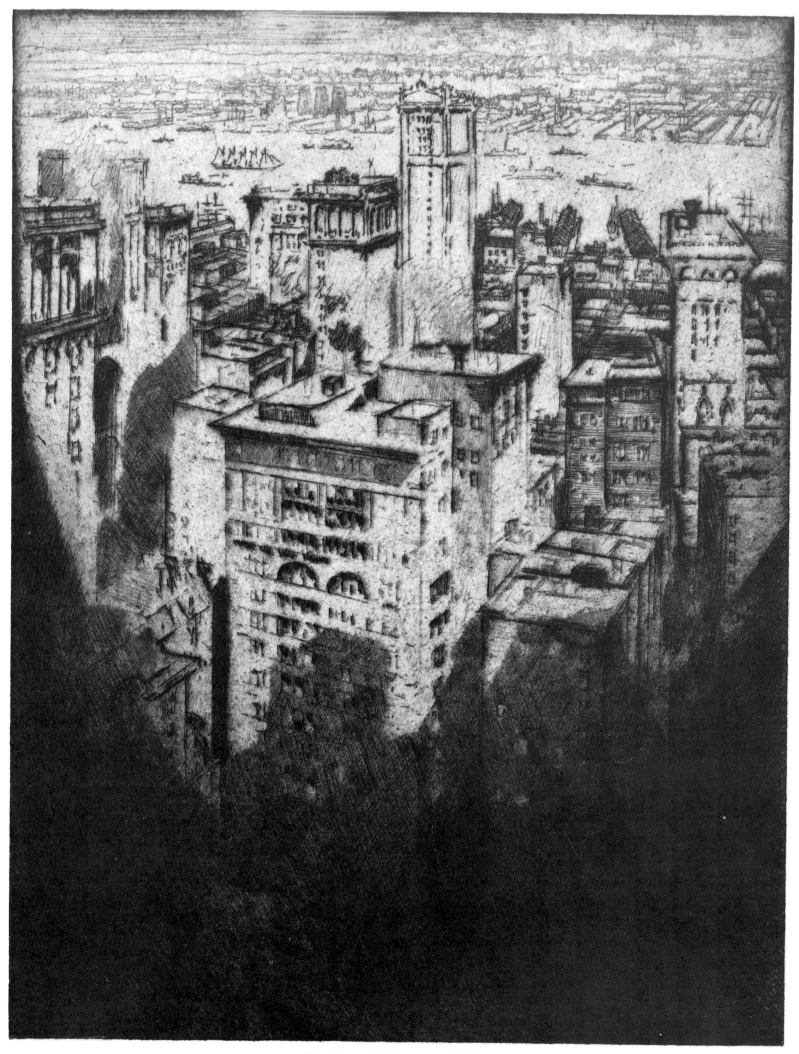

20. Among the Skyscrapers. 1908.

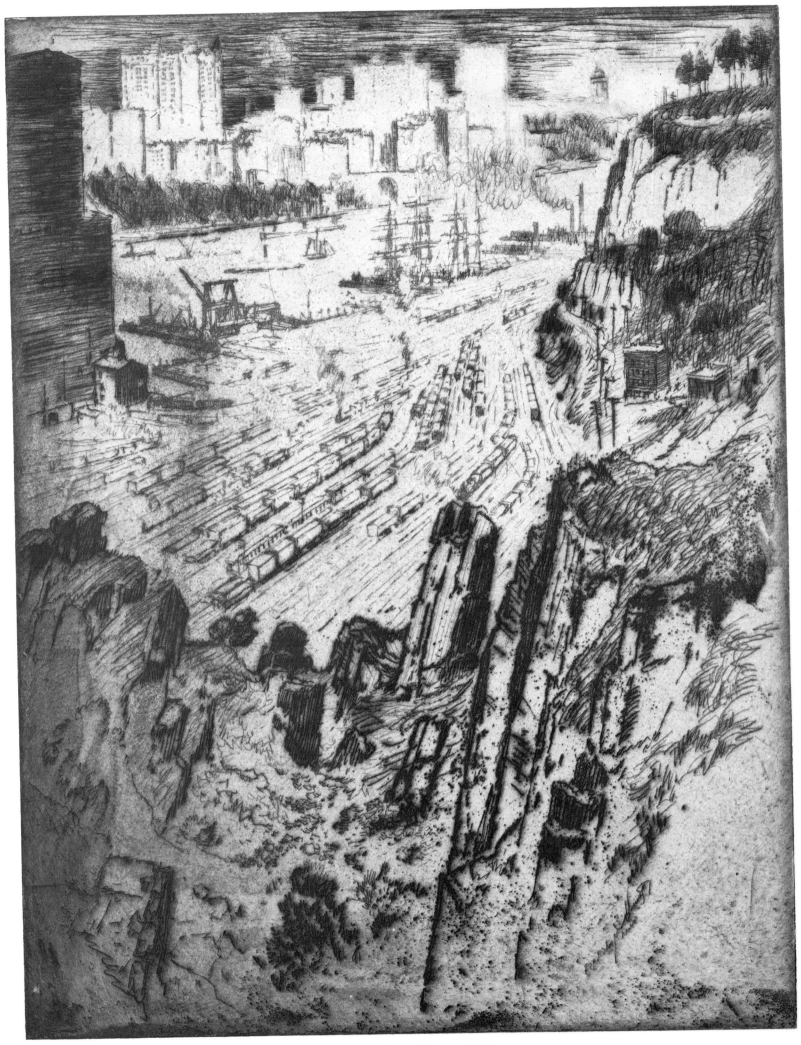

21. Palisades and Palaces. 1908.

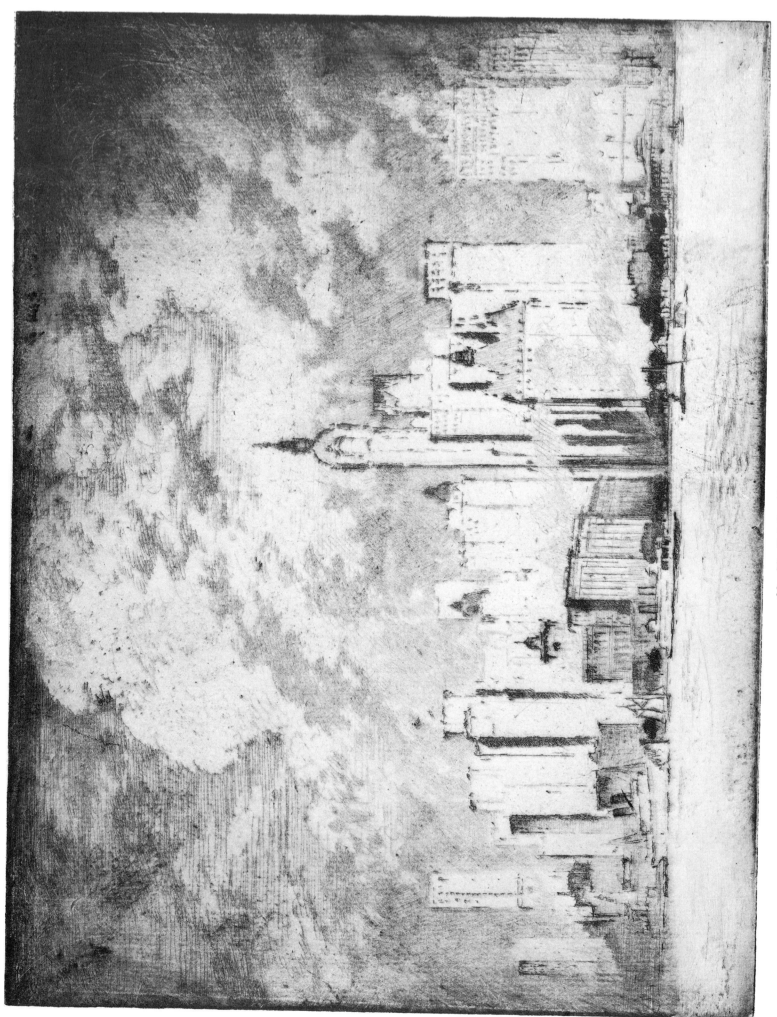

22. The Unbelievable City. 1908.

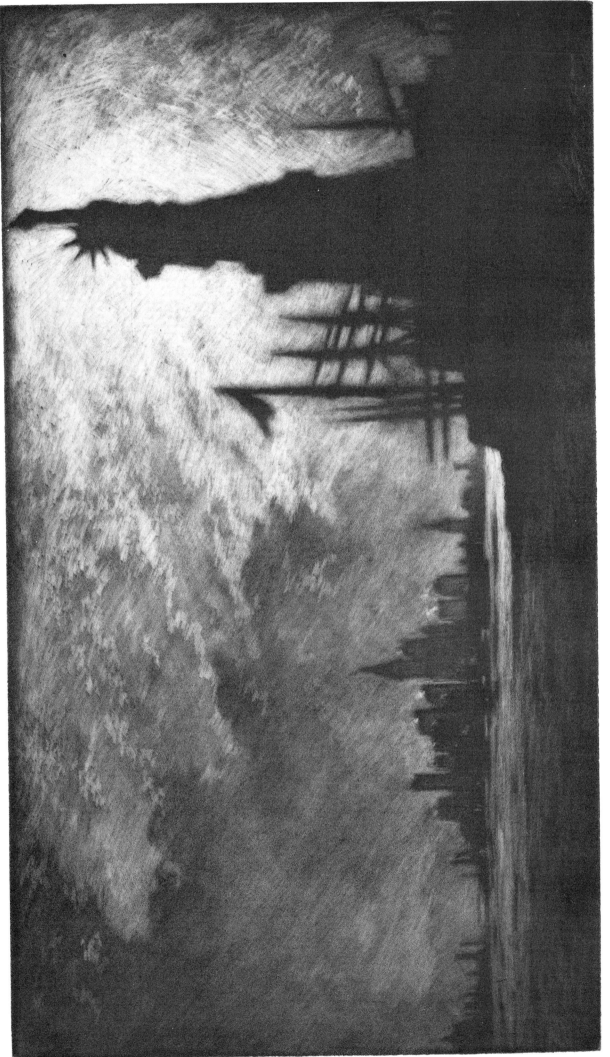

23. Hail America. 1908.

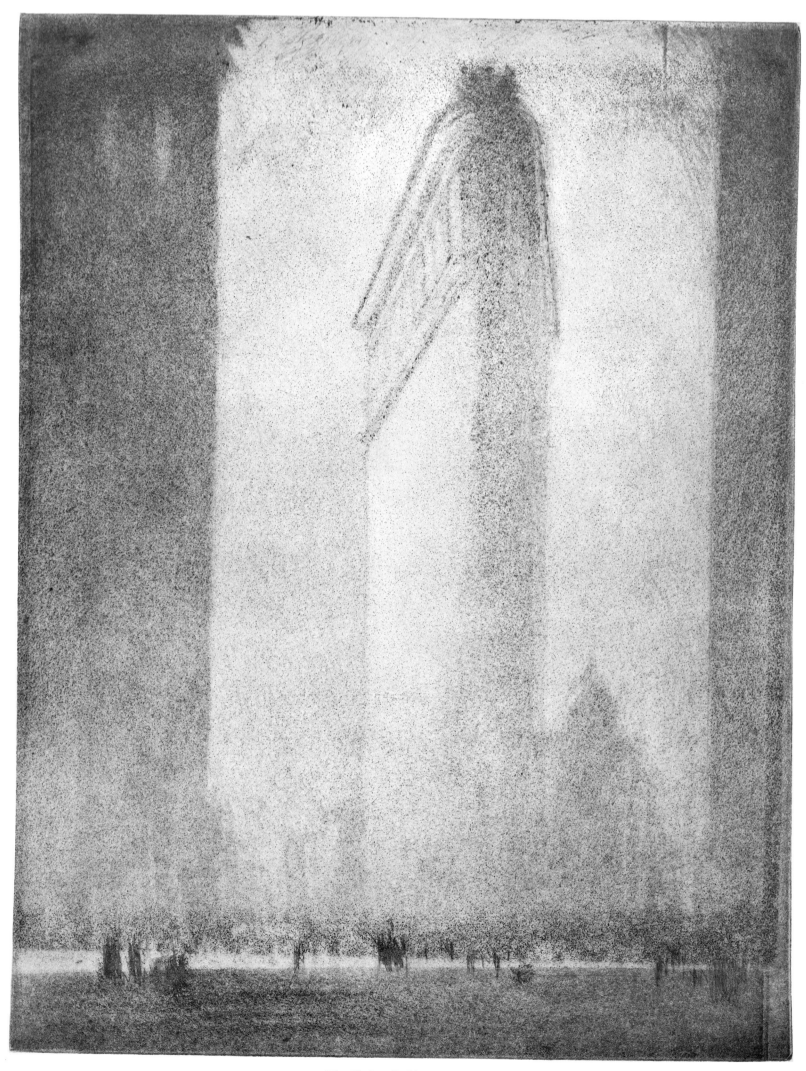

24. Flatiron Building. 1908.

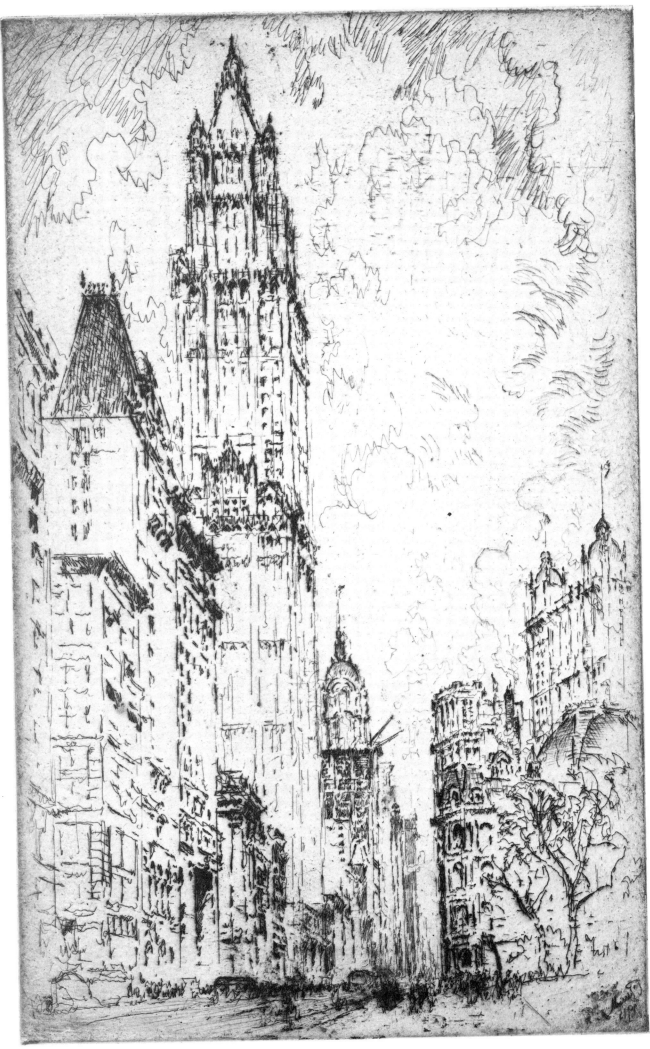

25. The Woolworth Building. 1915.

26. The City in 1915. 1915.

27. New York, from Governor's Island. 1915.

28. New York, from Hamilton Ferry. 1915.

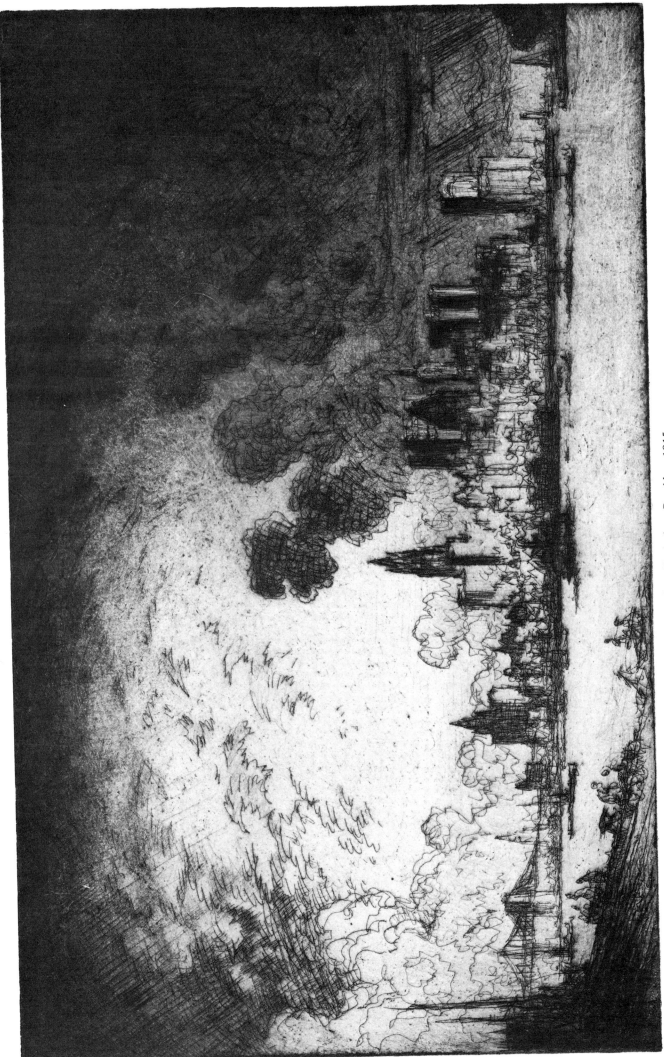

29. New York, from Brooklyn. 1915.

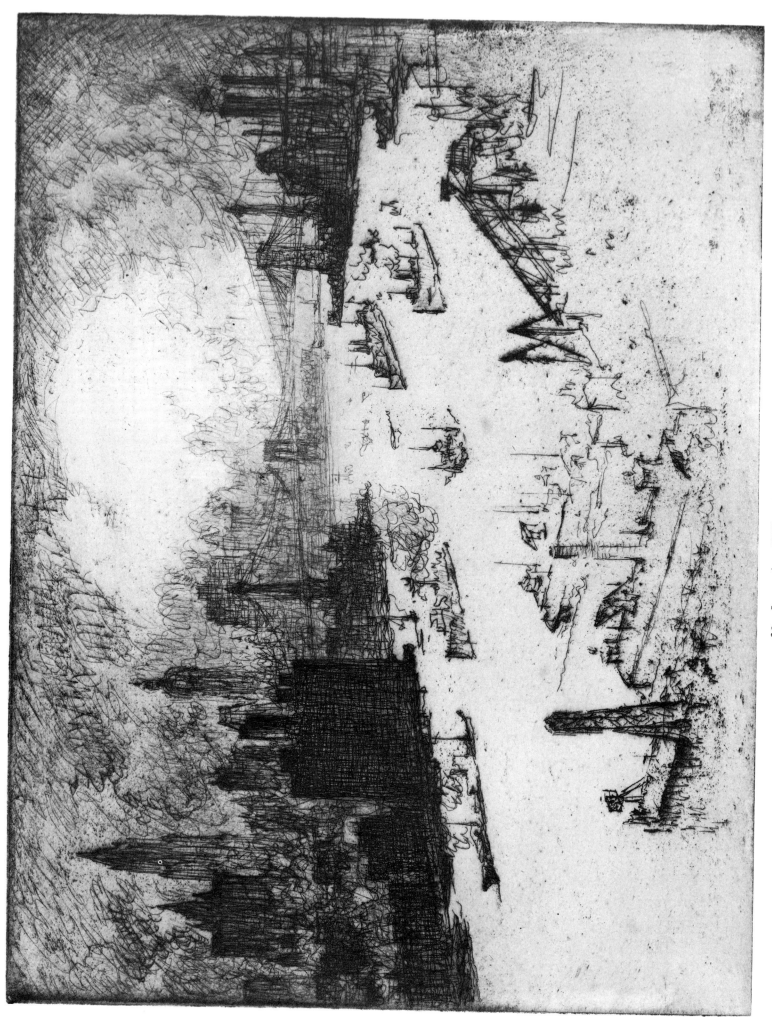

30. Sunset, from Williamsburgh Bridge. 1915.

31. The Bridge at Hell Gate. 1915.

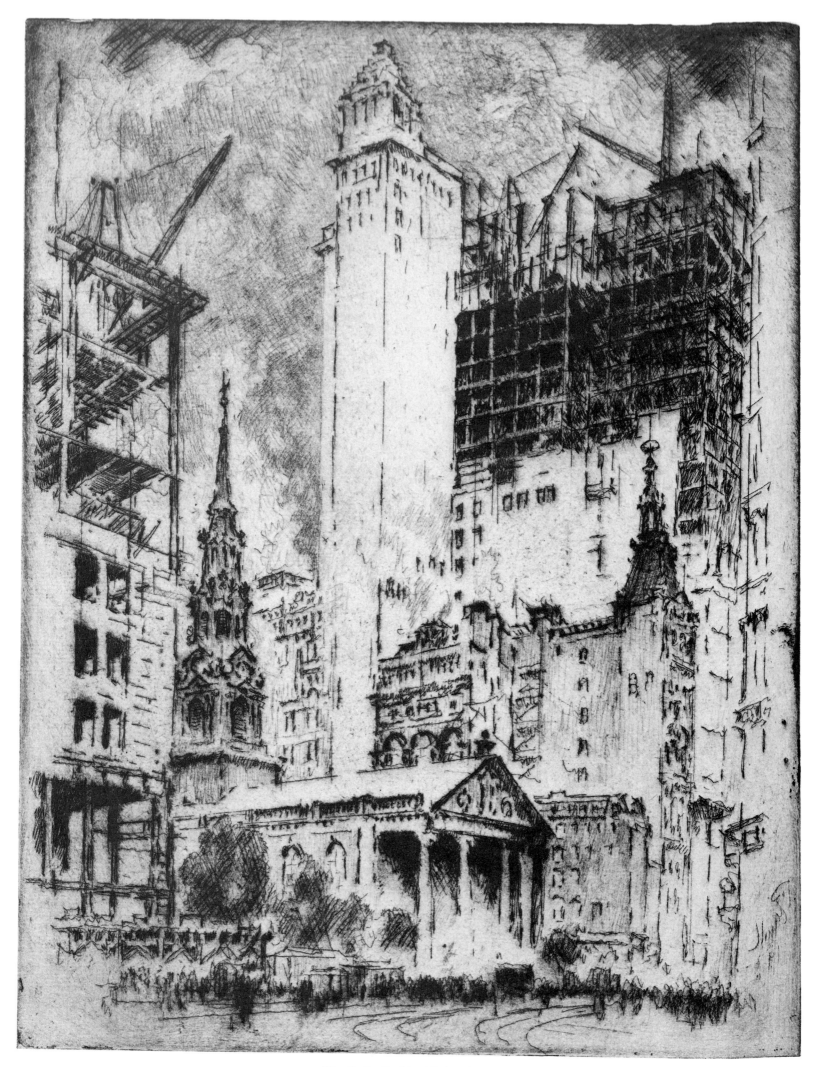

32. St. Paul's, New York. 1915.

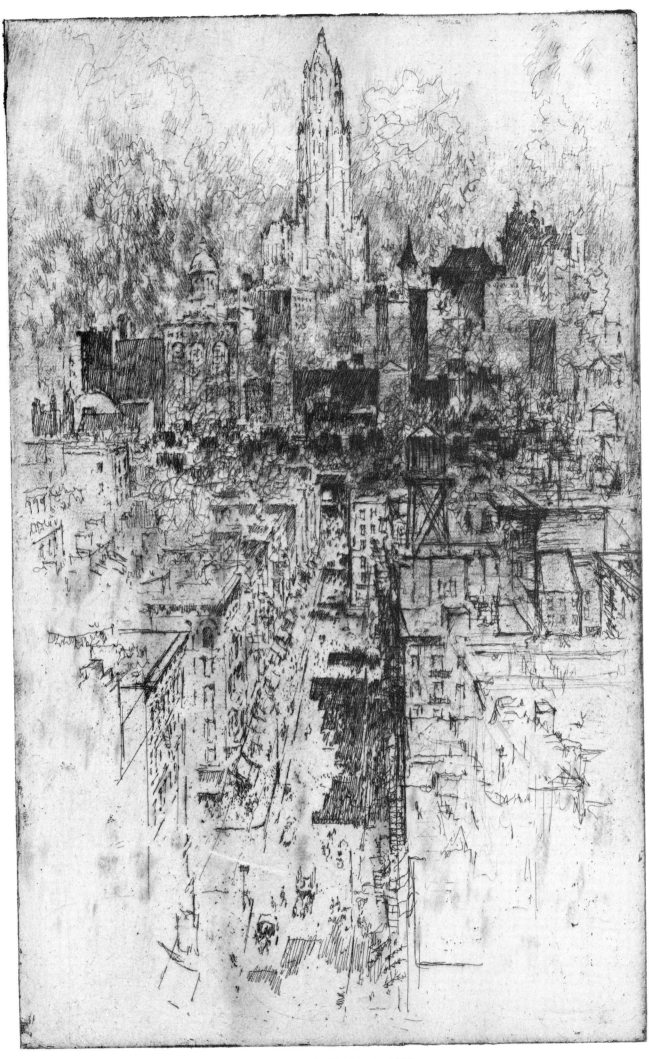

33. Up to the Woolworth. 1915.

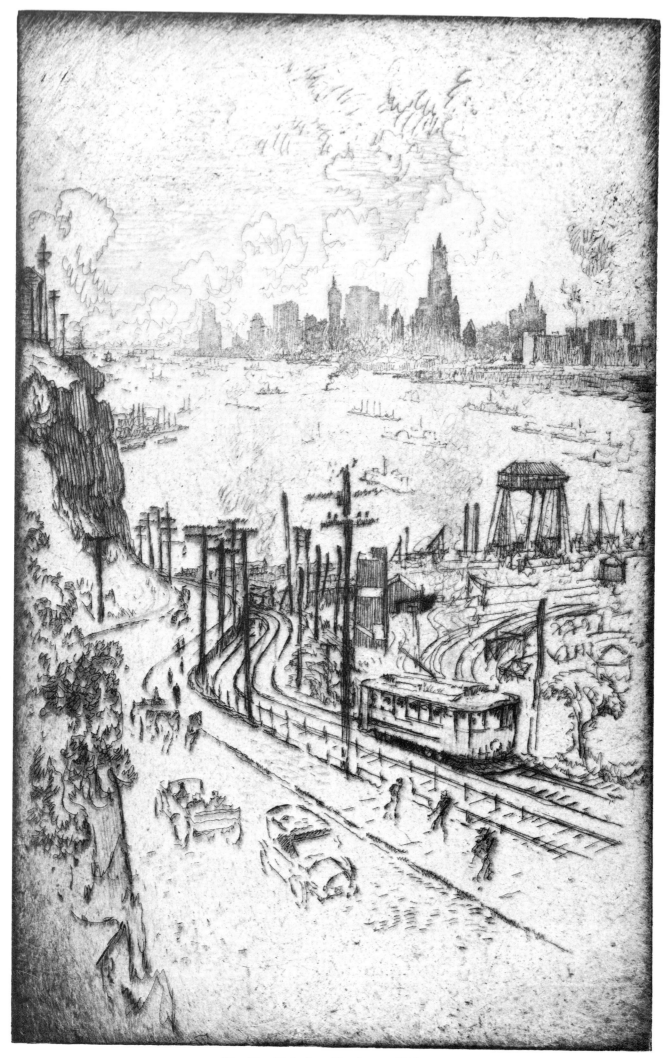

34. New York, from New Jersey. 1915.

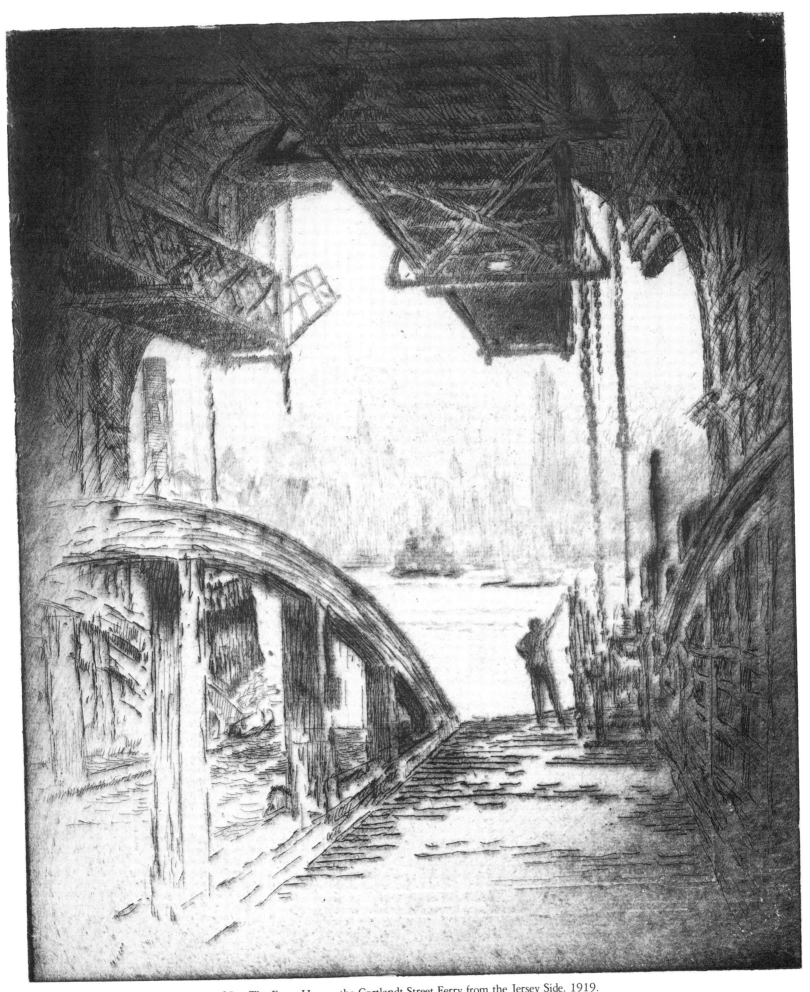

35. The Ferry House, the Cortlandt Street Ferry from the Jersey Side. 1919.

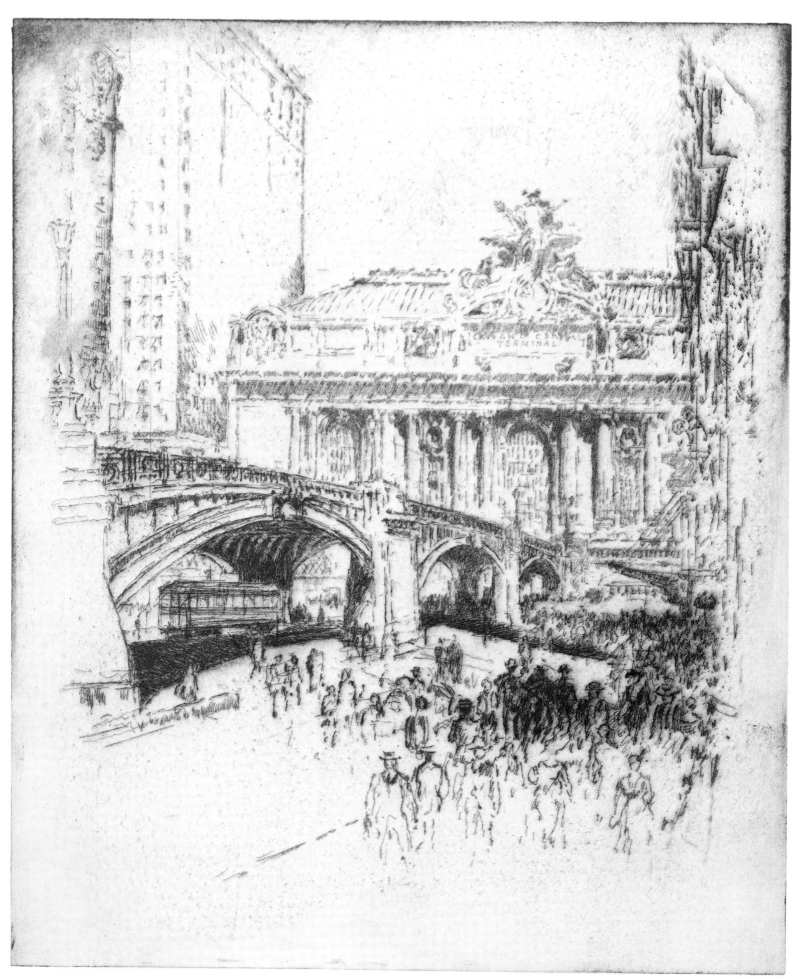

36. The Approach to the Grand Central, New York. 1919.

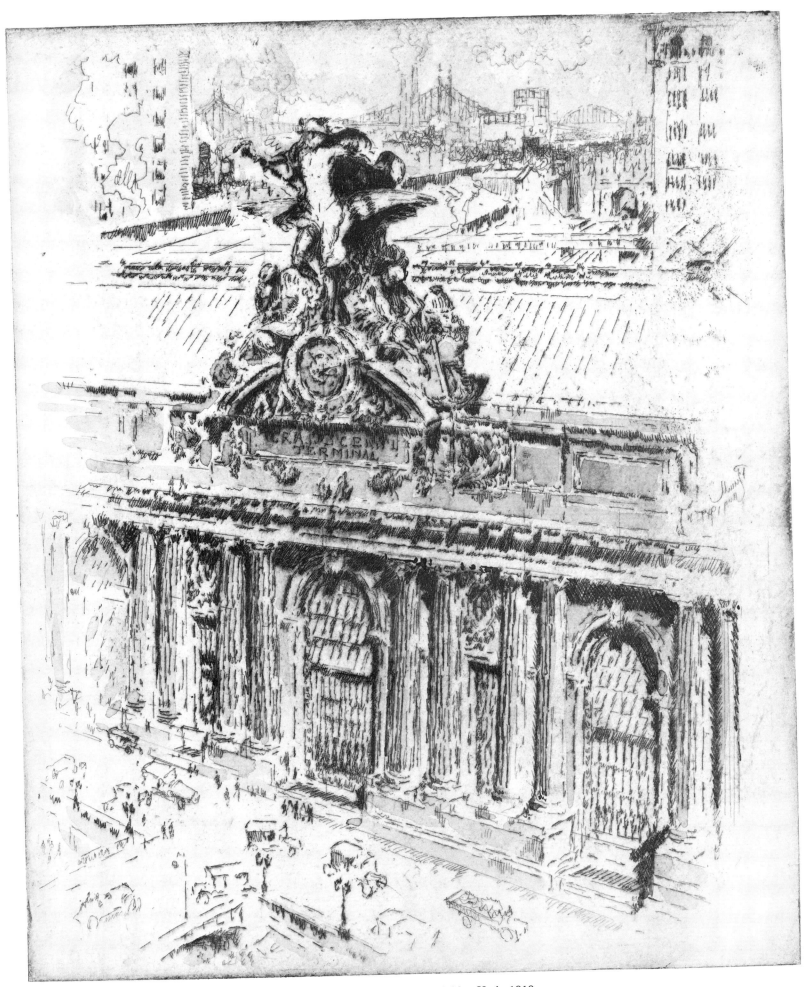

37. The Clock, Grand Central, New York. 1919.

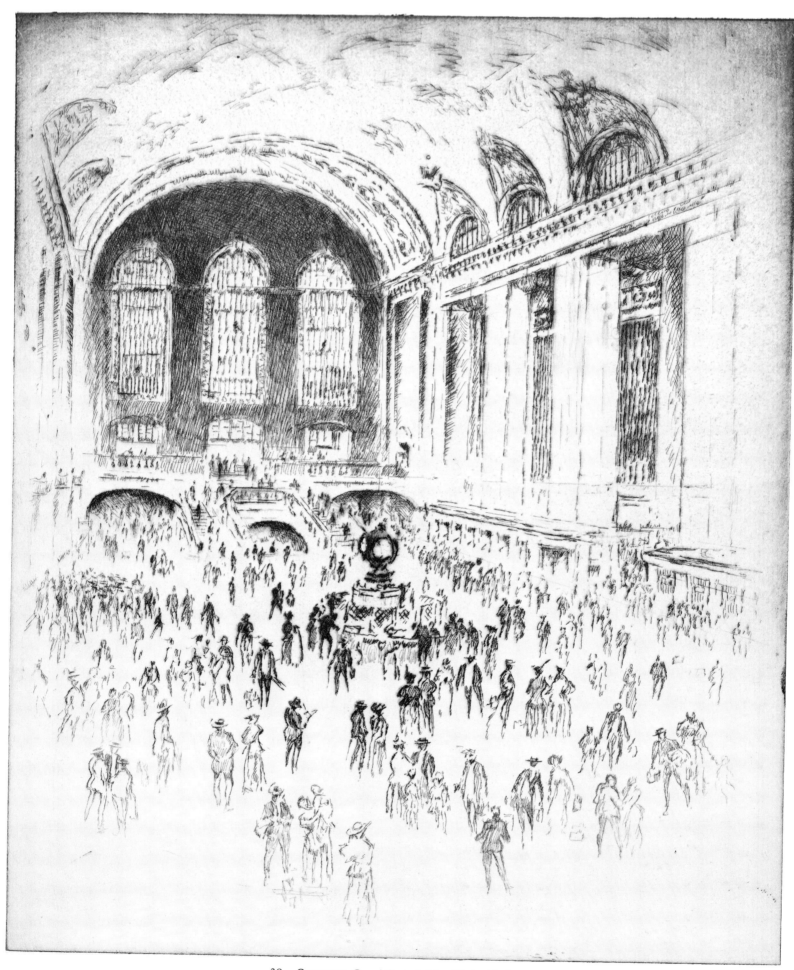

38. Concourse, Grand Central, New York. 1919.

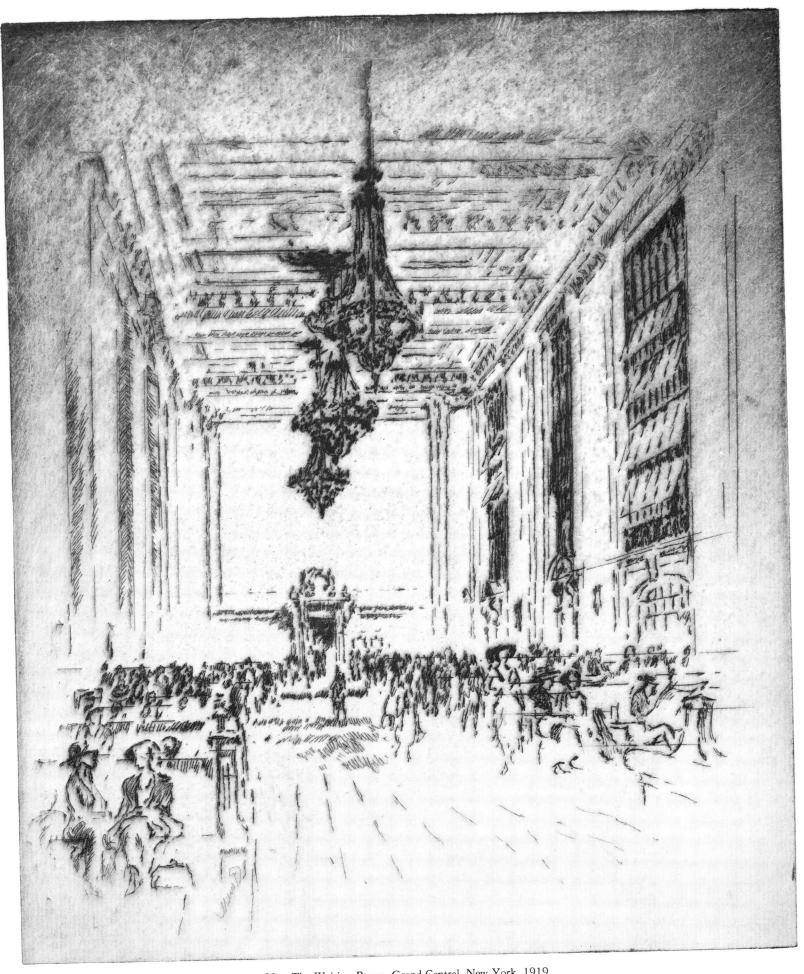

39. The Waiting Room, Grand Central, New York. 1919.

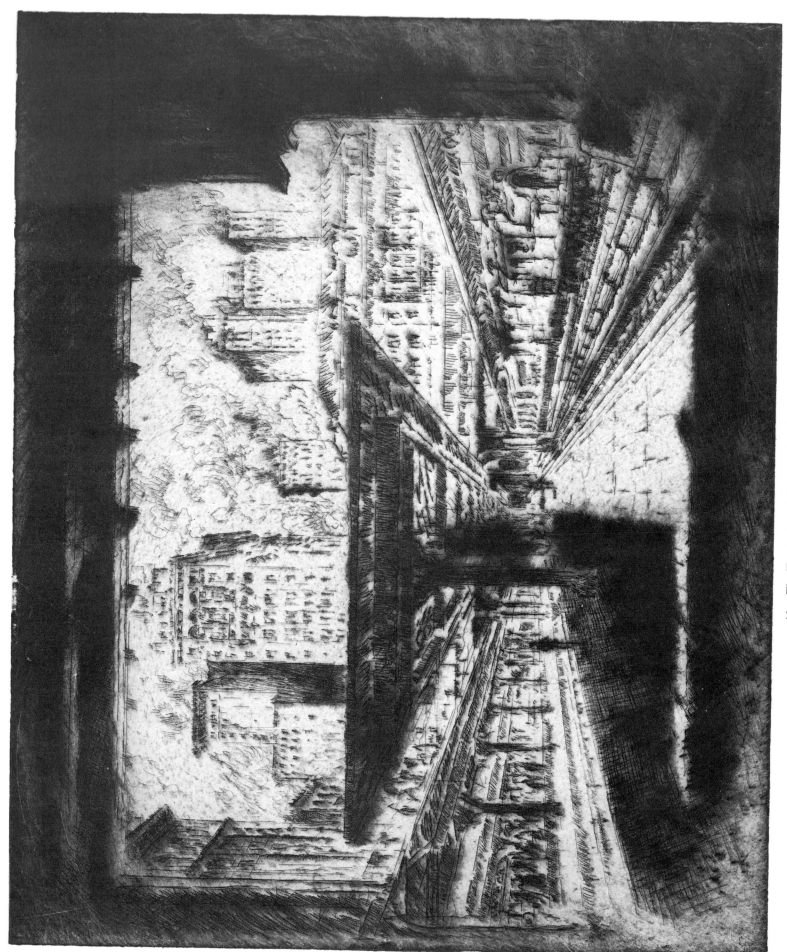

40. The Tracks, Grand Central, New York. 1919.

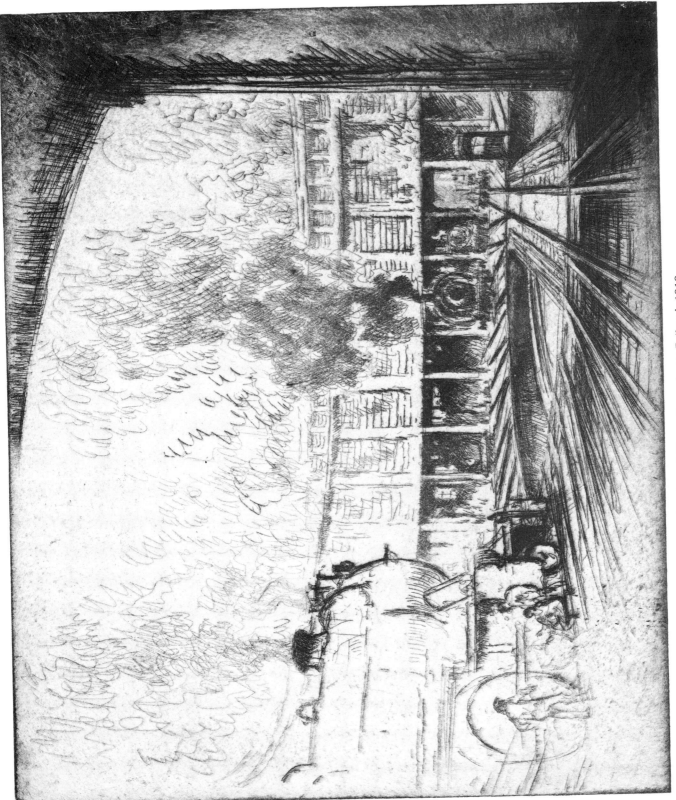

41. Round House, Pennsylvania Railroad. 1919.

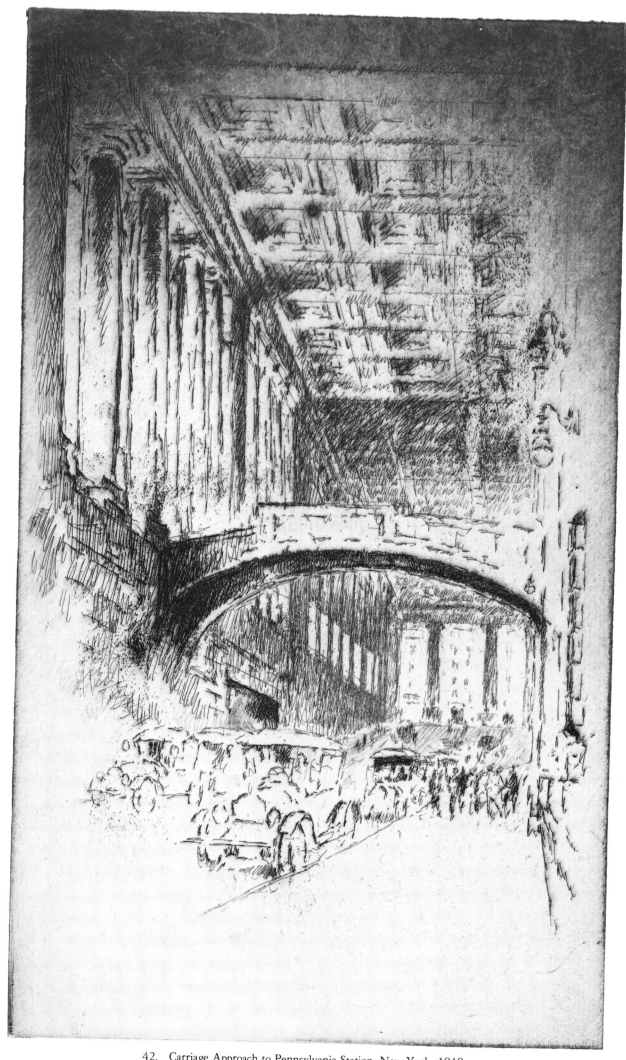

42. Carriage Approach to Pennsylvania Station, New York. 1919.

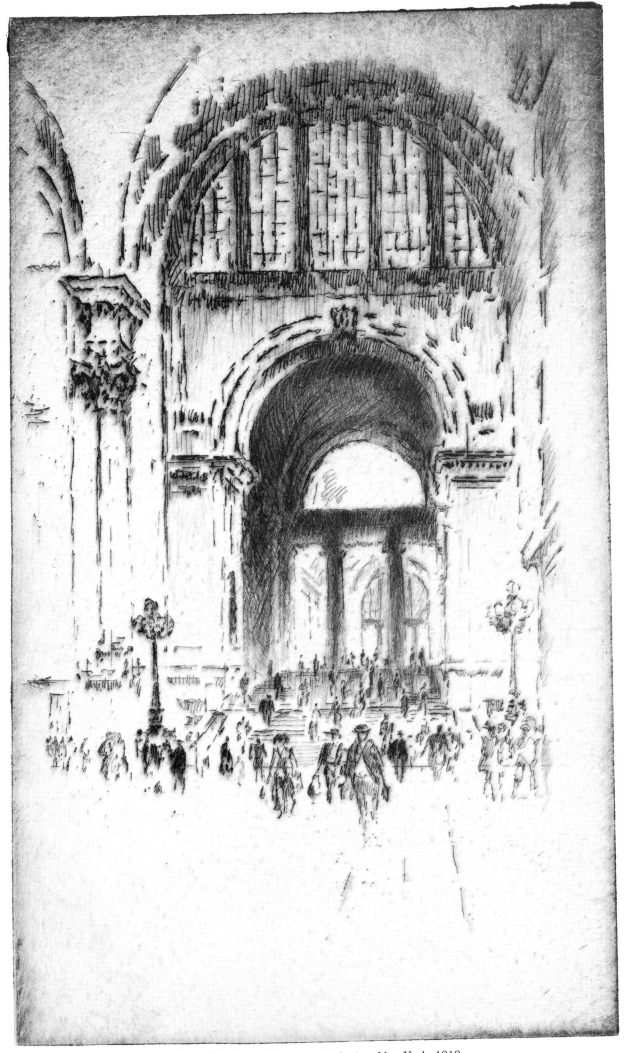

43. The Arcade, Pennsylvania Station, New York. 1919.

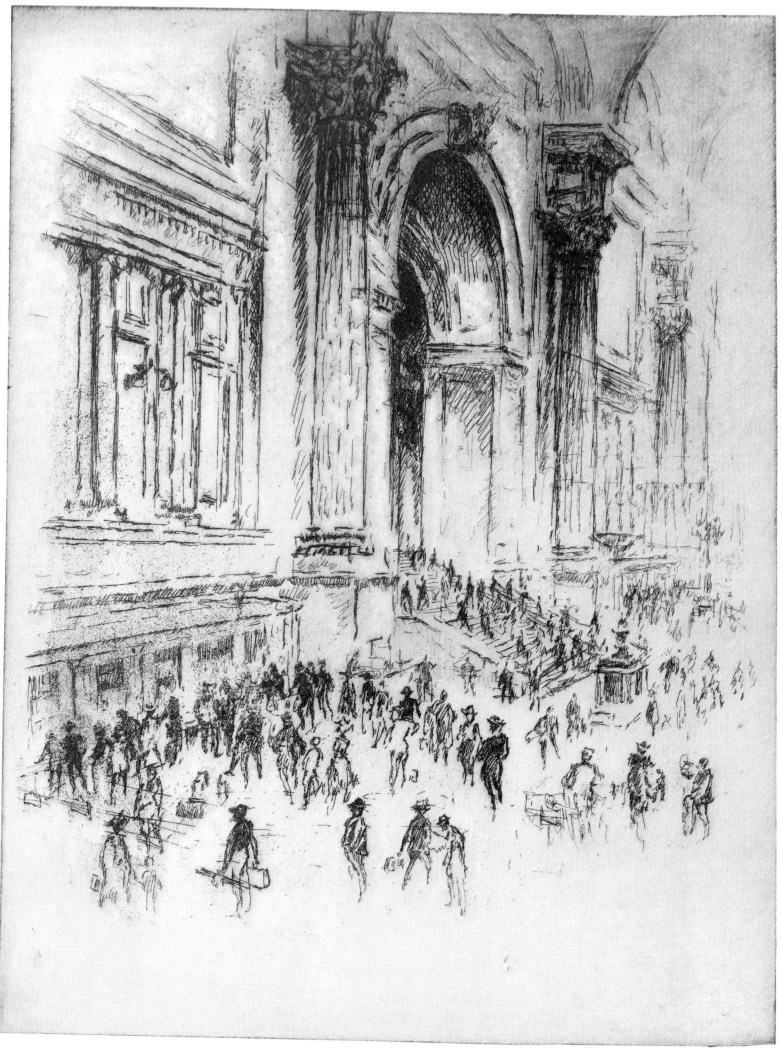

44. The Ticket Office, Pennsylvania Station, New York. 1919.

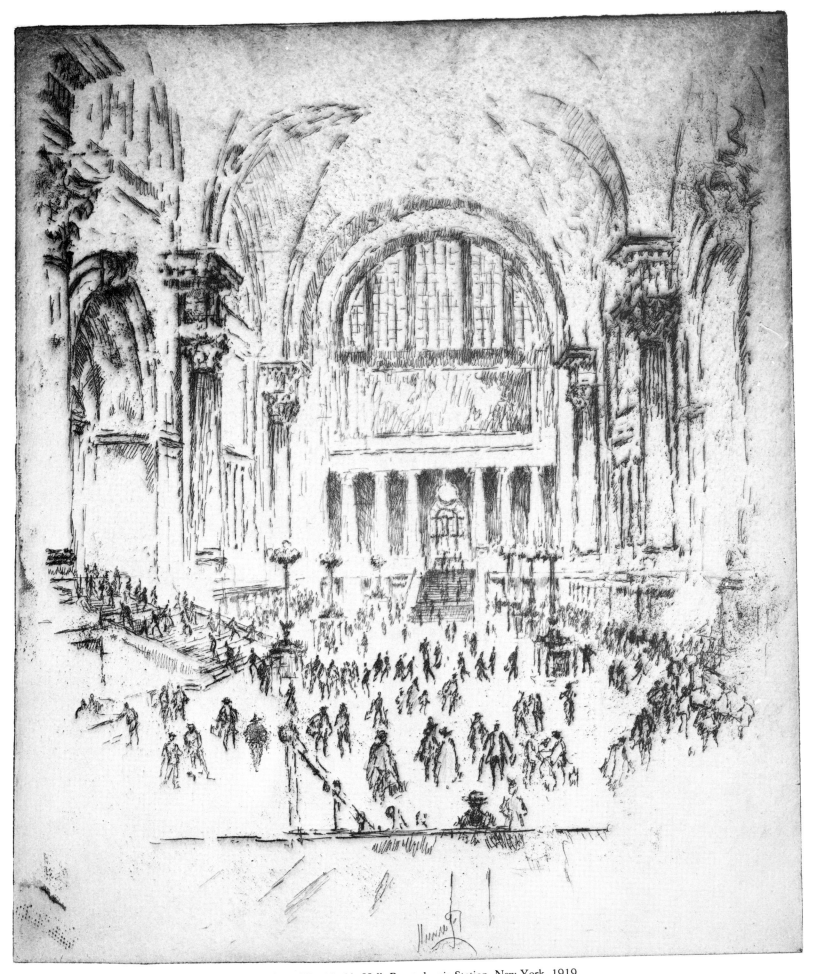

45. The Marble Hall, Pennsylvania Station, New York. 1919.

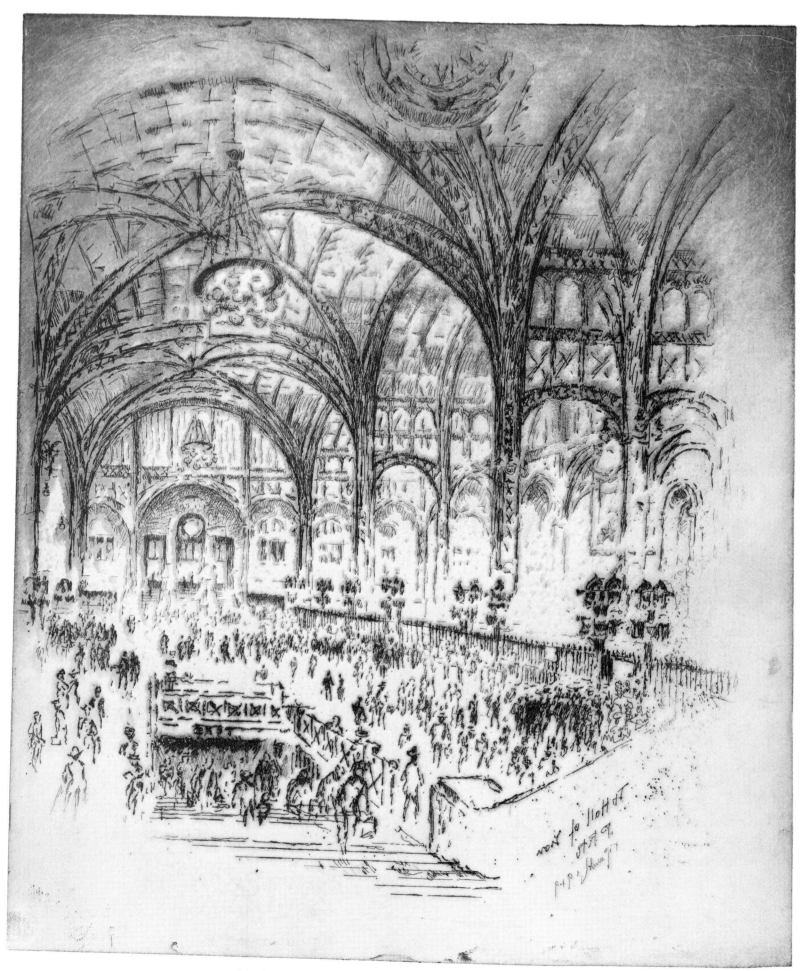

46. The Hall of Iron, Pennsylvania Station, New York. 1919.

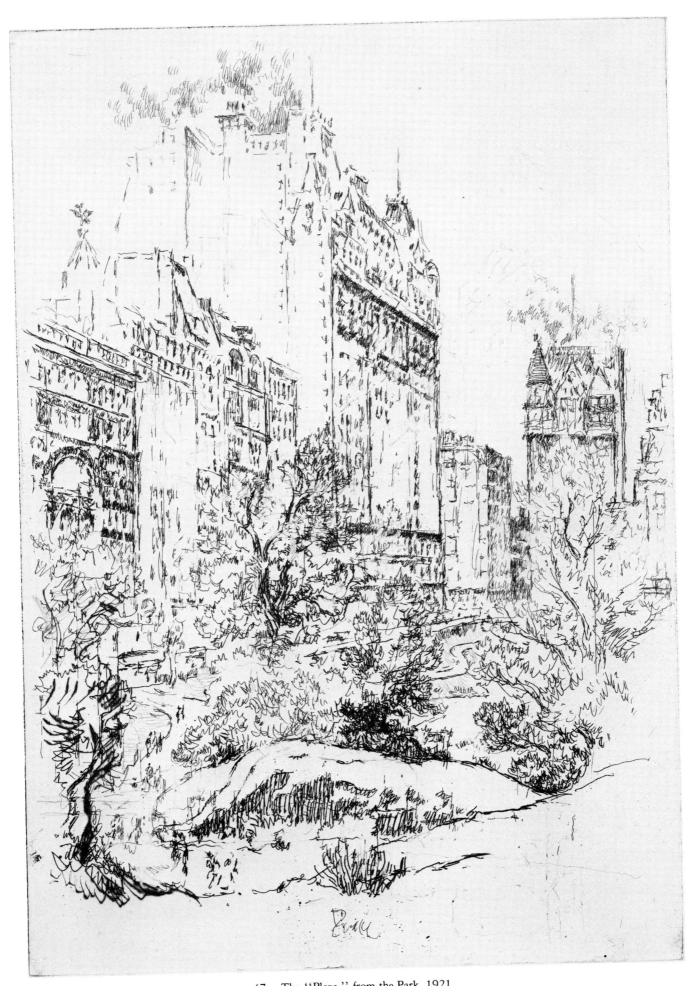

47. The "Plaza," from the Park. 1921.

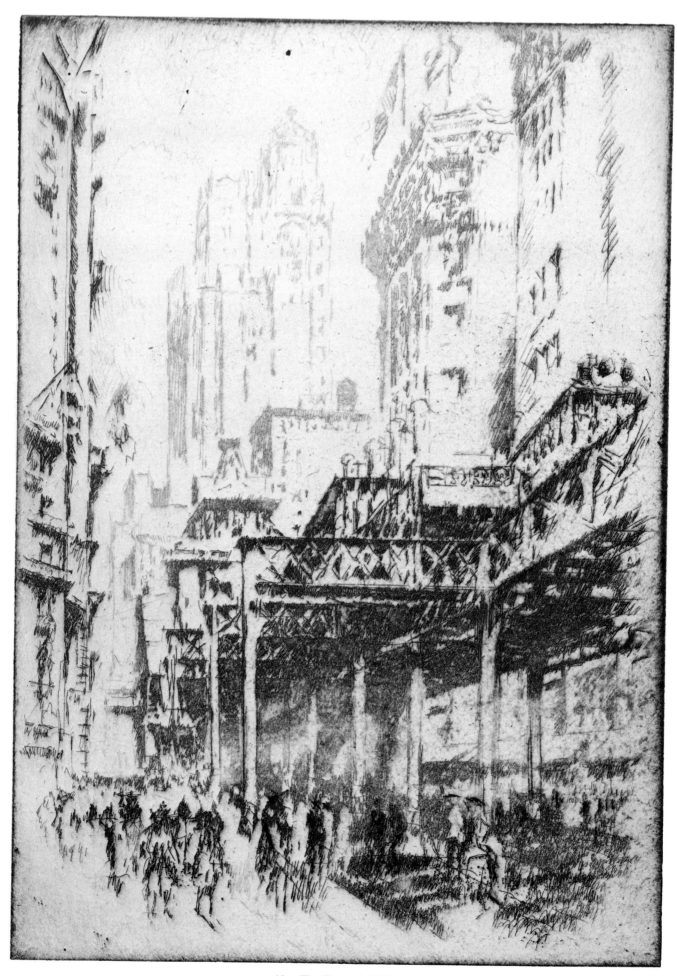

48. The Elevated. 1921.

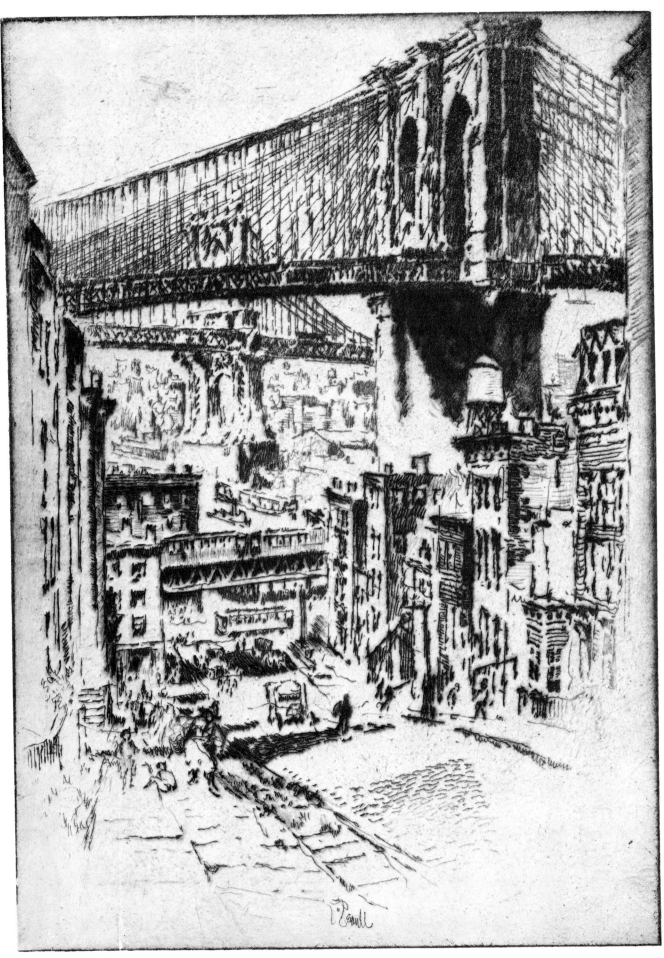

49. The Bridges from Brooklyn. 1921.

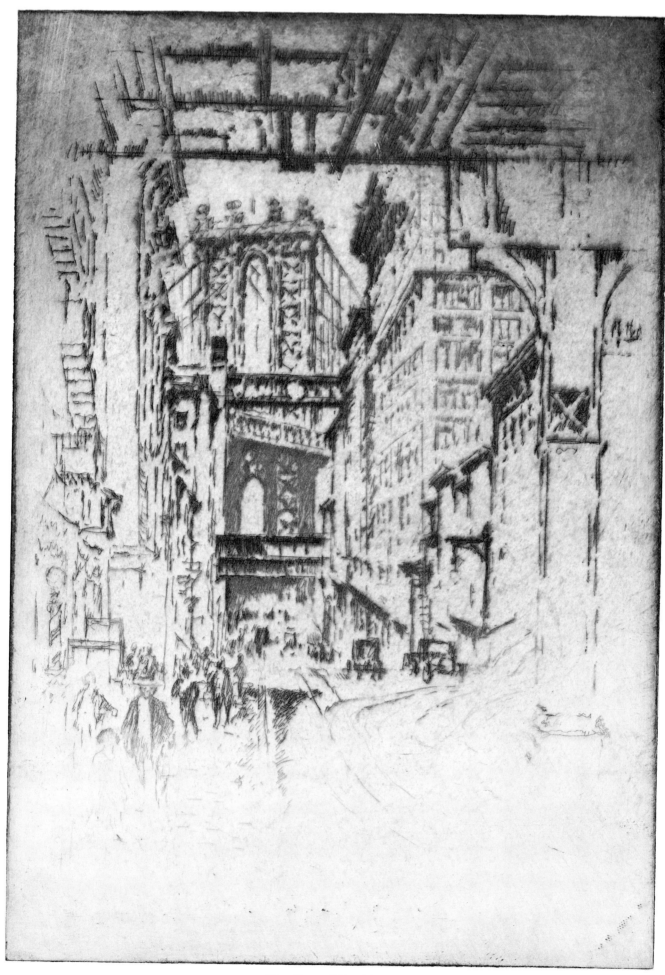

50. Cherry Hill. 1921.

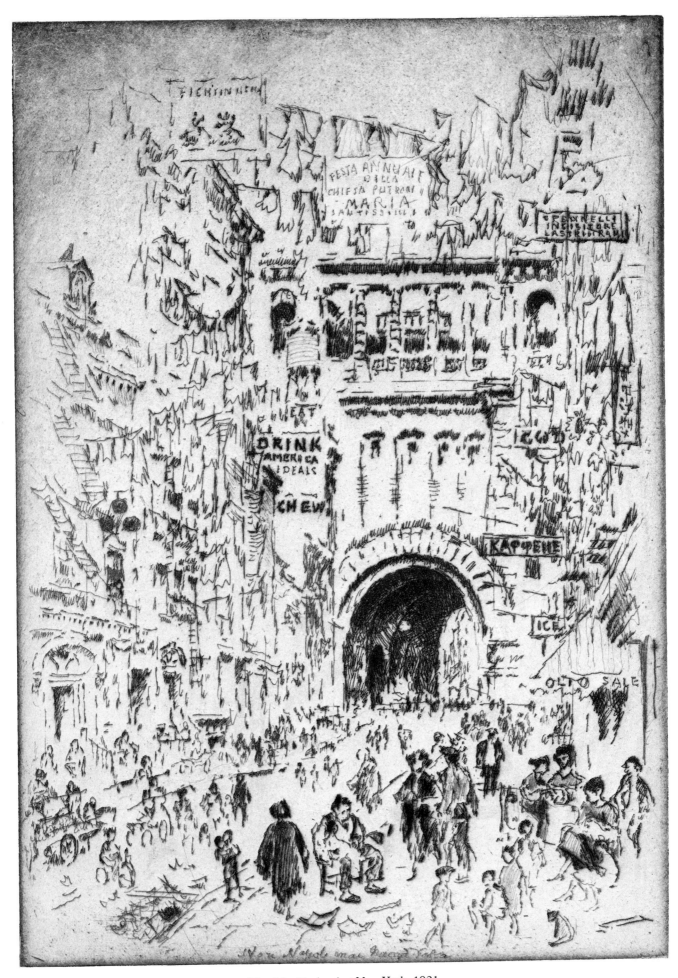

51. Not Naples, but New York. 1921.

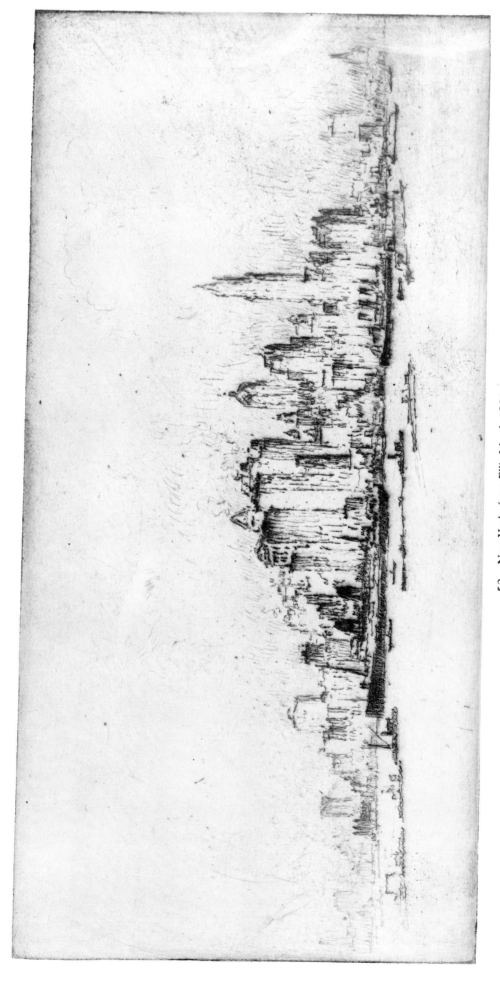

52. New York, from Ellis Island. 1921.

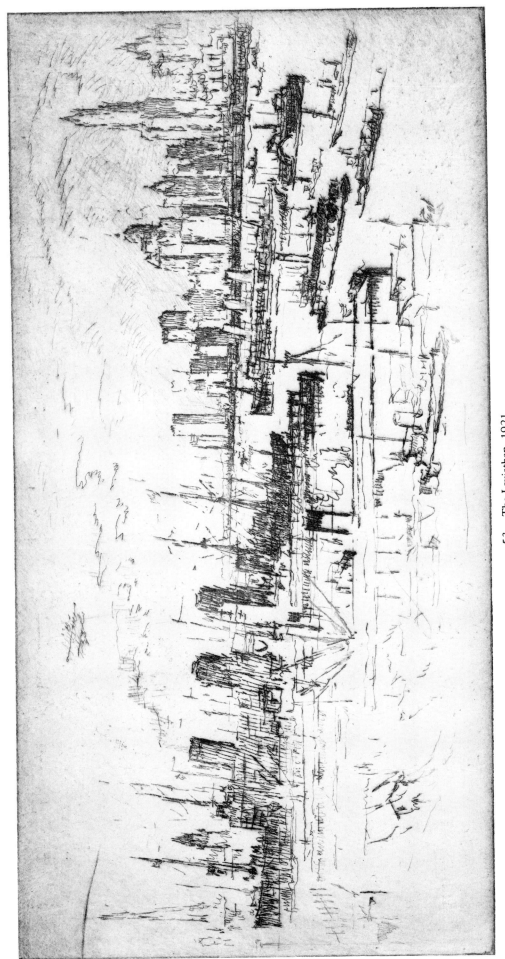

53. The Leviathan. 1921.

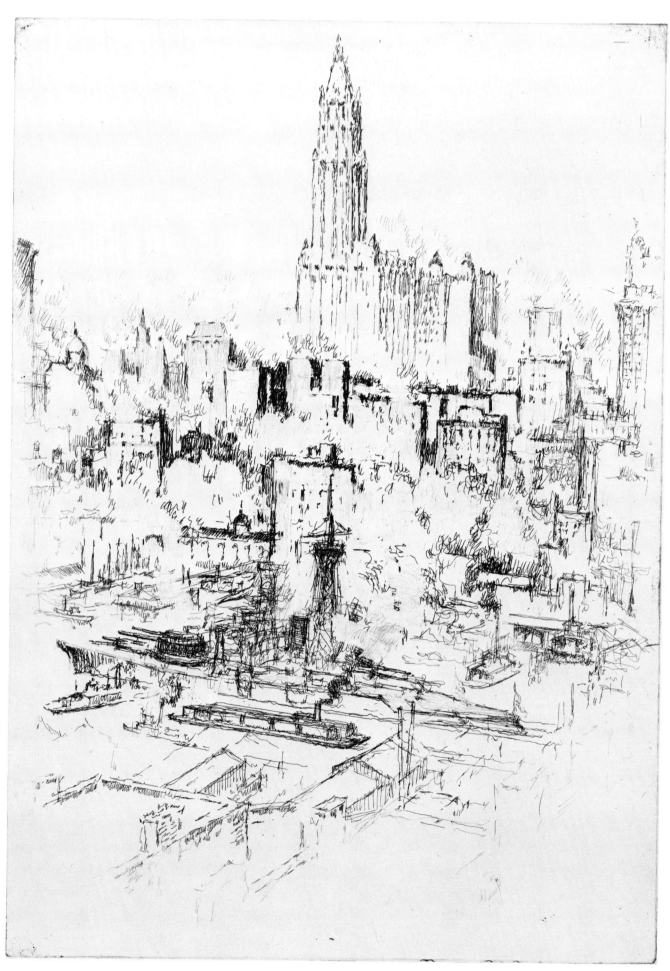

54. Warship Coming In. 1921.

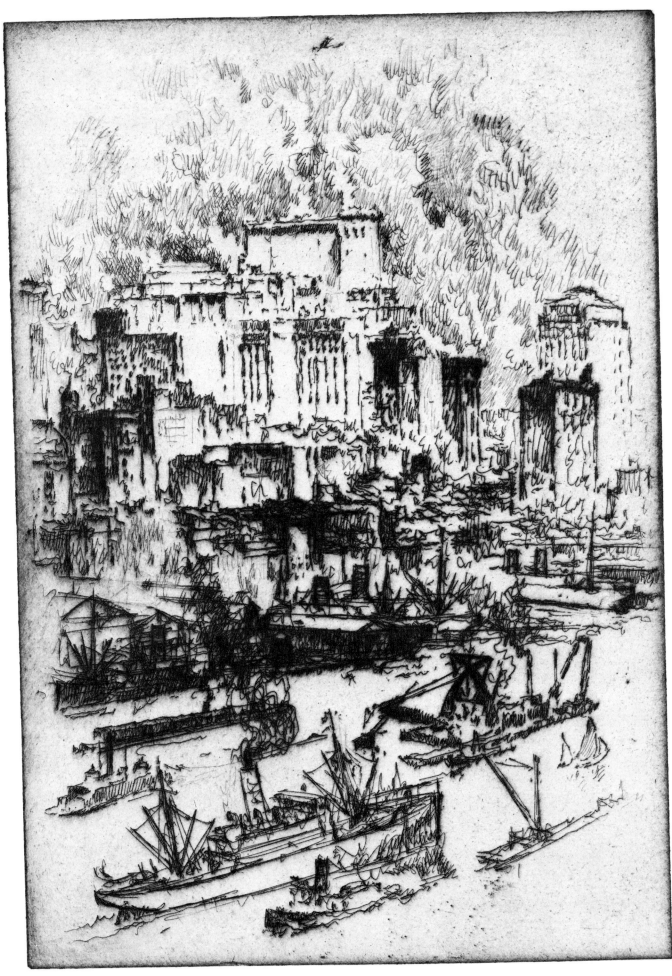

55. The Cunard Building. 1921.

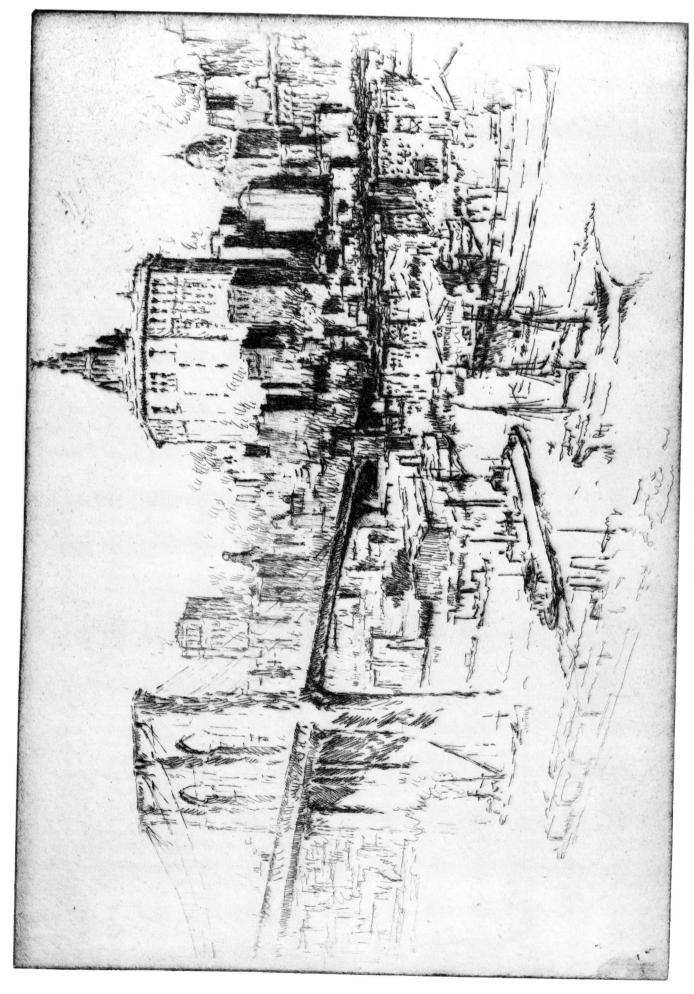

56. Municipal Building. 1921.

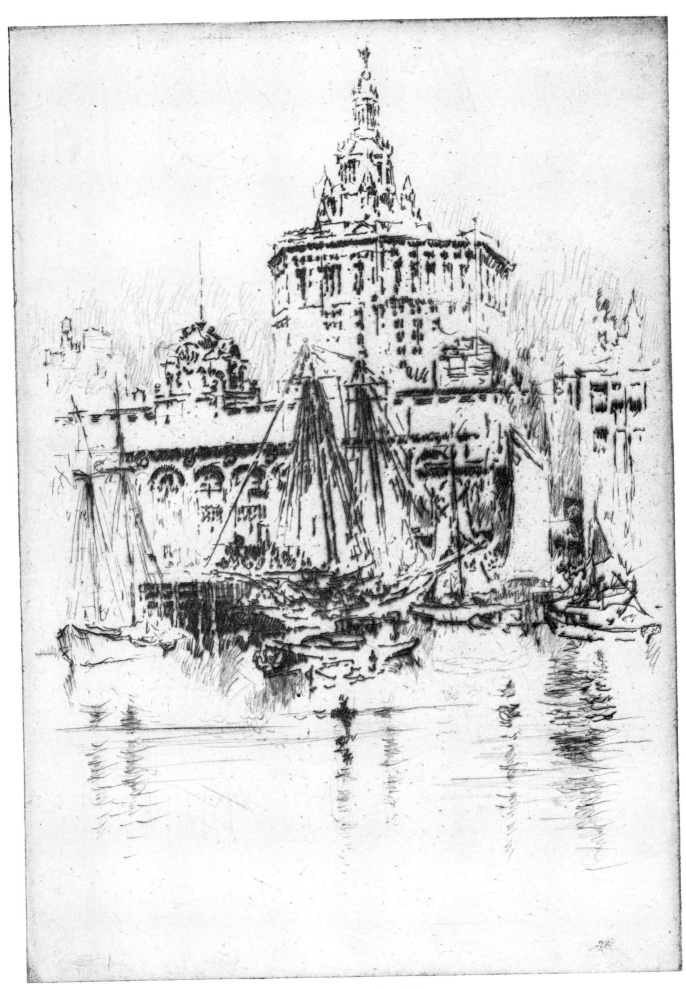

57. New Fish Market. 1921.

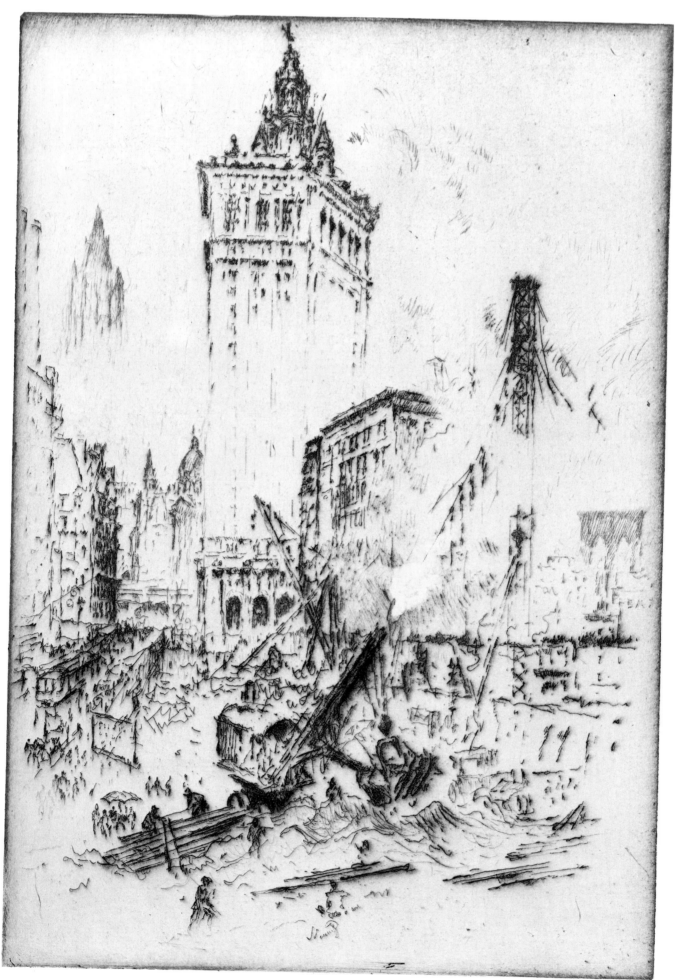

58. The Steam Shovel. 1921.

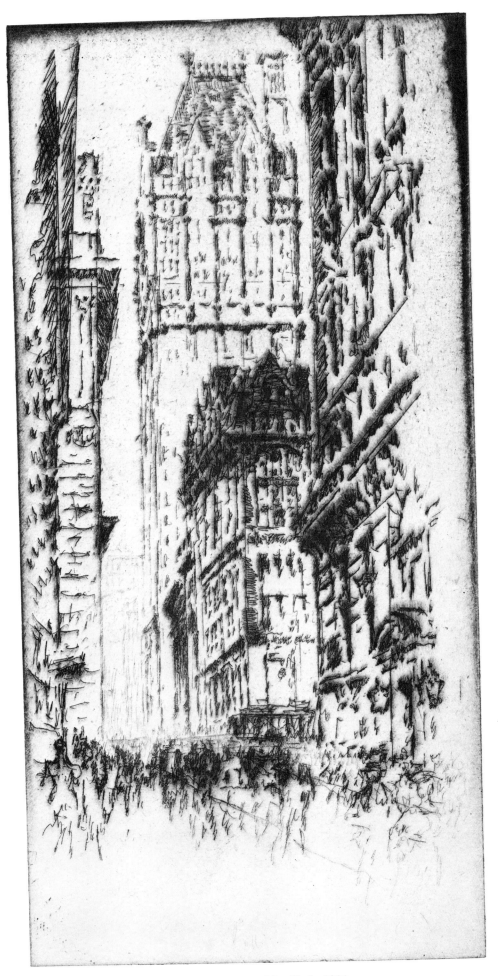

59. Liberty Tower, New York. 1921.

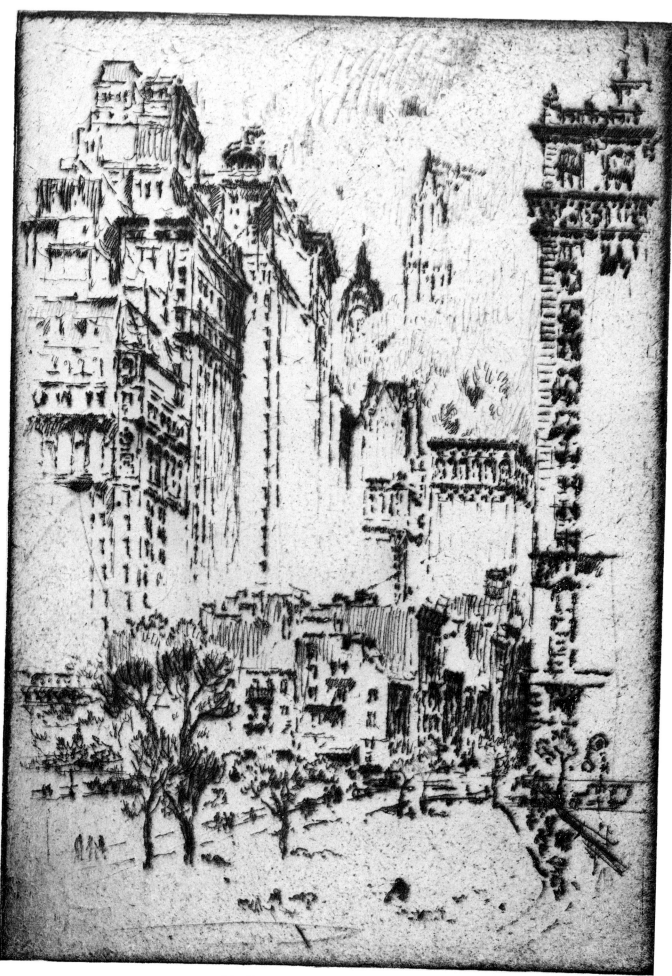

60. From the Lowest to the Highest. 1921.

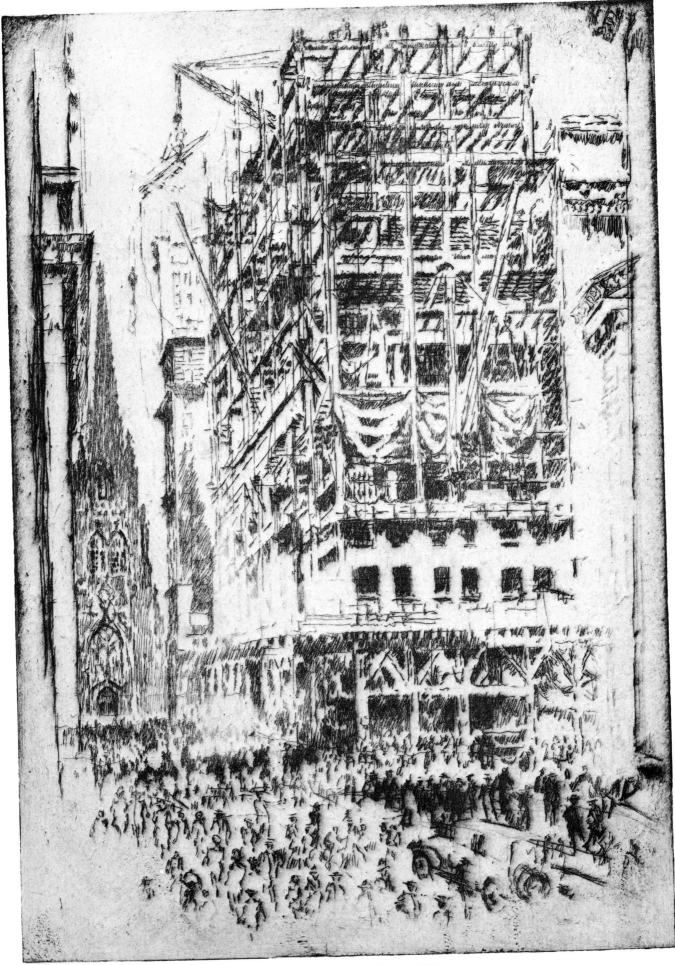

61. The New Stock Exchange. 1921.

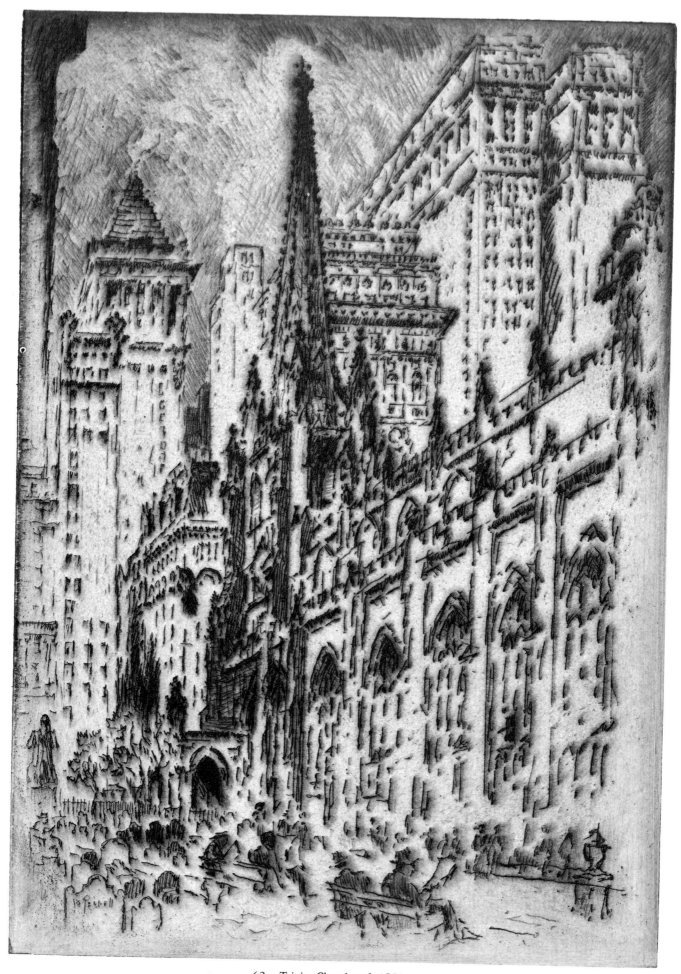

62. Trinity Churchyard. 1921.

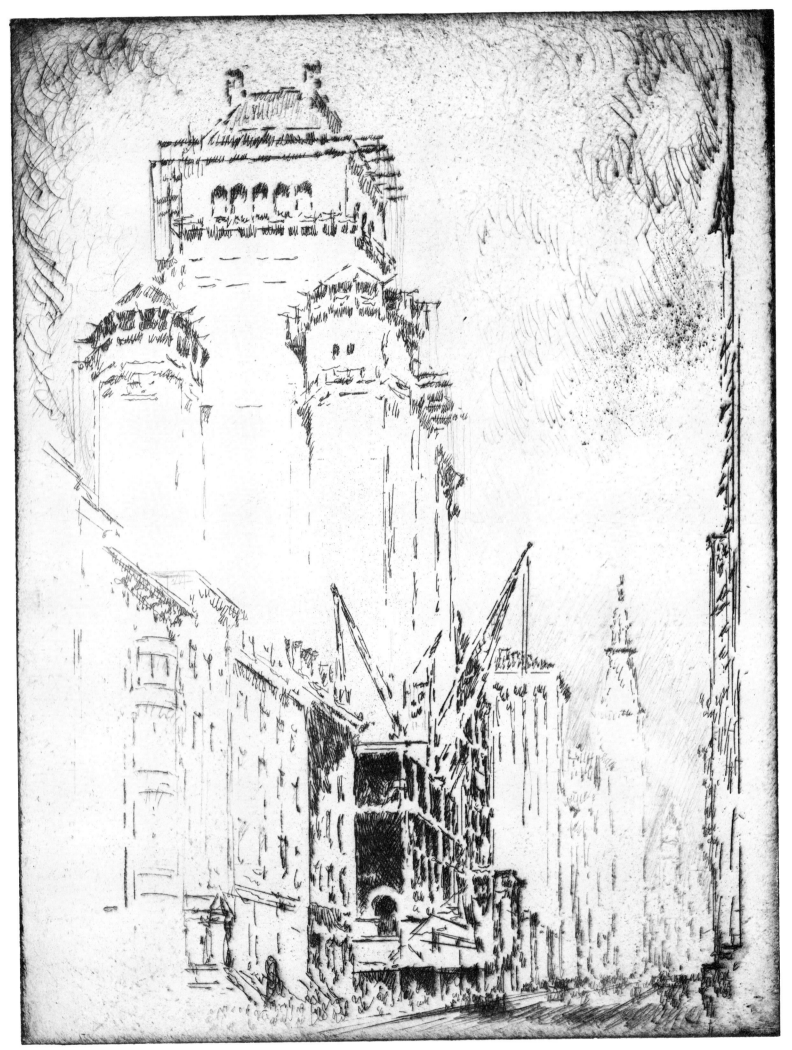

63. Madison Avenue, Fraternity House. 1923.

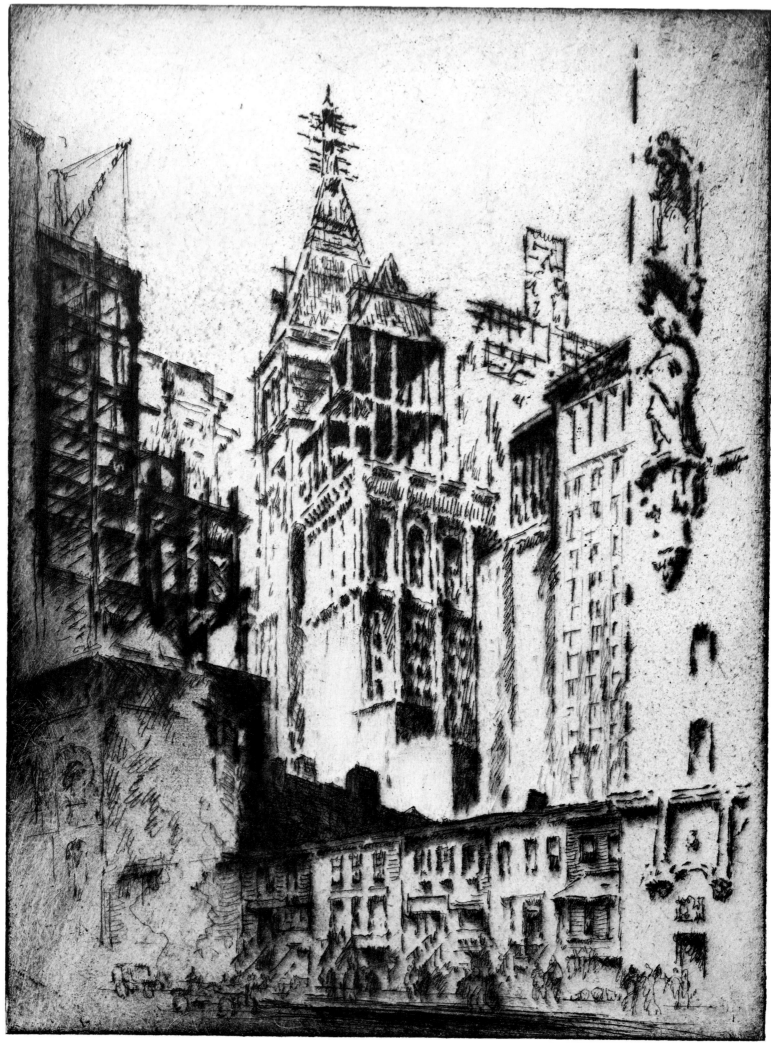

64. The Times Annex, from 40th Street. 1923.

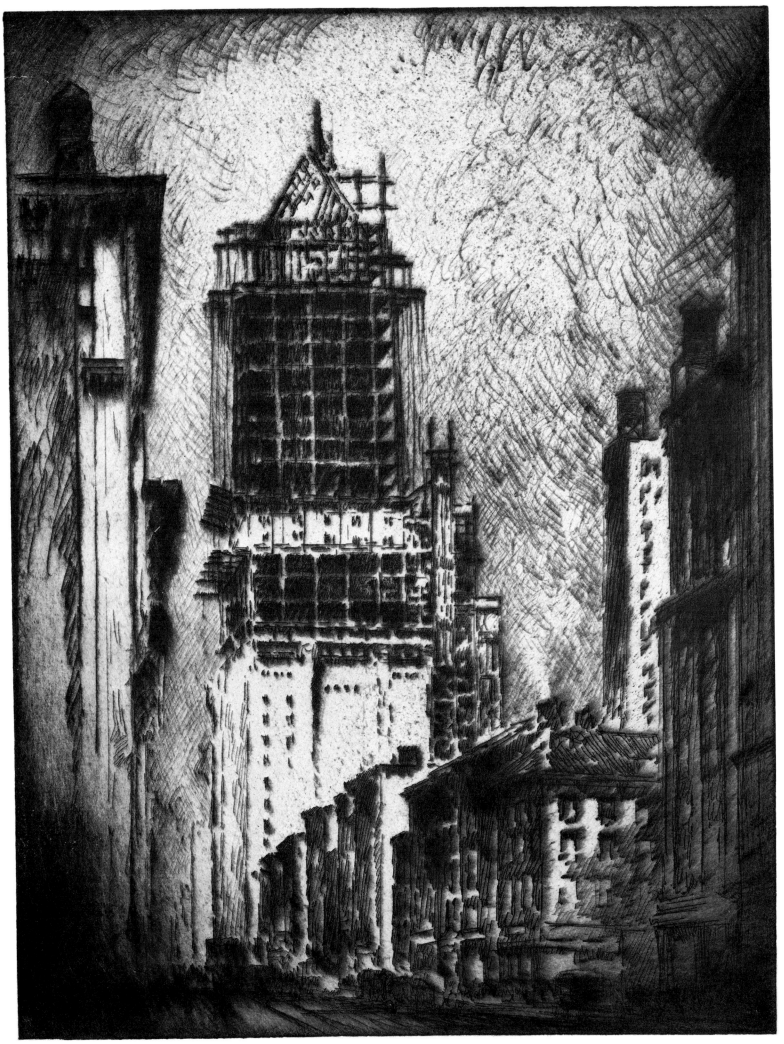

65. Madison Avenue. 1923.

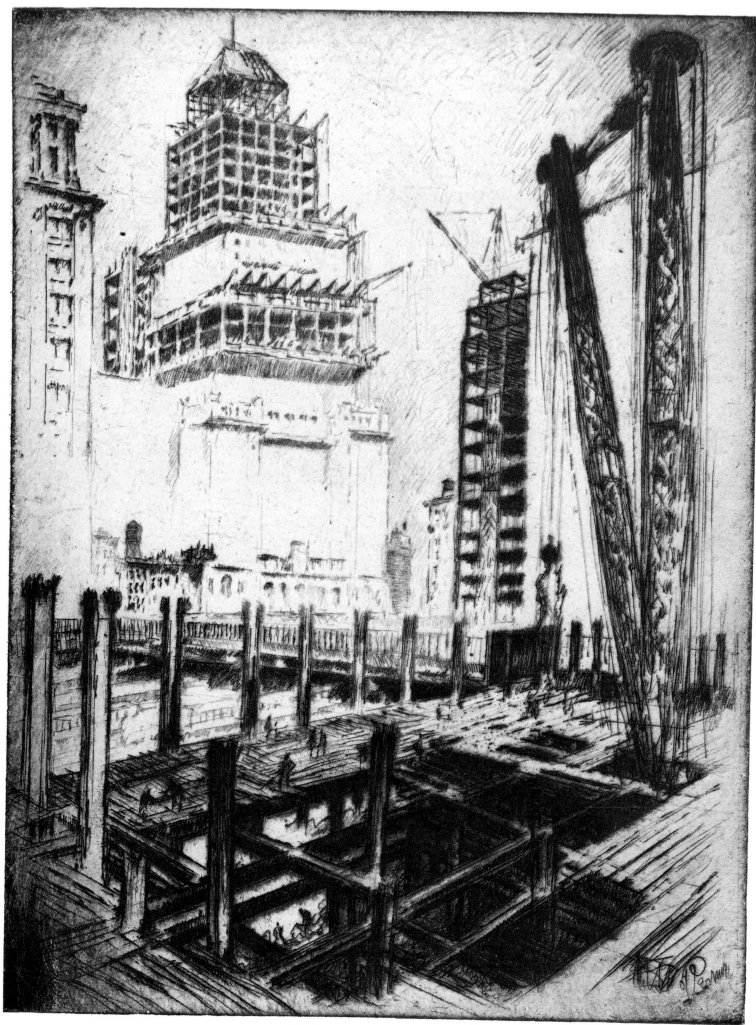

66. An Orgy of Building. 1923.

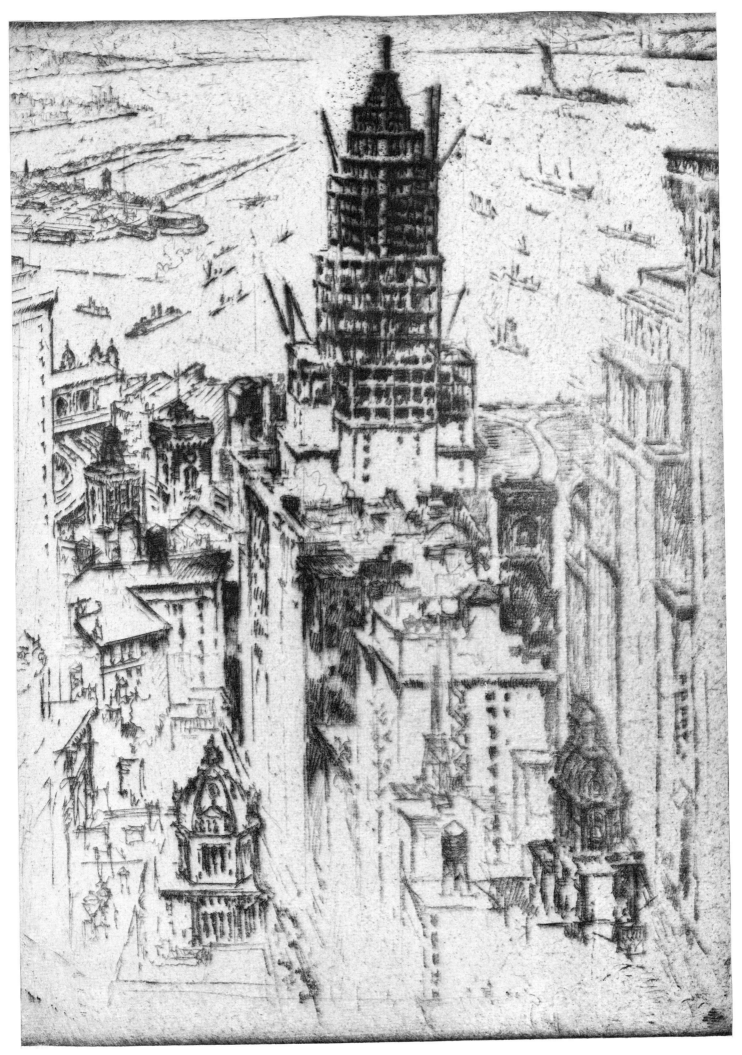

67. The Latest Tower. 1923.

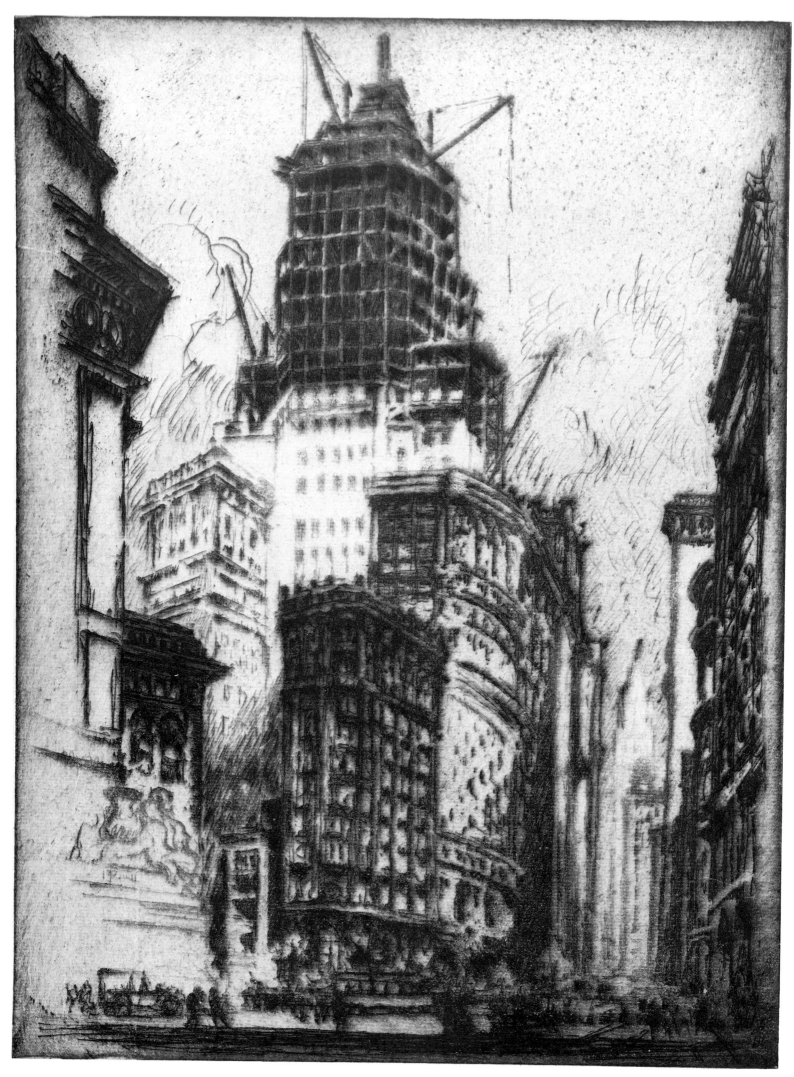

68. Standard Oil Building. 1923.

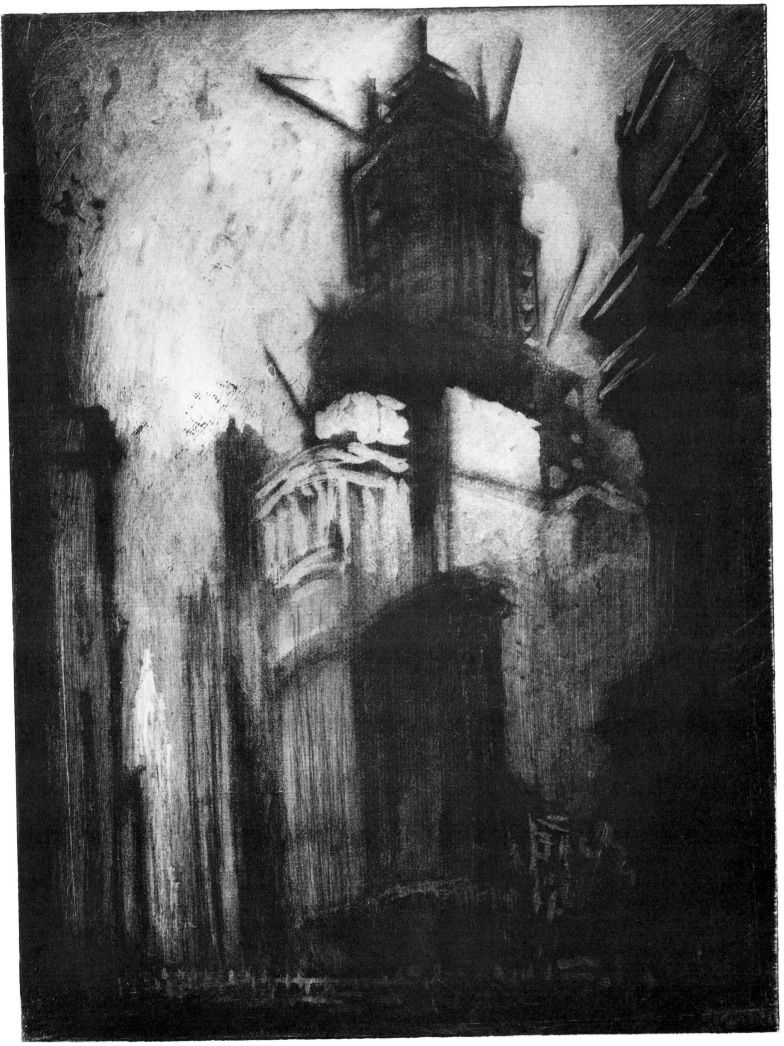

69. Rebuilding Broadway, Standard Oil Building. 1923.

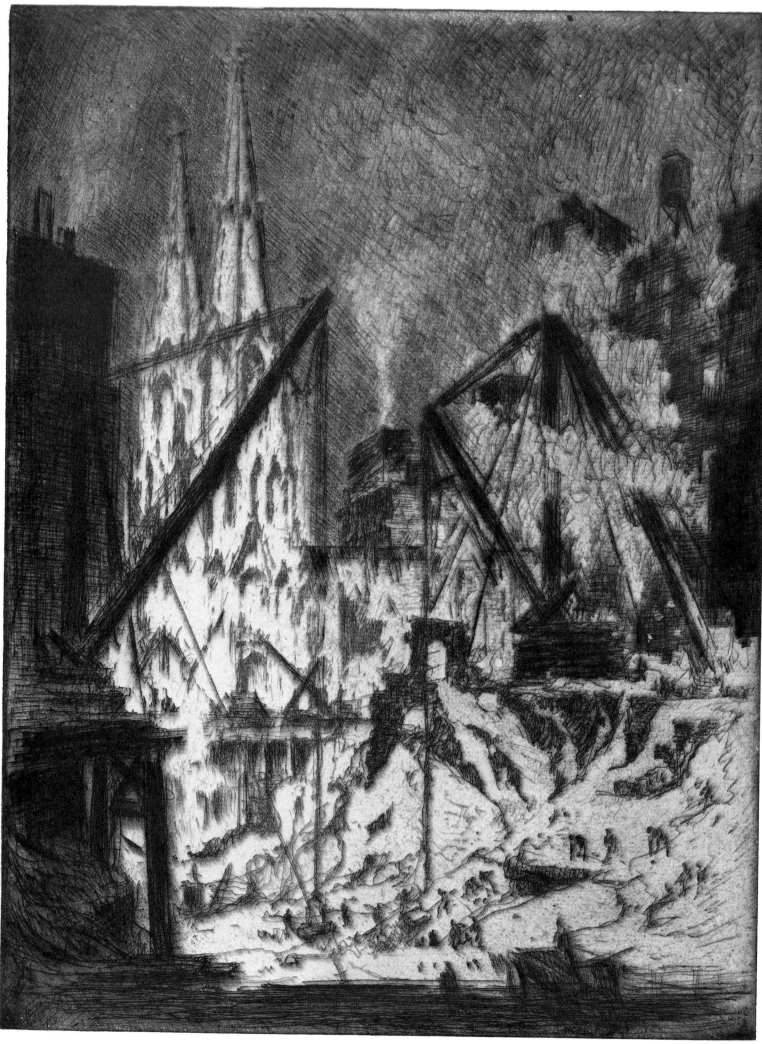

70. The Foundations at the Cathedral, Saks Building. 1923.

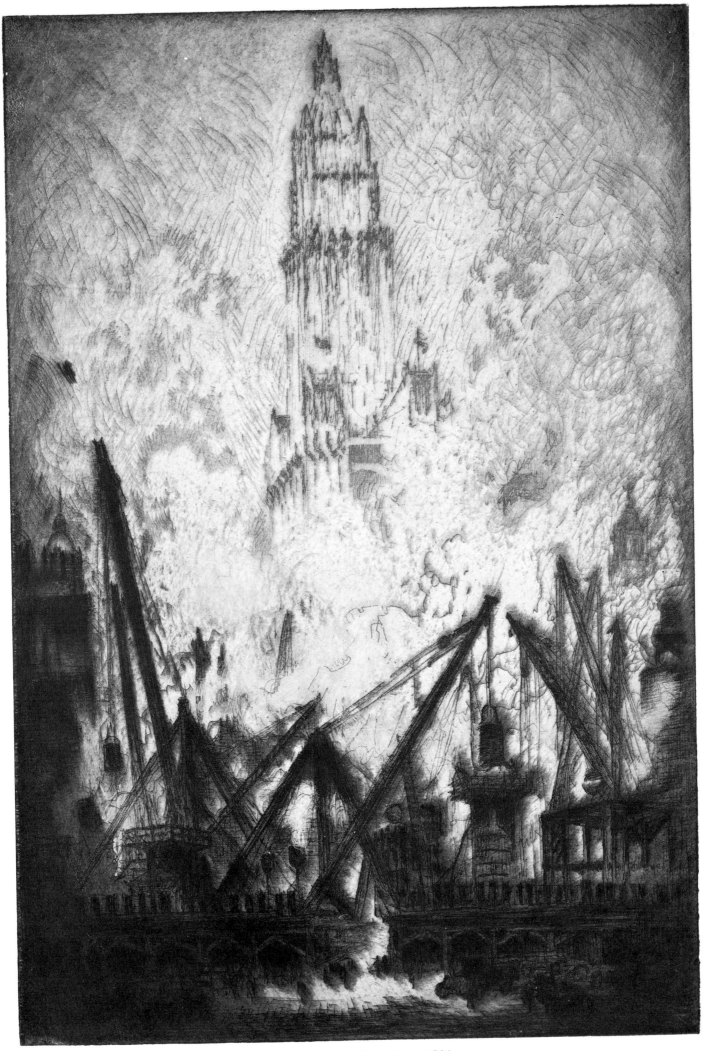

71. Caissons on Vesey Street. 1924.

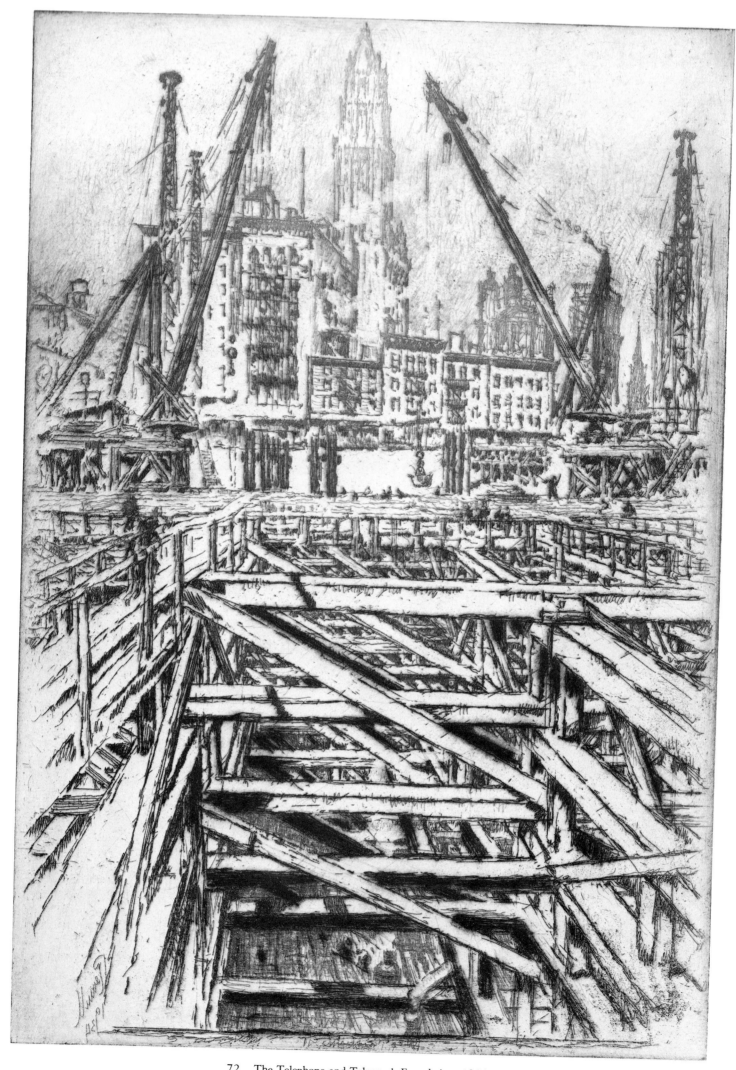

72. The Telephone and Telegraph Foundation. 1924.

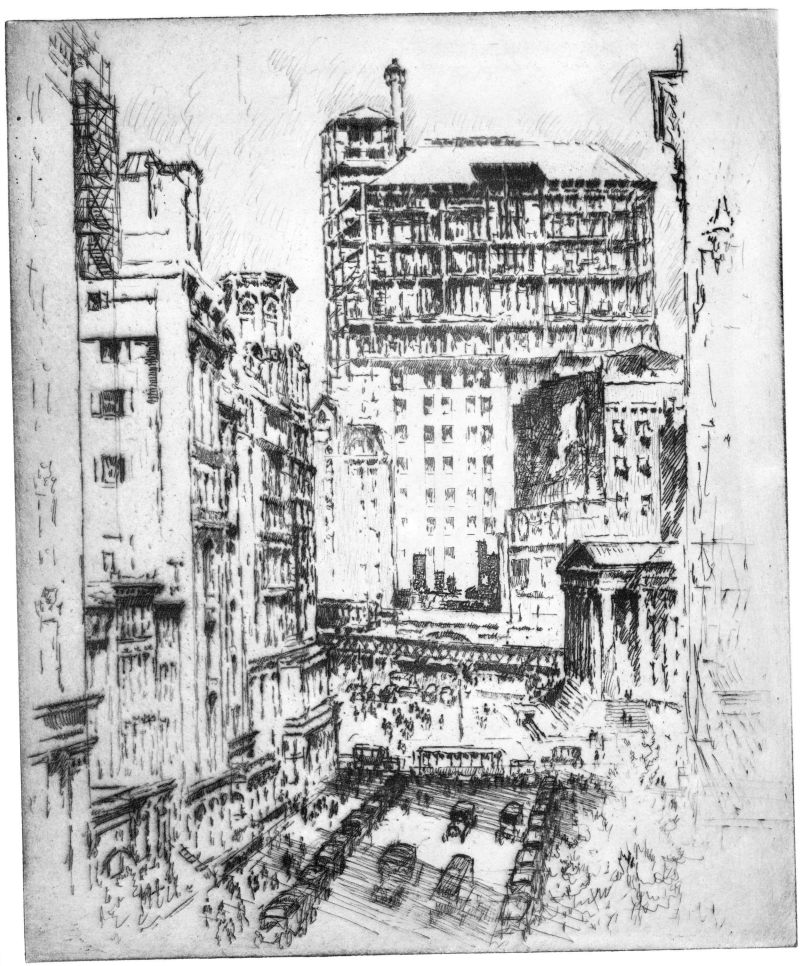

73. General Office Building, Brooklyn Edison Co. 1923.

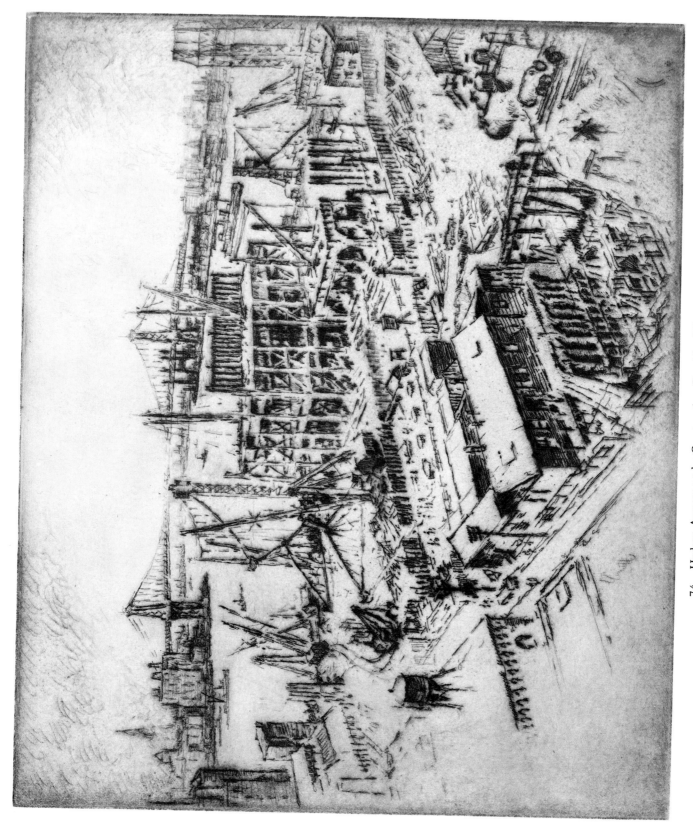

74. Hudson Avenue under Construction, Brooklyn Edison Co. 1923.

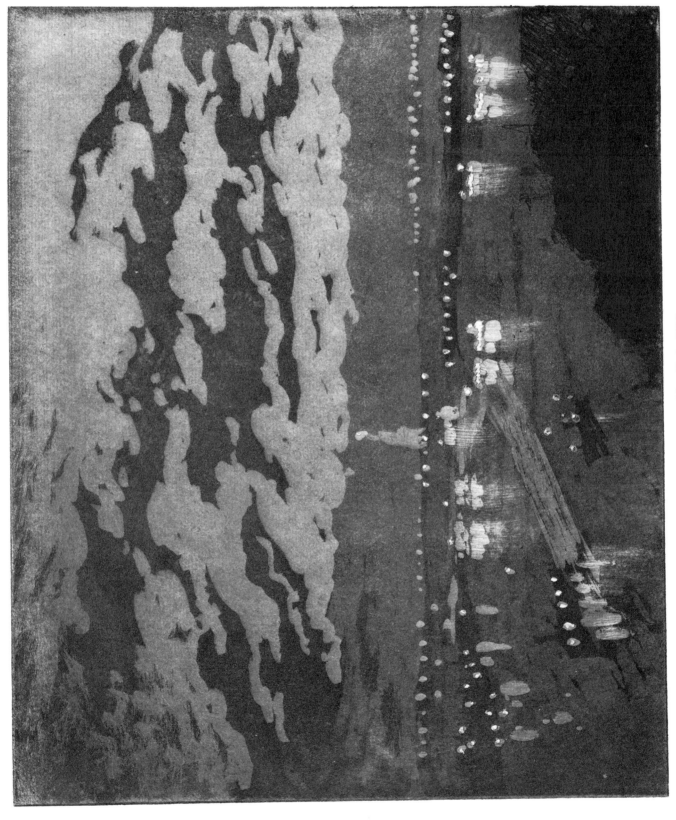

75. The Bay, New York. 1922.

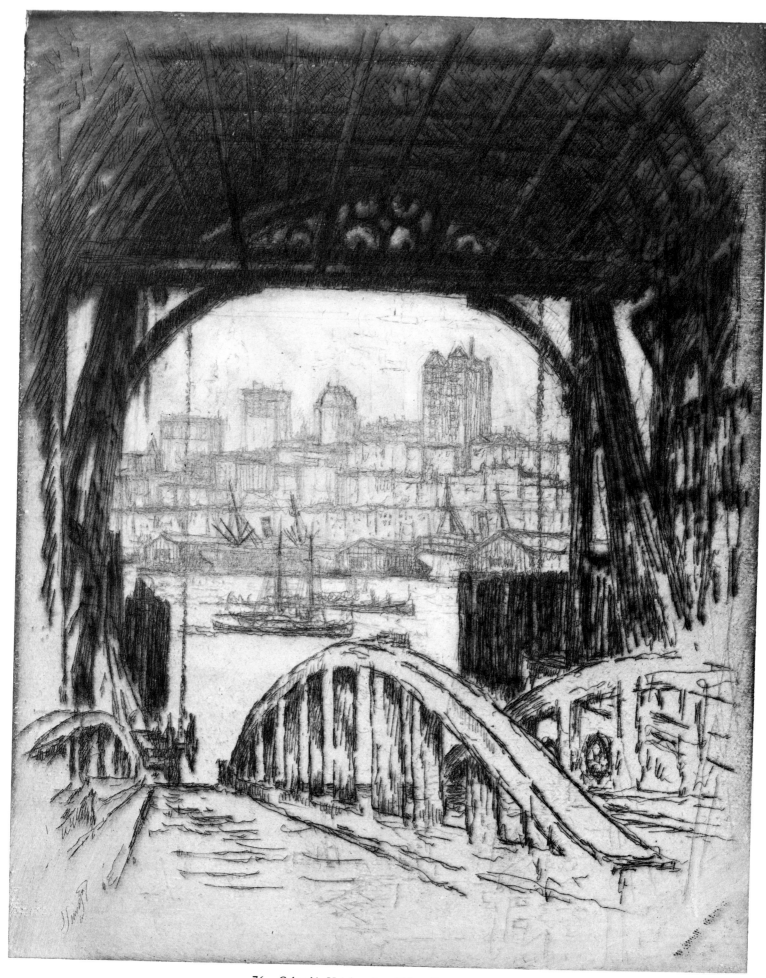

76. Columbia Heights, from Fulton Ferry. 1924.

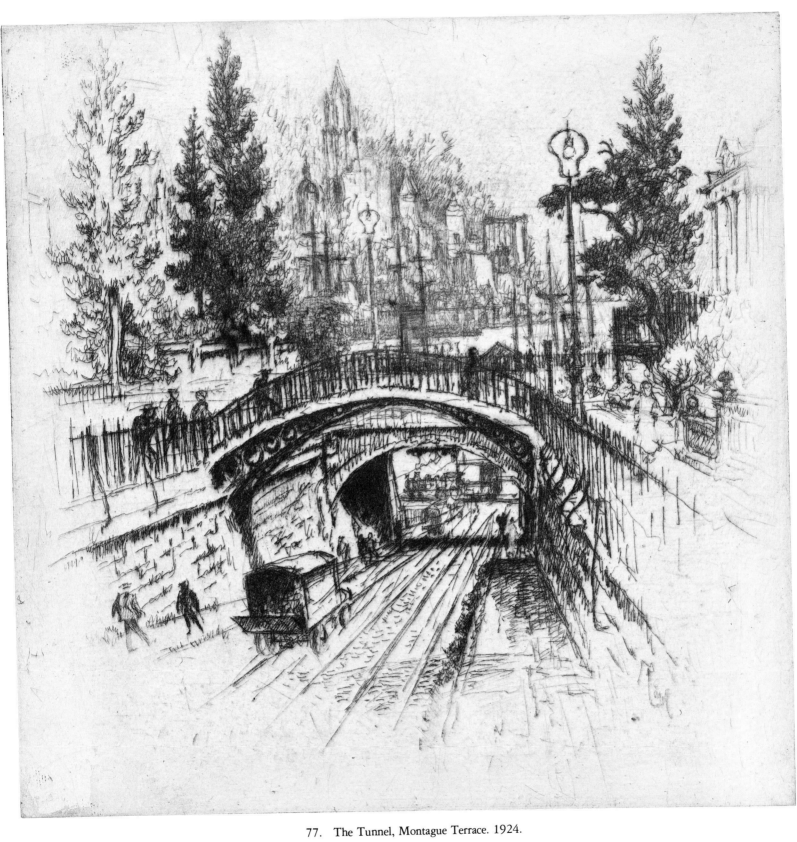

77. The Tunnel, Montague Terrace. 1924.

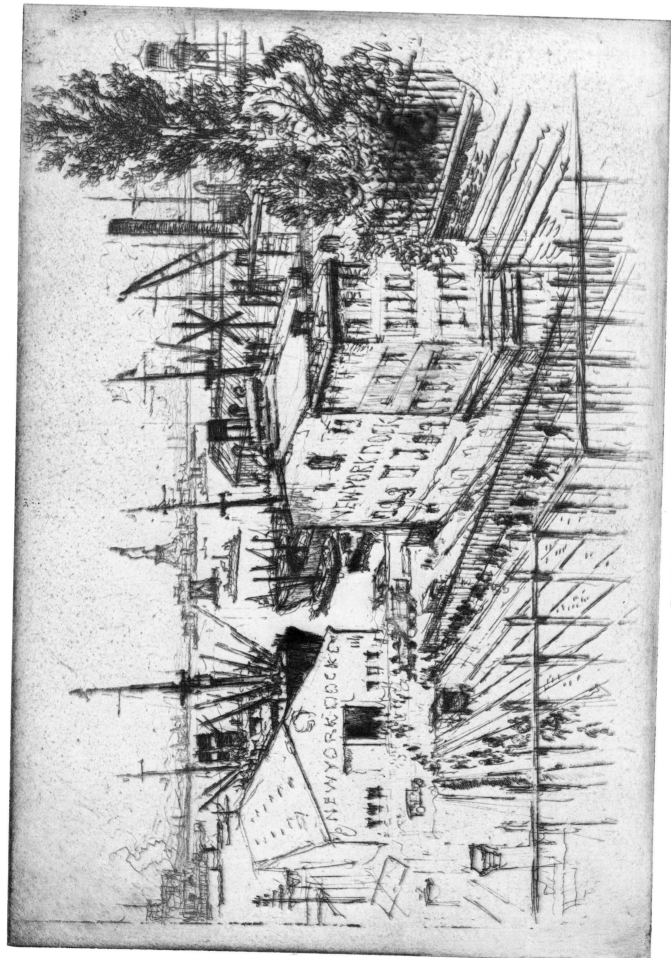

78. The Docks, from Columbia Heights. 1924.

79. Pierrepont Place, Montague Terrace. 1924.

80. Montague Terrace, Children Skating. 1924.

81. New York, from Grace Court. 1924.

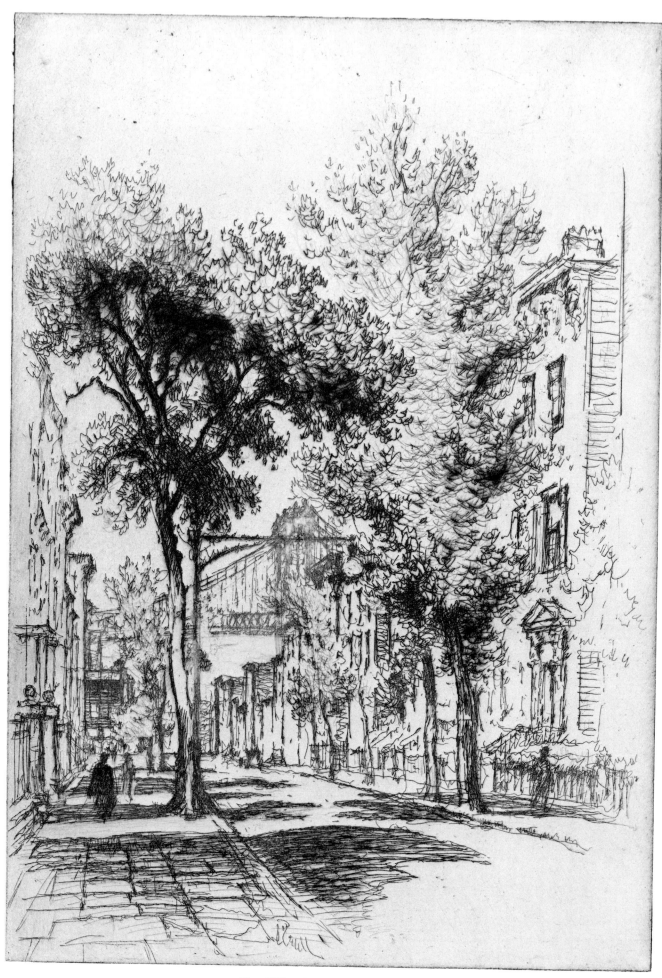

82. Willow Street, Brooklyn. 1924.

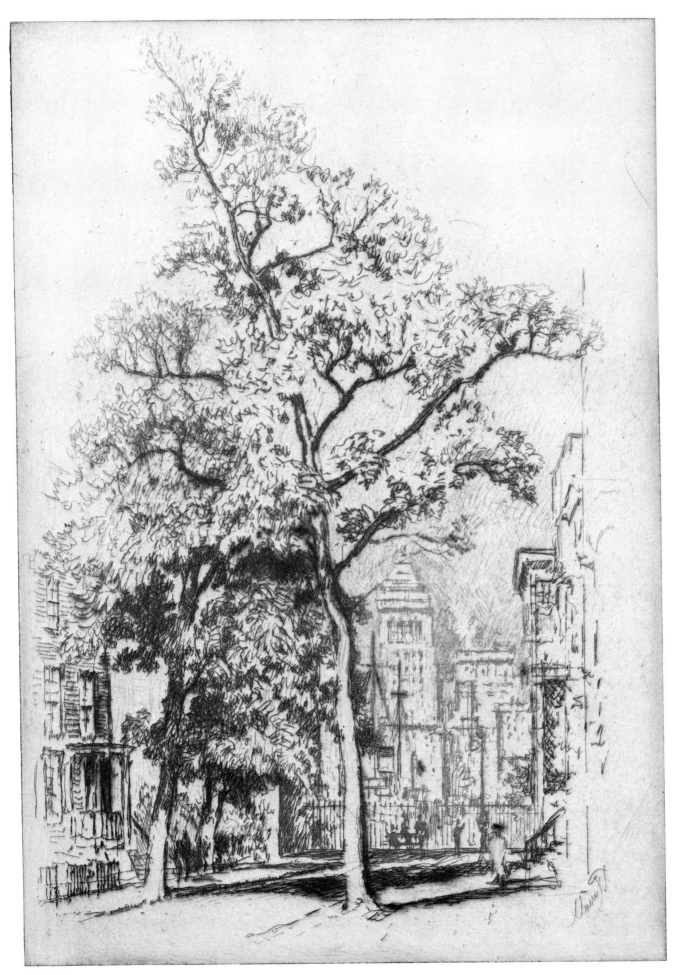

83. Pineapple Street. 1924.

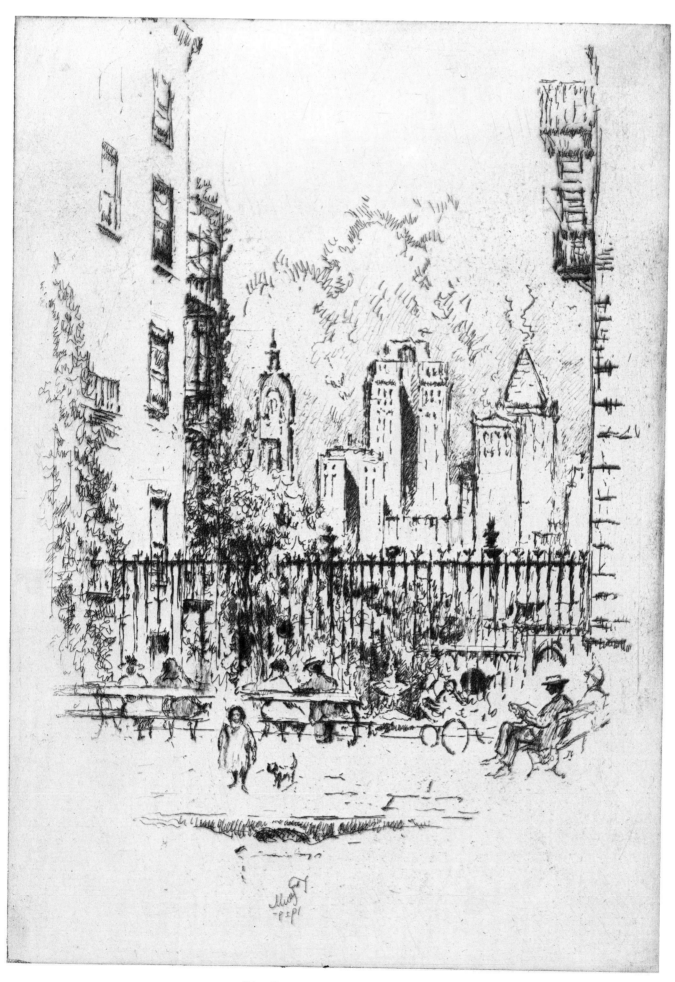

84. Orange Street, Brooklyn. 1924.

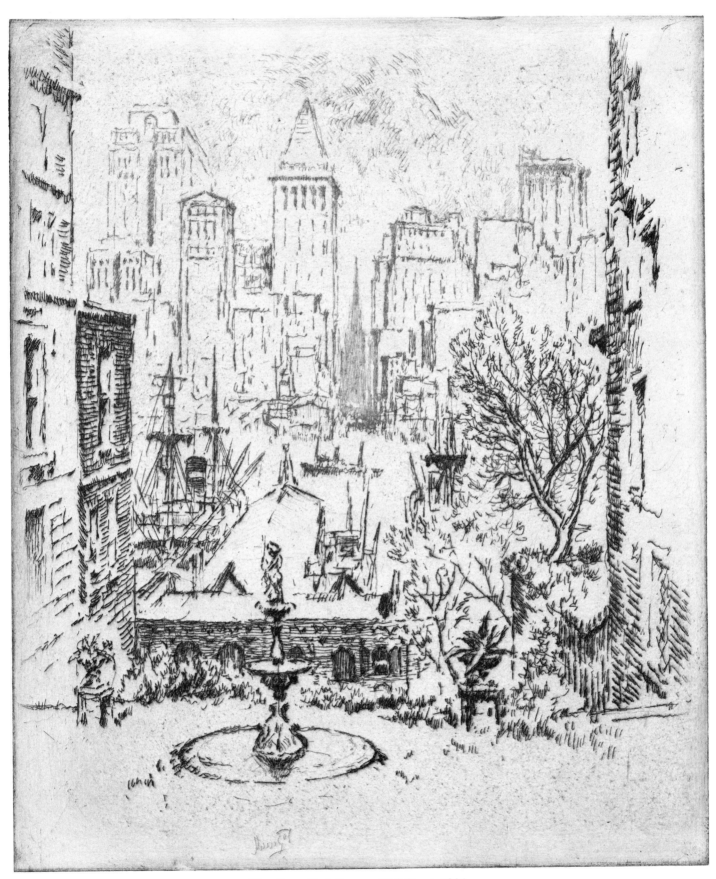

85. From Clark Street to Wall Street. 1924.

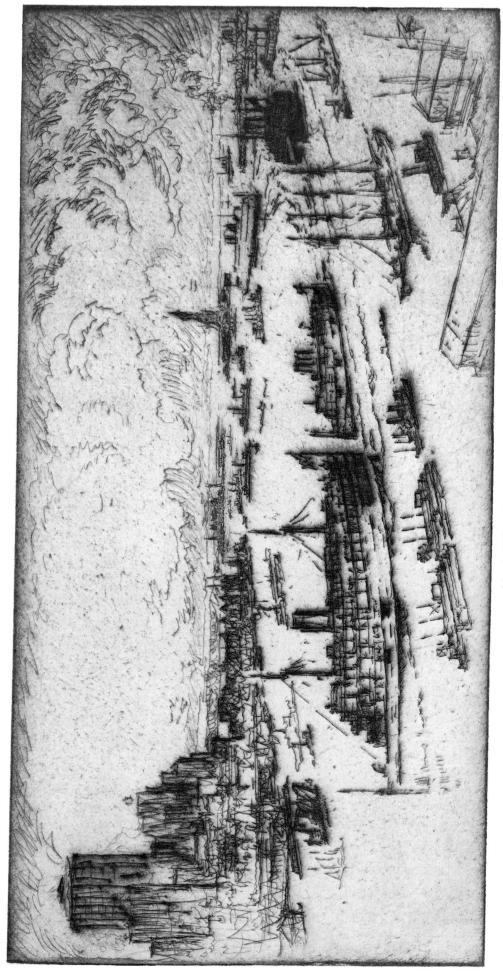

86. Fall River Boats Going Out. 1924.

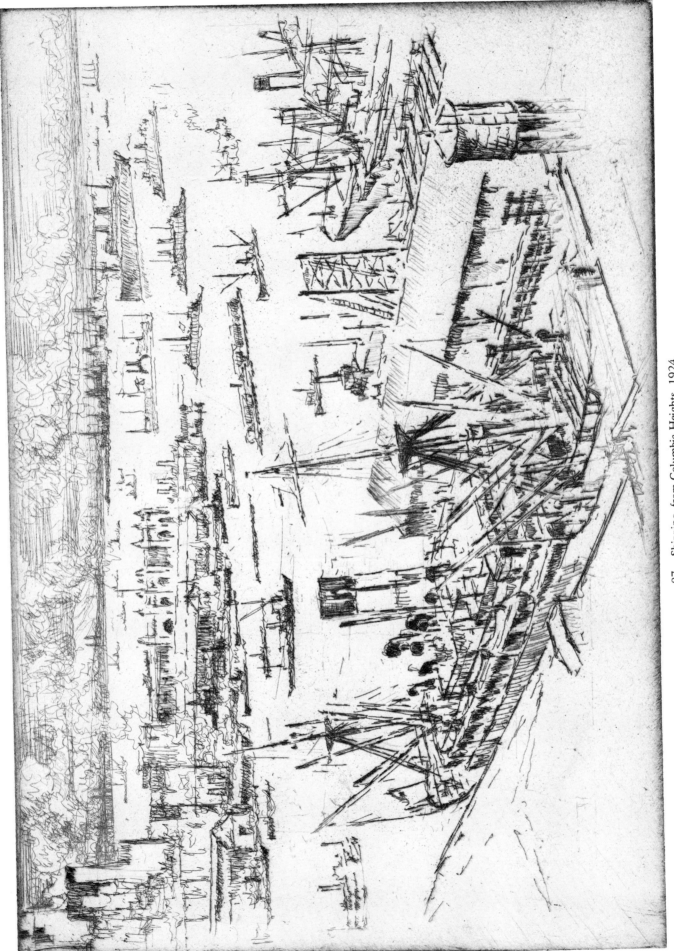

87. Shipping, from Columbia Heights. 1924.

88. Out of My Brooklyn Window. 1923.

89. The Deserted Ferry. 1924.

Notes on the Plates

Titles, dates, catalogue numbers and plate measurements (in inches, height before width) are those given in Louis A. Wuerth's *Catalogue of the Etchings of Joseph Pennell*. Unless otherwise noted, the medium is etching.

Since the artist almost always drew from his subject directly upon the prepared copper plate, the print image is consequently exactly reversed from the actual orientation of the subject. (This, of course, can be corrected by looking at the print in a mirror.) There are, though, the following exceptions: Plates 24 (W499), 63 (W818), 64 (W812), 67 (W815), 69 (W814), 72 (W827), 73 (W805), 74 (W810).

The description of the frontispiece, ''The Woolworth, Through the Arch,'' will be found in its chronological place, following the description of Plate 58.

THE NEW YORK SERIES OF 1904
(Plates 1–17)

Pennell did more than 28 etchings of New York in 1904 (a few are unrecorded in Wuerth, including Plate 14), the number of proofs ranging, as usual for him, from 25 to 90.

In these prints there is a sparkling freshness and an inspired intensity. Awed by the skyscrapers, the artist drew most of them from street level looking up, with the reduced scale of hastily suggested people giving even greater monumentality and substance to the tall buildings. Contextually the views are amplified by contrasts of the present with the past, the small and the tall, the religious and the commercial, old construction methods and the new. Pennell's sensitivity to the shifting focal clarity of atmosphere and the clear, clean quality of light (New York had an ordinance against burning soft coal!) recalls the formative influences of the Spanish illustrators Fortuny, Rico, Casanova, Vierge and Fabres. Technically this effect is achieved through the omission of single continuous definitive lines, in favor of the broken suggestive impressionist line and the substitution of spots for lines when indicating shadow masses.

A master of selection and suggestion, Pennell depicts acutely observed details with amazing formal flexibility, massing them into a unified composition that insists on an internal artistic integrity and at the same time is convincingly veracious in its topographical documentation. Visual emphasis is concentrated along an off-center vertical axis, with the composition usually fuzzing out peripherally before it reaches the edges of the print. Despite this Whistlerian device, this series makes the most decisive stylistic break with Whistler up to that time, especially in Pennell's projective identification with the subject.

A new trend in magazine illustration of the time was heralded by the publication in *The Century* of six of these etchings without text.

1. TRINITY CHURCH, FROM THE RIVER. 1904. W324. 11¾ x 8⅜.
For almost 50 years Trinity Church (Richard Upjohn, architect; completed 1846), on the West side of Broadway facing the mouth of Wall Street, was the tallest point on the New York skyline. In 1894 the Manhattan Life Insurance Company Building (Kimball and Thompson, architects), at 64–66 Broadway, faintly visible to the extreme left, with its 17 stories plus dome, rose 60 feet above Trinity's 284-foot spire. Ten years later both structures were becoming submerged by the skyscrapers towering around them.

Looking from the Hudson River eastward (but at a reversed print image), the most prominent buildings, left to right, are: the Empire Building at 71 Broadway, corner of Rector Street (the very tall structure at the left; 20 stories, 293 feet high; Marc Eidlitz & Son, builders); nestling beside it (above the ''NY Boat Oar Co''), the ''neo-French Renaissance'' Union Trust at 80 Broadway, opposite Rector Street and Trinity churchyard; and (the last completely seen structure before the right edge) the American Surety Company (100 Broadway, southeast corner of Pine Street, 21 stories, 306 feet high; Bruce Price, architect; now the Bank of Tokyo). Barely discernible on its roof is the U.S. Weather Bureau Station.

''It needs Old Trinity Church, with its slender Gothic spire and mossy churchyard—the prim, Colonial City Hall, the harbor filled with shipping—Battery Park and Bowling Green—to nestle round the cliff-like piles of architecture and connect them with earth and human life. Given these environments, the skyscraper has power to change the face of the greatest American city from crude ugliness to irregular loveliness, and with the varying glamor of sunrise or sunset, storm or fog, velvet shadow or electrical illumination, New York grows into a city of enchantment with a wondrous, fleeting, mysterious beauty'' (''Pennell's Masterly Etchings,'' p. 286).

2. FOUR-STORY HOUSE. 1904. W329. 10¾ x 7⅜.
The artist drew this view directly onto his prepared copper plate while looking in a northeasterly direction across Broadway near the corner of Rector Street. The fence corner and trees on the right are in Trinity churchyard. On the southeast corner of Wall Street, at No. 1, is a modest four-story brick building, dwarfed by skyscrapers and doomed to make

way for a taller structure (see Plate 62). The buildings along Broadway can be identified as: Union Trust, far left; United Bank Building, northeast corner of Wall; and American Surety, far right. The tall double-sectioned structure rising in the center is the Hanover Bank.

3. THE GOLDEN CORNICE, I. 1904. W349. 10¾ x 7¼.
From almost the same spot as that for the previous print, we see on the right the cast-iron enclosure around Trinity churchyard. On the left, at the northeast corner of Wall Street, is the United Bank Building, separated from the American Surety by the low and narrow Schermerhorn Building. The elaborate decoration of the American Surety, with its spectacular ornate cornice, contrasts with the functional steel framework of the 21-story Trinity Building seen going up across Broadway; it was erected in only 63 days by the George A. Fuller Company.

The steel-skeleton framework—open, light, flexible and strong—made it possible to build upward to heights never possible with stone-on-stone masonry construction, which required with increased height correspondingly thicker lower walls to sustain the dead weight. Since the exterior walls in steel-frame structures are non-weight-carrying, they are simply a continuous curtain (masonry or otherwise) hung from the steel frame. The exterior walls, being nonsupportive, do not have to be laid up from bottom to top; they are supported at each floor by the beams and girders of that floor and by the vertical columns of the building. An open interruption can be seen here between the seventh and tenth floors.

4. WALL STREET. 1904. W344. 11¾ x 8⅜.
Pennell incised this etching just west of South Street, looking west on Wall Street—past Front Street, Water Street and the Second Avenue Elevated Railroad at Pearl Street—to Trinity Church.

Electrification of the trolley and elevated lines began in 1899; the third-rail system was first used in 1901. It was estimated in 1903 that the surface and elevated lines of the City of New York carried more passengers each year than all the steam railroads of North and South America combined. In 1904 mass transportation was also improved by the opening of the first subway line—from Brooklyn Bridge north to Grand Central Station, west with 42nd Street to Times Square, and then north under Broadway to West 145th Street.

5. THE SHRINE. 1904. W336. 11¾ x 6⅞.
The focus of this etching is the Martyrs' Monument at the north end of Trinity churchyard, a tall freestone Gothic-style monument dedicated to the patriots of the American Revolution who died imprisoned during the seven-year British occupation of New York City (1776–1783). It was fortuitously erected in 1852 while the City was proposing to cut a street through the churchyard at this point. We are looking up Pine Street past (on the right) the northern portico of the Sub-Treasury (now Federal Hall National Memorial), across the junction with Pine of Broad and Nassau Streets, and past the massive Hanover National Bank and the American Surety Company. From the left inward are the Fourth National Bank; the earlier Equitable Life Assurance Society Building (built 1870, burned 1912) at 120 Broadway, Cedar to Pine Streets, the first office building in the world with a passenger elevator; and across Broadway to the churchyard and Trinity Building under construction.

As well as steel-skeleton structure and caisson foundations, the development of an efficient electrically powered

traction elevator allowed for unlimited vertical construction, and shaped the New York skyline. Six floors were the walk-up limit, with rental values much less for floors above that. With elevators, higher floors above street noises and with a view were preferred.

6. CANYON, NO. 1. 1904. W332. 10⅛ x 5⅜.
The surprising precision with which Pennell's impressionist technique could define architecture allows one to identify the richly corniced building receiving full light as that of the Atlantic Mutual Insurance Company, 49 Wall to Exchange Place. The artist is standing on William Street between Cedar and Pine, looking toward Wall and Exchange Place.

7. THE STOCK EXCHANGE. 1904. W331. 11¾ x 7½.
When Pennell etched this view of the heart of financial America, the New York Stock Exchange on Broad Street, designed by George B. Post, had just been completed (1903). Its pedimented white-marble facade of Corinthian columns is on the right between the Gillender Building (with cupola) and the Commercial Cable Company Building. At the far right is the Blair Building, bought by the Exchange in 1928. To the left, on the northeast corner of Broad and Exchange Place, there still stood (although not defined here) the 10-story Mills Building, one of the first of the large office buildings predating steel-frame construction. The crowd clustered in the foreground is the outdoor Curb Exchange, brokers who could not get a place on the Stock Exchange. Looking northward up Broad Street from Exchange Place, one sees at 28 Wall Street the Doric portico of the Sub-Treasury (used as such 1862–1925), completed in 1842 as a customs house by Ithiel Town and Alexander Jackson Davis. On the historic site of Federal Hall (1699–1812, originally the colonial city hall), where in 1789 Washington was inaugurated as the first President, this Greek Revival masterpiece was in 1904 the depository of gold and silver bullion. It is now Federal Hall National Memorial. To its right in the etching, at the foot of Nassau Street, rises the Hanover Bank. Beyond is a structure which appears to be the National Bank of Commerce.

"In these buildings," wrote the French novelist Paul Adam, "the face of America is concentrated. To erect donjons of 25 stories, to superimpose business offices therein, to exalt above the city the omnipotence of money as the tower of the feudal castle was exalted of yore above the surrounding country—what exact and happy symbolism is this! Our ignorance has fondly maintained, hitherto, that the Yankee possesses no personal art. Here is the refutation" ("Pennell's Masterly Etchings," p. 287).

8. LOWER BROADWAY. 1904. W328. 11¾ x 7¾.
The artist is looking south from the corner of Fulton Street. The building with the ornate hipped roof with grille and dormers is Washington Life, on the southwest corner of Broadway and Liberty Street. Pennell called Broadway "the finest street in the world." Most of the office buildings that mushroomed during the first decade of this century were built along Broadway between Battery Park and 23rd Street. By 1904 electric trolleys had replaced the horse-drawn passenger car. Three years before, there had been initiated a completely electrically equipped system on the Broadway, Columbus Avenue and Lexington Avenue lines of the Metropolitan Street Railway Company. In 1898 the horseless autotruck had been the latest innovation in street traffic.

9. ST. PAUL BUILDING. 1904. W334. 11¾ x 8⅜.
With this 25-story structure, 310 feet high, designed by

George B. Post and owned by H. O. Havemeyer, New York in 1897 possessed the world's tallest building, a distinction previously held by the Masonic Temple Building in Chicago. Located on the southeast corner of Broadway and Ann Street (the former site of Barnum's Museum and later of the Herald Building) and adjacent to St. Paul's Chapel, it was demolished in 1959 to be replaced by the Western Electric Building. The location of this view was the east side of Broadway at the corner of Vesey Street, just north of the intersection of Park Row and Broadway. To the far right is the Park Row Building. The short Clark Building in between, at the corner of Ann Street, has a detective agency sign displayed.

10. PARK ROW. 1904. W326. 11⅞ x 7.
At the turn of the century Park Row was "Newspaper Row," the publishing center for the city's dailies; the *Sun, Times, Tribune* and *World*. In this view, we stand on the eastern edge of City Hall Park looking southward down Park Row to St. Paul's Chapel on Broadway between Fulton and Vesey. On the far left, at the intersection of Broadway and Park Row, is to be seen a portion of the mansard-roofed Federal Building, a massive granite structure called "Mullett's Monstrosity," which was completed in 1875 to house the city's main post office and U.S. courts. On the far right, looking inward, are three buildings still standing: the old Times Building (41 Park Row) and the Potter Building. In the center is the Park Row Building, or Syndicate Building (Robert H. Robertson, architect, 1899), which in 1904 was the tallest structure in New York—30 stories, 390 feet from the sidewalk to the top of its two towers, from which there was a panoramic view of the city. Eight passenger elevators were originally installed to carry more than 6000 persons housed in its offices. Just beyond it can be seen part of the St. Paul Building.

11. THE THOUSAND WINDOWS. 1904. W333. 11¾ x 6¾.
For this etching, the artist was east of Nassau Street looking down Ann Street, across Broadway and into Vesey Street. The Park Row Building (center) inspired Pennell's title. To the right are the St. Paul and (far right) Bennett Buildings, with a low wing of the National Park Bank between.

12. UNION SQUARE AND BANK OF METROPOLIS. 1904. W327. 12 x 8⅜.
Looking northwestward across Union Square (conceivably from a balcony of the Union Square Hotel in the southeast corner of the square, or from the base of Henry Kirke Brown's equestrian statue of Washington, before it was moved to the center of the square), Pennell drew onto his copper plate the group of three buildings on the west side of the square occupying the block between 15th and 16th Streets: (left to right) the Hartford Building, the Decker Building and the Bank of the Metropolis (31 Union Square West; Bruce Price, architect, 1902). Union Square, indeed a rallying place for the Union cause during the Civil War, but actually named so because of the union of Park Avenue South and Broadway, in 1904 was in the retail shopping section, after being superseded as a theatrical center in the '90s by the "Rialto" area along Broadway from Madison Square to 42nd Street. Union Square was not to become the center of America's radical movement until somewhat later, in the years preceding World War I. *The Century* magazine, for which Pennell did many illustrations, had its offices on the northeast edge of the square.

13. HOLE IN THE GROUND. 1904. W345. 11¾ x 8⅜.
West of Union Square on 16th Street at the southeast corner of Fifth Avenue, Pennell recorded this excavation for the Nickerbocker Building, 79–83 Fifth Avenue. Looking eastward, we see on the north side of 16th Street a row of loft buildings and the grandiose cornice of the Bank of the Metropolis.

14. BROADWAY NORTH FROM GILSEY HOUSE TO TIMES TOWER. 1904. Not catalogued in Wuerth. 9⅜ x 6⅛.
Looking north on Broadway, from the Gilsey House (a hotel built 1869, closed December 1904) at No. 1200, northeast corner of 29th Street and Broadway, to the Times Building (under construction), Pennell records the diversity of hotels and theaters on the Rialto. The low building near the center is Wallack's Theatre, which opened in 1882 at the northeast corner of 30th Street and Broadway, with Sheridan's *School for Scandal*, succeeding two earlier theaters on Broadway owned by the Wallack family of actor-managers, one at Broome (opened 1852), the second and most popular at 13th Street (opened 1861). After Lester Wallack retired this third theater reopened as Palmer's Theatre in 1888. Its name was changed back to Wallack's in 1895. Next to Wallack's in the etching is the New Grand Hotel on the corner of 31st Street. In the next block is the Hotel Imperial, the tallest building in the center of the print. Beyond Greeley Square can be seen the 33rd Street El station.

15. THE TIMES BUILDING. 1904. W339. 11⅞ x 8⅜.
This modern campanile, seen from the north end of Times Square (extending from 42nd Street to 47th Street; until 1904 known as Longacre Square), was begun in 1903 and completed in 1905. Shown here under construction, its steel frame has been almost completely surfaced with glazed terracotta and pink granite to embellish it with an eclectic combination of Gothic and Renaissance details. Hanging scaffolds could be adjusted by means of winches to a height convenient for the workmen. Shaped also by the pie-slice proportions of its site at the intersection of Broadway and Seventh Avenue, this famous 22-story landmark by Cyrus L. W. Eidlitz and Andrew C. MacKenzie was dubbed "the second Flatiron Building." After having been 50 years on Park Row, the *New York Times* occupied this tower only until 1913, when the Times Annex on 43rd Street was built. (The tower, remodeled in 1966, is now the Allied Chemical Tower.) Looking south from 46th Street, we see the Hotel Astor on the left and the New York Theatre on the right.

16. FORTY-SECOND STREET. 1904. W350. 11¾ x 7¾.
To achieve this vantage point, Pennell must have worked from the platform of the Second Avenue El Station. Looking west on 42nd Street all the way to the Times Building at Broadway and Seventh Avenue, he includes vaguely on the left (north side of the street) the double-towered structure of the old Grand Central Station, beyond which can be seen the Hotel Manhattan at the northeast corner of Madison Avenue and 42nd Street (opened 1896). On the south side of the street, at Park Avenue between 41st and 42nd Streets, is the Hotel Belmont, then the tallest hotel (292 feet) in the world. Between it and the El station can be seen a tower of the Manhattan Storage Warehouse.

17. THE STATUE OF LIBERTY. 1904. W343. 11⅞ x 8½.
This is the first of Pennell's sweeping panoramas of New York. Probably drawn from one of the 390-foot towers of the Park Row Building, it includes a breathtaking view across the skyscrapers of Lower Manhattan, from Park Row to Up-

per Bay, past the Statue of Liberty and Bedloe's Island, to Brooklyn and Staten Island. Here can be seen the concentration of high-rise structures at the southern tip of Manhattan, location of the country's leadership in finance and business. By the turn of the century New York was the world's largest port, the richest city and the most densely populated metropolitan area. The Statue of Liberty is in this print an effective symbol of free enterprise.

THE NEW YORK SERIES OF 1908
(Plates 18–24)

Wuerth records 120 etchings in this series, which was done while Pennell was in New York to illustrate John C. Van Dyke's book *The New New York* (published 1909).

This second set is characterized by panoramic views. From the Brooklyn Bridge, the top of the Singer Tower, the Palisades and various ferries, Pennell does his first skylines of that dream city of which Van Dyke cautioned: "If you touch it, it will fade away and leave only a grouping of harsh facts" (*The New New York*, p. 4). Seeing utility as the basis of its beauty, Pennell never penetrated to those facts which would have seemed to him insignificant if measured against this grander scale and its suggestions of the power and energy of New York life. His Wonder of Work theme appears, and is marked by that impersonal coolness.

These plates were more heavily worked to produce a darker tonal coloration, which had been hinted at in some of the English and French prints produced during the interim since 1904, and which would become more prominent in his 1909 Pittsburgh plates of factories belching smoke into sulphuric skies. A hazy greyness suggests thick atmosphere; the sky is saturated with lines. Dark areas sweep across some of the prints, obscuring and dramatizing. Blunter lines replace the airy, delicate ones of 1904.

With an increasing interest in tonal coloration, Pennell turned to mezzotint, by way of aquatint and sandpaper mezzotint. The sandpaper technique could produce, through less laborious means, effects very similar to traditional mezzotint. In this process a sheet of sandpaper of the desired texture is placed face down on a copper plate already grounded as for an etching and run through the press, producing an allover textured surface, through which the acid will bite as in the case of aquatint. After this sandpaper ground has been bitten, a drawing is traced or transferred onto the plate. All parts to be white are then stopped out and bitten; then all the greys are stopped out and bitten. A final biting produces the blacks.

18. NEW YORK, FROM BROOKLYN BRIDGE. 1908. W490. 11 x 8⅜.
In this view of Lower Manhattan, south from the Brooklyn Bridge, Pennell finds drama in the progression of structures from dockside over bleak Lower East Side tenements up to the majestic skyline of soaring palaces, recently crested by the Singer Tower. Below, at Peck Slip, is South Street with its row of ship chandlers' shops, sail lofts, and steep-roofed warehouses. The block of buildings to the right (to Beekman Street) is still standing. On the corner, with five stories and a slightly pedimented roof, is Meyer's Hotel (John B. Snook, 1873). Located on the northeast corner of Broadway and Liberty Street, the Singer Building (Ernest Flagg, architect; 1906–08; 47 stories) was the first of three successively tallest-in-the-world towers built as super-billboards for mass-marketing giants: Singer Sewing Machine, Metropolitan Life Insurance and F. W. Woolworth. Completed in 1908 and demolished in 1967, the Singer's 612-foot record was exceeded in 1909, within 18 months, by the 700-foot-high

Metropolitan Tower. Other identifiable buildings on the skyline are the Park Row Building (top left) and (next to it) the St. Paul Building, and 60 Wall Street to the far right.

19. THE WEST STREET BUILDING, FROM THE SINGER BUILDING. 1908. W491. 11 x 8½.
When completed in 1905, the West Street Building was the most imposing structure on the West Side. Twenty-three stories and 324 feet high, it occupied the block on West Street between Albany and Cedar Streets. Designed by Cass Gilbert, who eight years later would complete the Woolworth Building, the West Street Building already effectively combined a clear expression of verticality and intricate Gothic-inspired detail to create an effect of graceful lightness. It was occupied by the offices of Bell Telephone, Dupont Powder, Lackawanna Railroad and other important companies, with club rooms on the top floor. The building faced the ferries for the B & O and Pennsylvania Railroads and the Jersey Central Ferry. Across the busy Hudson lie the Morris Canal Shipping Basin and Jersey City. The Central Railroad of New Jersey Building is the tall building (at the left) on the corner of Liberty and West Streets. From a vantage point three crosstown blocks away, atop the Singer Tower at Liberty and Broadway, below we can see the elevated line on Greenwich Avenue crossing Liberty Street, congested with traffic to and from this major point for ferry service for railroad passengers headed west and south, or for the commuters living in New Jersey. The piers of the Liberty Street Ferry are to the far left (north); those of the Central Railroad of New Jersey are in front of the West Street Building; and those of the Metropolitan Steamship Company and of the Central Railroad of New York are to the right (south). To the north, just beyond the Liberty Street Ferry, was the Cortlandt Ferry of the Pennsylvania Railroad Company. It was also at that point that the Hudson and Manhattan Railroad tunnel (Hudson tubes, completed 1905) from Jersey City entered under Cortlandt Street on its way to the terminal three blocks east.

20. AMONG THE SKYSCRAPERS. 1908. Etching and drypoint. W494. 10⅞ x 8⅜.
Looking southeast from the Singer Tower, the artist presents us with a grand panorama of Lower Manhattan and of South Brooklyn from Brooklyn Heights to the Hamilton Avenue Ferry area, almost to Red Hook. The three tall blocky structures to the left are grain elevators just south of the Atlantic Avenue Ferry. The distant tower faintly visible to the right might be the tall clock tower at the Fulton and Flatbush Storage Company, on Nevins Street. In Manhattan, across the dark chasm of Broadway, we can identify the building cut by the left margin of the print as the Hanover Bank. Across town on Pine Street is the 362-foot 60 Wall Street tower (top center). To the right, at the angular intersection of Liberty Street and Maiden Lane, is the German-American Insurance Company (281 feet high, with 21 stories).

21. PALISADES AND PALACES. 1908. W496. 11 x 8⅜.
In an early expression of his Wonder of Work theme, Pennell effectively contrasts the massive, imposing forms of nature with those created through man's labor. Perched atop the Palisades overlooking the New York Central freight yards at Weehawken, almost directly above the mouth of the railroad tunnel through the cliffs, he was looking in a northeasterly direction up the Hudson. At this time freight terminals for all the western railroads were across the Hudson in New Jersey.

In the upper right-hand corner, Hillside Avenue circles

the cliffs. To the far left is a structure that could be the New York Central's huge grain elevator, which once stood at Pier 7 or 8. Across the river are big apartment houses and hotels on Riverside Drive, West End Avenue and Broadway, from about 72nd Street to Morningside Heights. The largest of these, near the upper left corner, stands about 72nd Street and West End Avenue or Broadway. The domed structure to the far upper right seems to be Grant's Tomb, Riverside Drive at 123rd Street.

Eleven years later, when Pennell did another etching from this location, he wrote: "There is no [other] such beautiful arrangement of lines in the world. The fan of fans spread out to reveal the great New York. What would Hiroshige have made of it—I do not know—but I know I have done it, and this is not the first time—for I saw it and etched it years ago in a different way—and hope to do it again—for if I have lost Europe I have gained America, and this is my country. I was only a foreigner over there" (Wuerth, *Etchings*, p. 239).

22. THE UNBELIEVABLE CITY. 1908. W498. 8⅜ x 10⅞.
In this view looking toward Lower Manhattan from Governor's Island, the skyline is riven by Broadway. To the right of center, left to right, are the Singer Tower, City Investing (next to it, and next highest), the three-pointed steeple of the Washington Building, the Bowling Green offices (behind and right) and Whitehall (next after a gap). At the base, left to right, are the Municipal Ferry Terminal, Battery Park and the Aquarium (used as such 1896–1941). The building that housed the Aquarium was erected in 1807 as the West Battery (after 1812 known as Fort Clinton); later it was the amusement place Castle Garden (1824–55) and the Immigrant Landing Depot (1855–90). Now it is Castle Clinton National Monument.

23. HAIL AMERICA. 1908. Mezzotint. W503. 8½ x 14⅞.
Although the mezzotint technique excludes incisive, spontaneous response to visual impressions, Pennell was interested in its tonal potentials, and after returning to England produced six others of London subjects during 1909. Dramatized by the backlighting of a full moon, Frédéric-Auguste Bartholdi's *Liberty Enlightening the World* (dedicated in 1886), the greatest colossus on earth, stands on the threshold of America. In this reversed composition the East River bridges are to the left.

24. FLATIRON BUILDING. 1908. Sandpaper mezzotint. W499. 13 x 9⅞.
Designed by the Chicago architect Daniel H. Burnham, the Fuller Building made the first major use of steel-skeleton construction in New York. Built in 1901–02 by the George A. Fuller Company (also builder of the Hudson Terminal Buildings, Trinity Building and the Plaza Hotel), it became known as the "Flatiron" because of its shape, which conformed to the small triangular lot of its site at the intersection of Broadway and Fifth Avenue at East 22nd and East 23rd Streets, at the southwest corner of Madison Square. It was financed by Harry S. Black, son-in-law of George Fuller and after Fuller's death president of the construction company. Twenty stories (300 feet) high, with 456 offices above the fourth floor, the building, including site, cost four million dollars. It was one of the most publicized of skyscrapers. The dome shape just to the right belongs to the 1894 Scribner Building (153–157 Fifth Avenue). In making this sandpaper mezzotint, Pennell did not work directly on the prepared copper plate in response to his subject, but instead transferred a drawing onto the plate, possibly by running them through the press together, therefore not reversing the print image.

THE NEW YORK SERIES OF 1915
(Plates 25–34)

When Pennell again turned to New York City for his subjects in etching, he had in the interim traveled extensively in Europe and America and to the Panama Canal following his Wonder of Work theme. The eleven etchings he produced during 1915 are assured in their diversity of viewpoint, scale and execution. A master of processes, Pennell possessed a touch ranging from spontaneous exactness shimmering with light to heavy blunt melodrama, which must have expressed his concerns over the war that threatened to ruin his life. The scribbled, excited line and dense tonal patterns are related to his preoccupation with lithography at this time. After doing many drawings of the British war effort and making a disturbing visit to Verdun to document the Front, Pennell gave up his home in London and returned in despair to America in 1917. Here he did a series of lithographs of American war work.

25. THE WOOLWORTH BUILDING. 1915. W675. 11¾ x 7⅞.
Three edifices each in turn once the tallest—St. Paul Building, Park Row Building and Singer Tower (second, first and third from the right, respectively)—are shown here dwarfed by the towering, majestic Woolworth. Located at 233 Broadway, from Barclay Street to Park Place, and facing City Hall Park, its 55 stories reach a height of 792 feet. In 1913 the Woolworth Building took the title of the tallest from the Metropolitan Life Insurance Building (1909, 700 feet, 50 stories above street level), but 17 years later this grand "Cathedral of Commerce" would itself defer to the Chrysler Building (1930, 1046 feet, 77 stories). Designed by Cass Gilbert, the Woolworth is a major contribution to America's "skyscraper style," gracefully expressing in its neo-Gothicism the soaring verticality of steel-frame construction.

For this view the artist was at the northwest corner of City Hall Park looking southward down Broadway. On the far left, cut by the frame, is the Smith Gray Building. Across Warren Street are Rogers Peet, Home Life Insurance and the Postal Telegraph Building. In the next block, between Murray Street and Park Place, six low buildings, none exceeding seven stories, contrast sharply with the gigantic Woolworth. At the south side of City Hall Park, above the trees, there is a glimpse of A. B. Mullett's Federal Building (demolished in 1939).

26. THE CITY IN 1915. 1915. W679. 8⅜ x 10⅞.
In 1915, when Pennell did his third series of New York etchings, the ever-changing Manhattan skyline had for two years been crowned by the 55-story Woolworth Building, and included the world's largest Municipal Building (the first spire at the left), the 39-story, pyramid-topped Bankers Trust, the 38-story Equitable Building behind it (the Woolworth and Singer Tower follow), the 32-story Adams Building (between the Singer and the three-pointed Washington Building) and the 34-story annex to the Whitehall Building (far right). The 47-story Singer Tower was becoming submerged within a mass of newer skyscrapers.

"It is marvelous, incredible. When you go out on the ferry to Staten Island, there is one moment on the trip when, looking back to Manhattan, you see the city cleft by the canyon of Broadway. I say that the Grand Canyon has nothing to equal that sight. If Broadway were a street in a European city, centuries old, American would flock there to visit it" (Pennell, quoted in the *New York Times,* Apr. 24, 1926, p. 6).

27. NEW YORK, FROM GOVERNOR'S ISLAND. 1915. W668. 7⅜ x 11⅞.

Across the harbor we see the bold steel arches of the Municipal Ferry Terminal. Seven slips, with a length totaling 700 feet, serviced the ferries to Staten Island and the three Brooklyn lines (Hamilton Avenue Ferry, Atlantic Avenue Ferry and South Brooklyn Ferry). To the far left is the Brooklyn Bridge. Governor's Island, a U.S. Army Headquarters 500 yards off the tip of Manhattan, had by 1900 been eroded by waves down to 70 acres from an area of around 170 acres in the seventeenth century. This lost land was replaced by fill from the subway excavations and dredged canals.

28. NEW YORK, FROM HAMILTON FERRY. 1915. W669. 8½ x 11.

The skyline is seen here from the Hamilton Avenue Ferry landing in South Brooklyn. The Municipal Ferry Terminal is faintly discernible at the right. This etching and the previous one are unusual among Pennell's renderings of New York for their picturesqueness, which recalls the *vedute* of the eighteenth-century Venetian painters Canaletto, Guardi and Bellotto. Pennell's ''Unbelievable City'' is a magnificent mirage, the backdrop for tiny inconsequential figures dwarfed by its immensity.

29. NEW YORK, FROM BROOKLYN. 1915. W671. 7⅜ x 11¾.

From almost the same location as the previous etching, this print is much more dramatic. The foreboding quality of light and the nervous, broader handling relate to Pennell's current work in lithography and seem to reflect his anxieties over World War I. Three years later he would do the ominous poster in color lithography that he called ''Buy Liberty Bonds or You Will See This'' (the printed poster bears a different motto), showing New York City bombed and burning.

30. SUNSET, FROM WILLIAMSBURG BRIDGE. 1915. W674. 8¹²/₁₆ x 11.

Almost overlooking the entrance to the old Brooklyn Navy Yard (1801–1966) from the second bridge (1903) to span the East River, we see to the south, past Corlears Hook on the Lower East Side, the Lower Manhattan skyline dominated by the Municipal Building, the Woolworth Building and the Singer Tower, and the two other bridges connecting Manhattan with Brooklyn, the Brooklyn Bridge (1883) and the Manhattan Bridge (1909). The industrial smokestacks on the right belong to the large sugar refineries and other factories on Kent Avenue in Williamsburg.

31. THE BRIDGE AT HELL GATE. 1915. W670. 8⅜ x 10⅞.

The New York Connecting Railroad Bridge, designed by Gustav Lindenthal, was begun in 1914 and completed in 1917. It made possible direct travel by rail between New England and the South, from Maine to Miami, by connecting the New York, New Haven & Hartford line with the Pennsylvania Railroad. The steel bowstring arch-truss spanning Hell Gate Channel (permitting tall-masted ships to pass underneath) is interpreted by Pennell as a magnificent gateway through which can be seen the great metropolis. This print is a fine expression of his Wonder of Work theme. The artist's viewpoint is from the Astoria (Queens) pier of the bridge, looking southwest past Ward's Island toward Upper Manhattan. The name Hell Gate for this narrow, treacherous channel between Astoria and Ward's Island probably comes from the Dutch *Hellegat,* meaning ''beautiful pass.'' For Pennell, Hell Gate Bridge was comparable to the rib vaulting in Chartres Cathedral. Here he drew it with the ro-

mance of a Salvatore Rosa, but with the romance of industry, not of Nature.

32. ST. PAUL'S, NEW YORK. 1915. W678. 11 x 8½.

In an ensemble of architecture from three centuries, St. Paul's Chapel of Trinity Parish, the oldest extant church and public building in Manhattan (1764–66; wooden spire, 1794–96; portico, 1768; Thomas McBean, architect), is dwarfed by the steel-skeleton constructions of the American Telephone and Telegraph Building (W. W. Bosworth, architect) to the south (right) and by the Astor House Office Building, across Vesey Street to the north. Located on Broadway between Fulton and Vesey Streets, St. Paul's was built to face a view of the Hudson River. The stone for the building was quarried from the area on three sides of the chapel that became the graveyard. The rich quality of St. Paul's High Georgian style echoes that of St. Martin-in-the-Fields, London, by James Gibbs, with whom McBean is said to have studied. This was the place of worship for Washington while the first President resided in New York. The L-shaped, steepled building beyond St. Paul's, with access to both Broadway and Fulton Street, is the Mail and Express Building (1891; Henry J. Hardenbergh, architect). It was replaced in 1922 by an addition to the American Telephone and Telegraph Building. The Astor House Office Building replaced the famous, once fashionable Astor House (opened 1836) where such eminent persons as Daniel Webster, Henry Clay, James K. Polk and Lord Ashburton were guests.

33. UP TO THE WOOLWORTH. 1915. W673. 11⅞ x 7¾.

The promenade on top of the masonry cable anchorage for the west end of the Manhattan Bridge was evidently Pennell's location for this elevated view over the Lower East Side. Below is Cherry Street, which passes through an arch in the anchorage (see Plate 51), in the midst of tenement slums overcrowded with immigrants. Interested in the dynamic inner forces that shaped the mighty metropolis, Pennell created in this print a pictorial metaphor of the American Dream by consciously contrasting lowly ''old-law'' tenements with the Woolworth Building, the tallest building in the world. Erected through the great wealth of a self-made man born on a farm in upstate New York, this skyscraper was both a monument to the individualistic initiative of Frank W. Woolworth and a ''sky sign'' advertising his moneymaking chain of five-and-ten-cent stores. To the left is the dome of the Pulitzer (World) Building; to the right are the steeple of the Tribune Building, the pitched roof of the American Tract Society Building and the twin towers of the Park Row Building.

34. NEW YORK, FROM NEW JERSEY. 1915. W677. 11¾ x 7⅜.

Before the Holland Tunnel was constructed (1920–27), all vehicular traffic between Manhattan and points west was carried across the Hudson River by ferries. Except for the Pennsylvania and Lehigh Railroads, which had direct access to Pennsylvania Station via their own tunnel, passenger service by rail terminated on the Jersey side of the river. Passengers continued on by ferries operated by the railroads, or through the Hudson tubes, used exclusively by the Newark–New York intercity Hudson and Manhattan Railroads.

Here we look down from the top of the hill on Clifton Avenue in Weehawken to the West Shore New York Central Railroad yards. Out of view just to the right is the West Shore Ferry terminal. Vaguely indicated above the front of the trolley and to the right are the roundhouse, a water tower and tracks curving toward the terminal.

According to the New Jersey Historical Society, the gabled structure on stilts at the water's edge is the old elevator terminal of the North Hudson County Railroad. At one time it was connected by viaduct to the top of the Palisades, with the trains receiving passengers right from the top of what were then the largest elevators in the world.

The Palisade and Union Hill (later Union City) trolleys were discontinued in 1949. The terminal for the southbound Union City trolley was at the Hoboken Lackawanna Ferry Terminal and the Hudson and Manhattan Railroads' tube station. The Palisade trolley ran on the old bed for a steam railroad to Fort Lee, Palisade Park and Coytesville.

On the skyline, right to left, can be seen the Municipal, Woolworth, Singer, Equitable and Whitehall Buildings.

THE RAILROAD ACTIVITIES SERIES OF 1918–19 (Plates 35–46)

During 1918 and 1919, a period of much travel for him, Joseph Pennell did his series of 43 railroad etchings, which include stations, freight yards, bridges, viaducts and ferries, in New York, Philadelphia, Washington, Chicago, St. Louis, Niagara, Pittsburgh, Mauch Chunk, Mahanoy City, Pottsville, Shamokin and Wilkes-Barre. During July and part of August 1919, he worked in New York, etching the Cortlandt Street Ferry and the two great gateways to the nation, the Grand Central and Pennsylvania Stations. The entire Railroad Activities Series was published and first exhibited in 1919, the date given by Wuerth to all the prints in the series. The artist's comments given below with these prints are those written by Pennell for the catalogue for that exhibition in New York with Frederick Keppel & Co.

35. THE FERRY HOUSE, THE CORTLANDT STREET FERRY FROM THE JERSEY CITY SIDE. 1919. W676. 12 x 10.

The Cortlandt Street Ferry, at the site of the old Paulus Hook Ferry established in 1764, was one of the most important links for commuters between Manhattan and Jersey City and for travelers headed to points west and south.

"How the ferry takes one back to my early days when, with a pile of prints or drawings under my arm I came over from Philadelphia early in the morning to show them to Keppel's, or *The Century* or *Harper's*. But when in the old days I came, Babbit's Soap Works was the highest building in New York, and Colgate's Soap Factory the most picturesque in Jersey City. How have the mighty risen, the new New York has come, come in my life time. I have seen it come, loved it, and drawn it, and I shall go on drawing it till the end, it is mine, it was made for me" (in Wuerth, *Etchings*, p. 232).

36. THE APPROACH TO THE GRAND CENTRAL, NEW YORK. 1919. W692. 12 x 10.

Grand Central Terminal, which replaced the first Grand Central opened in 1871, was the world's largest and costliest railroad station when completed in 1913. Designed by the architectural firm of Whitney Warren and James A. Wetmore and engineered by the firm of Reed and Stem of St. Paul, Minnesota, the grandiose Beaux-Arts structure was placed squarely across Park Avenue, thereby giving it an impressive vista from the south, as well as facilitating the plan for the extensive system of underground tracks extending northward underneath Park Avenue to 96th Street. An imaginative arched approach (1917) spanning 42nd Street divides to carry Park Avenue at the second-story level on either side around the station, to rejoin and continue northward at 46th Street. To the left rises the Commodore,

largest of the hotels at Grand Central (2000 rooms) and, with the Biltmore, railroad-owned.

"Superb is the swing of the bridge leading to the station but it is supremely useful. And as William Morris said, everything that is useful should be beautiful, many things in America are, even if they grow out of dung heaps. I believe much of the beauty and use of the past grew up in the same way" (Wuerth, *Etchings*, p. 238).

37. THE CLOCK, GRAND CENTRAL, NEW YORK. 1919. W695. 12 x 10.

The central portion of Grand Central's facade took the form of a grand triumphal arch crowned by the largest sculptural group in the world. Mixing classic and native symbolism to represent "Transportation" (or is it "The Glory of Commerce"?), this 48-foot-high group in molded concrete reinforced with a steel armature, clustering around a clock 13 feet in diameter, includes along with the American eagle, Mercury as Progress, Hercules (or is it Vulcan?) as Physical Energy, and Minerva as Mental Strength. Designed by the Beaux-Arts sculptor Jules-Alexis Coutan, it was installed in 1914. The heroic full-length bronze of "Commodore" Cornelius Vanderbilt (New York Central president, 1868–77) was placed at the bottom of the large center window of the facade in 1929. From a window in the Belmont Hotel, southwest corner of Park Avenue and East 42nd Street, one can see over the roof of Grand Central the open tracks behind, and in the distance the Queensboro Bridge (opened 1909; originally called Blackwell's Island Bridge) and, surprisingly, Hell Gate Bridge.

"People ask me why I go to the Belmont. I go to get things like this out of the window, and from every room on every side I get subjects just as inspiring. No other station in the world is so magnificently decorated, composed so well, or poses so well from a window, or is so well worth doing" (Wuerth, *Etchings*, p. 239).

38. CONCOURSE, GRAND CENTRAL, NEW YORK. 1919. W694. 12 x 10.

With the awesome spatial magnificence of a great basilica, Grand Central's main concourse, placed more than a story below street level, measures 125 feet by 385 feet. Enormous square piers 125 feet tall support the "barrel-vaulted" plaster ceiling suspended from steel trusses. At the ends great glass windows 75 feet high let in natural light, and at the west end, shown here, a grand staircase leads down from Vanderbilt Avenue. Botticini marble and sheets of artificial Caen stone sheathe the walls and columns. In the center is the circular information booth with its golden clock—the meeting place for millions. Opposite the ticket windows, which are on the south wall, gates give access to the tracks. In the blue ceiling the constellations of the universe by Paul Helleu were once illuminated according to their relative intensity.

"The finest hall in the modern world. The meeting place of all America, here the nation gathers not to pray but to get information. Yet it is a temple, the Temple of Travel, and when the shouter entones: Train leaving at eleven forty-five for Albany, Schenectady, Utikay, Skeneatelies, Rome, Cayugay, Aathens, Syracuse, Canadaraque, Rawchester—on track 39—all a-boa-rd—it all fades away and I am again in Turkey*—til some one knocks me back into New York and never begs pardon and the stars begin to twinkle in the roof and the little men to run back and forth across the window panes" (Wuerth, *Etchings*, p. 238).

*Likely a reference to Hagia Sophia in Istanbul.

39. THE WAITING ROOM, GRAND CENTRAL, NEW YORK.
1919. W697. 11¾ x 10.

In an elegant, uplifting space with five great chandeliers hanging from five great coffers, a space flattering in its civic extravagance, passengers quietly wait, separated from the frantic rush of the main concourse.

" 'What a mistake you make in doing these big buildings,' was the comment of the Editor when I offered him these prints. He did not even ask to see them. How the Editor hates character and loves imitation. . . . And despite his taste I know I am right in etching the greatest triumphs of modern American art, and shall go on doing it" (Wuerth, *Etchings,* p. 239).

40. THE TRACKS, GRAND CENTRAL, NEW YORK. 1919.
W693. 10 x 12.

The New York Central assumed enormous costs in electrifying all its urban tracks and building such an extravagant terminal on three entire blocks of valuable midtown land. These expenses were relieved when it was decided to sell the air rights to its extensive underground railroad yards, extending for a mile north of the station to 59th Street. Through a special new system of protecting foundations from railroad vibrations, a complex of fashionable hotels, apartments, clubs and office buildings went up over the two levels containing 67 underground tracks. In this print, looking from a passenger-loading platform somewhat west of the station building itself (seen to the right), we see buildings on East 42nd Street. To the south, at the far left edge, is the Hotel Biltmore, which occupies the block from 43rd to 44th Streets, between Madison and Vanderbilt Avenues.

"Track beside track, you cannot see the width of them—you cannot understand the mystery of them—but they are there and they all work, and above them framed in by the sheds over all the sky high hotels" (Wuerth, *Etchings,* p. 238).

41. ROUND HOUSE, PENNSYLVANIA RAILROAD. 1919.
W708. 10 x 12.

Ever aware of the energy behind the metropolis' activities, in his Railroad Activities Series Pennell necessarily included the powerful engines and the workers whose skills manipulated them. At this time the Pennsylvania Railroad roundhouse was in the terminal at Meadows (Kearny), New Jersey. That is the more likely location for this print, although the Long Island Rail Road, which used Pennsylvania Railroad engines, had a roundhouse in its service yards at Jamaica, Long Island.

42. CARRIAGE APPROACH TO PENNSYLVANIA STATION,
NEW YORK. 1919. W698. 11¾ x 7.

Pennsylvania Station (designed by McKim, Mead and White, completed 1910, demolished 1963), located between Seventh and Eighth Avenues between 31st and 33rd Streets, was the earlier of the two great railroad stations in New York City. Whereas exteriorly Grand Central took the form of some Beaux-Arts world's-fair exhibition hall, Penn Station declared the preeminence of railway transportation by evoking the grandeur of ancient Rome. The massive forms of its colonnaded exterior (84 Doric columns, 35 feet tall) made up a central block flanked on the north and south by open pavilions and connecting wings. Giving direct access to the General Waiting Room, these pavilions, one of which is shown here, were enclosed driveways for passenger vehicles.

"Not to a palace or a pantheon does this lead, but to the porters, the Red Caps of the Pennsylvania, when there are

any about, waiting to take you to the ticket office, but it is a masterpiece" (Wuerth, *Etchings,* p. 240).

43. THE ARCADE, PENNSYLVANIA STATION, NEW YORK.
1919. W701. 11¾ x 7.

On the east (Seventh Avenue) side of the central block of the station was the main entrance for pedestrians, who, as seen here, approached the extravagantly vast space of the General Waiting Room through a barrel-vaulted arcade and a great staircase.

"Dignified beyond words, to look at, horrible beyond words to have to climb up or shuffle down. These stairs but a worthy shrine to Cassatt,* who if he cannot say as Wren says in St. Paul's, *circumspice,* can say of the station, I caused it to be built. I conquered New York" (Wuerth, *Etchings,* p. 241).

44. THE TICKET OFFICE, PENNSYLVANIA STATION, NEW
YORK. 1919. W707. 11¾ x 9.

Ticket booths on either side of the grand staircase lined the east wall of the General Waiting Room, which Pennell, in admiration of its spacious functionality, described as "the dignity of usefulness" (Wuerth, *Etchings,* p. 243).

45. THE MARBLE HALL, PENNSYLVANIA STATION, NEW
YORK, 1919. W704. 12 x 10.

The General Waiting Room, based architecturally on the tepidarium in a Roman bath, had a lofty ceiling of plaster vaulting complete with coffers hiding the steel structure. Here were the ticket windows, parcel office, telephones and information desk. To the left is the grand staircase leading to the main pedestrian entrance on Seventh Avenue. Straight ahead, looking from the identically corresponding location on the south end of the space, is the entrance from the carriageway on the north side of the station. To the right (on the west side of the hall) is the passageway to the waiting rooms and the great Train Concourse.

" 'Wares der train go frum?' he asks and as he stops bewildered at the portal, never a 'please' never a 'thank you' when I sometimes tell him. We have no time to be polite any more, we are not even taught to be. But overpowered by the marble and the murals he overlooks the door which leads to the Hall of Iron" (Wuerth, *Etchings,* p. 242).

46. THE HALL OF IRON, PENNSYLVANIA STATION, NEW
YORK. 1919. W703. 12 x 10.

The most spectacular of the spaces within Penn Station were those in the great Train Concourse which gave access to the boarding platforms. A spiderweb of glass and steel-ribbed construction translated the ancient Roman structural forms of domes, vaulting and arches into a major machine-age architectural achievement.

"Marvelous the construction, mighty the spaciousness, and in the mystery of all this might, this embodiment of engineering skill and architectural design, the right carrying on of tradition, the poor mortal grabbing his grips, and hustling his family, overlooks or cannot find the right mouse hole that takes him to his train" (Wuerth, *Etchings,* p. 241).

MANHATTAN AND BROOKLYN, 1921–25
(Plates 47–75 and Frontispiece)

After Pennell and his wife moved to Brooklyn in 1921, Pennell produced 107 etchings of New York subject matter, from a total of 165 or more. None dates later than 1925. As

*Alexander J. Cassatt, seventh president (1899–1906) of the Pennsylvania Railroad, brother of the Impressionist painter Mary Cassatt.

well as Manhattan subjects, these include his Brooklyn Heights Series (in the next section) and a set of six etchings in 1923 for the Brooklyn Edison Company. Still the master of printmaking processes and of expressing the quintessence of a place, Pennell made these works among his most authoritative. Trying out new choices in media and presentation of subjects, even in the last ones he achieved a freshness of approach and imagination that show him fully in command of his creative abilities.

47. THE "PLAZA," FROM THE PARK. 1921. W787. 10 x 7.

The Plaza Hotel (center), located between 58th and 59th Streets on the west side of Grand Army Plaza, opened in 1907 as the world's largest (19 stories, 252 feet high) and most luxurious hotel. It was designed as the model of elegance in the Beaux-Arts "French Renaissance" style by Henry J. Hardenbergh, the architect of the 1893 Waldorf Hotel and of the Dakota Apartments. Also located in this upper Fifth Avenue area of New York's most sumptuous hotels was the Netherland (1893), the turreted Romanesque-style building (far right) on the northeast corner of 59th Street and Fifth Avenue. Between it and the Plaza can be seen, on the southeast corner, the Savoy Hotel (1892). Running diagonally across the print is Central Park South, on which an entrance to Central Park gives access to the paths among the large outcroppings of Manhattan mica schist in that area. Pennell must have drawn this from the top of one of them.

48. THE ELEVATED. 1921. W789. 9⅞ x 7.

One of the most active spots in the city was the intersection of Broadway, Sixth Avenue and 33rd Street, between Greeley Square just to the south and Herald Square to the north. This area was serviced by a labyrinth of public transportation: the Sixth Avenue Elevated shown here, streetcars, the BMT and Seventh Avenue IRT subways, the Hudson Tubes and Pennsylvania Station, a block away. The very heart of the retail-shopping district, this was the site of three great department stores: Gimbel's (far right, with window awnings at street level), Saks and Co. (with flags on the roof) and Macy's (not visible), the world's largest. At the beginning of the "Great White Way," the world's largest theater district, extending from 34th Street to the Times Square area, this was also the center of the largest hotel district. To the far left, recognizable by its balconies and oblique corner, is the Hotel McAlpin, facing Broadway between 33rd and 34th Streets. Faintly visible in the center of the etching are (left) the white terra-cotta-coated World-Tower Building, 110–112 West 40th Street near Sixth Avenue (30 stories, built by Edward West Browning, 1915, at which time it was the world's tallest office building on a plot of such small dimensions), and beyond, at 132 West 42nd Street, between Sixth and Seventh Avenues, the Bush Terminal Building (Helmle & Corbett, 1918, 35 stories high and on a plot only 50 by 200 feet).

49. THE BRIDGES FROM BROOKLYN. 1921. W782. 9⅞ x 6⅞.

From the northern end of Columbia Heights, looking down from the Brooklyn Heights bluff, we see the trolley and elevated lines on Fulton Street which led to the old Fulton Ferry terminal, lying just to the south of the massive granite tower of the Brooklyn Bridge (John A. Roebling and Washington A. Roebling, completed 1883). Ferries can be seen crossing the East River. Beyond is the open steelwork tower of the Manhattan Bridge (O. F. Nichols, engineer, 1909).

The wooden frame house with bay window and three dormers, on the far right, is still standing.

50. CHERRY HILL. 1921. W784. 10 x 7.

Across the East River in Manhattan, from underneath the Pearl Street Elevated in the area of Franklin Square, we see the colossal forms of the west tower of the Manhattan Bridge overlapped by a portion of the Brooklyn Bridge. This area, known as Cherry Hill, now vastly changed, was a fashionable residential area in the late eighteenth century. By 1900 the old Fourth Ward district had deteriorated into a problem slum area. Franklin Square (originally St. George Square), at the intersection of Cherry, Dover, Frankfort and Pearl Streets, was named for the merchant Walter Franklin, whose house at No. 3 Cherry Street was the residence of President-Elect George Washington for a short time in 1789, before he moved to 39 Broadway, and then on to Philadelphia in 1790 when the capital was relocated there. The site of this first White House is under a pier of the Brooklyn Bridge.

51. NOT NAPLES, BUT NEW YORK. 1921. W776. 9¾ x 6⅞.

Not a Manhattan version of the triumphal arch of Alfonso of Aragon at Castel Nuovo, Naples, the architectural wonder here is the masonry pier anchoring the suspension cables on the west approach to the Manhattan Bridge, which cut a swath through the densely populated tenement area in the southeast quarter of the Lower East Side. Atop it, through the arcades of a balustraded lookout, can be seen a trolley car crossing the bridge. It was from that vantage point that Pennell in 1915 had drawn "Up to the Woolworth" (Plate 33). Below, passing through an arch in the base, Cherry Street teems with a street life of pushcarts and tenants seeking the space and light of the streets as a relief from their dismal, crowded, unventilated and poorly lighted flats. A polyglot of street signs—in Greek, German, Italian, Chinese and English—indicates the ethnic diversity of immigrants who were packed into this area after the open-door immigration policy was initiated in 1880. Amid lines of drying clothes a banner announces the "Festa Annuale della Chiesa Patrona Maria Santissima." Nearby the artist inserted a sign in not-quite-correct Italian for himself: "J. Pennelli incisitore lastri di rami" (J. Pennelli, engraver of copper plates). Other signs, "Drink," "America," "Ideals," "God," inserted among those for coffee, ice, olive oil and salt, seem of ironic intent on the part of the artist, who had already become aware, even if indirectly through the photographs of Jacob Riis and Lewis Hine, of the squalid working and living conditions into which immigrants were forced. This is Pennell's most populated print and his least unsympathetic of the new Americans, against whom he usually expressed a definite bias.

52. NEW YORK, FROM ELLIS ISLAND. 1921. W777. 5 x 9⅞.

From 1892 to 1954, Ellis Island was the main point of entry for immigrants into the United States, with the peak number of 1,285,349 admitted in 1907. For those awaiting clearance, the Manhattan skyline, symbol of the realization of their potentials, must have been an incredible sight. In this print two outbound transatlantic passenger vessels pass the tip of Manhattan.

53. THE LEVIATHAN. 1921. W786. 5 x 10.

The *Leviathan*, the largest vessel and one of the most luxurious in the world when built, lies in berth at the United

States Lines pier in Hoboken. Launched in 1914 as the *Vaterland* by the Hamburg-American Line at an estimated cost of 12 million dollars, it could accommodate 3210 passengers but required a crew of 1196. About five city blocks long (950 feet) and weighing 144 million pounds when loaded, it could cross the Atlantic in a little over five days. Making only three crossings before World War I, the *Vaterland* was seized by the United States in 1917 at Hoboken, renamed the *Leviathan* and used as a troop transport. After the war she was converted from coal to oil and was operated by the United States Lines between New York and Southampton and Cherbourg. The biggest money-loser in American maritime history, she was withdrawn from service in 1934 and was finally scrapped in 1938.

54. WARSHIP COMING IN. 1921. W770. 9⅞ x 7.
A battleship steams up the East River past the South Street piers and those at the foot of Columbia Heights, headed for the United States Navy Yards on Wallabout Channel, midway between the Brooklyn and Williamsburg Bridges. Its mast and the Woolworth Building vertically divide the composition in half (incidentally calling to mind that the word ''skyscraper'' was first used in reference to tall masts of sailing vessels). Even without conclusive evidence, it is tempting to identify this as the battleship *New York*.

55. THE CUNARD BUILDING. 1921. W775. 10 x 7.
New York's harbor, the busiest and one of the finest in the world, has been vital to the life and growth of the metropolis as a world center. Pennell impressively affirms this relationship in this industrious shipping scene which melds into the skyscrapers of the financial district. These include the massive forms of the United States headquarters for the British-owned Cunard White Star Line, the oldest transatlantic ship line and the leading one in New York for ocean-going traffic. Located at 25 Broadway, this luxurious building (not clearly defined here) was completed in 1921 by the architect Benjamin Wistar Morris, with Carrère & Hastings (New York Public Library, 1911; Frick Mansion, 1914) as consulting architects.

56. MUNICIPAL BUILDING. 1921. W795. 7 x 9⅞.
At the Manhattan end of the Brooklyn Bridge and facing City Hall Park, the grandiose Municipal Building (begun 1908; McKim, Mead and White, architects), when it was opened in 1914 to house the offices of 6000 city employees, was the largest structure for civic government in the world. Built at a cost of about 12 million dollars, this flattened U-shaped structure embellished with colonnades, superimposed lanterns, pinnacles, urns and obelisks, contains 650,000 square feet of floor space in its 42 stories, and is 580 feet high (including the 24-foot crowning statue, *Civic Fame*). Difficulties in constructing sound foundations required 116 pneumatic caissons, some 260 feet below street level and 239 feet below water level. Looking from Columbia Heights in Brooklyn, Pennell included to the right (south) the dome of the World Building on Park Row and the tower of the Tribune Building at Printing House Square. The building to the left topped by a globe could be the New York Life Insurance Company Building (McKim, Mead and White, 1896) at the corner of Broadway and Leonard Street. The Hartford Line is shown at Pier 20, foot of Peck Slip (see Plate 18).

57. NEW FISH MARKET. 1921. W797. 10 x 6⅞.
Dominated here by the massive Municipal Building and obscured by fishing boats, the Fulton Fish Market, on the

north side of Fulton Street between South and Front Streets, was the focal point of a six-block area along the South Street docks comprising the largest wholesale fresh-fish market on the Atlantic Coast. Established in 1821 as a general retail market, it was replaced in 1882 by a new structure which collapsed in 1908, to be rebuilt in 1911. Next door was the Fulton Ferry. Nearby was the famous old seafood restaurant, Sweets (still in operation). The French script on the margin of this print attests Pennell's preference for printing on aged European papers, often endpapers of old books. Paper for him was as important as any other factor in making an etching.

58. THE STEAM SHOVEL. 1921. W779. 10 x 7.
Excavation is in progress here for the New York County Courthouse (1926, on a plan by Guy Lowell in 1912), east side of Foley Square north of Pearl Street. To the far left, looking south from Worth Street, beyond Foley Square down Centre Street, is Surrogates Court (Hall of Records) at 31 Chambers Street. The edifice underneath the Municipal Building and just to the right is the old Hollenbeck (Health Department) Building, no longer standing. In the left distance, past the Manhattan terminal of the Brooklyn Bridge, on Park Row are the Tribune and the World Buildings, with the Woolworth Building also crowded in. To the far right, beyond a construction tower, is the west pier of the Brooklyn Bridge.

FRONTISPIECE. THE WOOLWORTH, THROUGH THE ARCH. 1921. W785. 9⅞ x 6⅞.
The Municipal Building sits astride Chambers Street, forming an arch which has been called the ''Gate of the City.'' In this print we look through this Chambers Street arch, across City Hall Park past the French-inspired City Hall (1802–12; Mangin and McComb, architects), to the Woolworth tower, in which a light could be seen from 75 miles out to sea.

59. LIBERTY TOWER, NEW YORK. 1921. W794. 9⅞ x 4⅞.
At a point on Liberty Street just east of Trinity Place, we look across Broadway to Liberty Tower, on the northwest corner of Liberty and Nassau Streets. Completed in 1909 by architect Henry Ives Cobb, it resembles the West Street Building finished by Cass Gilbert four years earlier. The Chamber of Commerce of the State of New York (1901) is the low dark mass between the tower and the Beaux-Arts style building on the northeast corner of Broadway. The Singer Building on the northwest corner of Broadway and Liberty Street, is to the far right.

60. FROM THE LOWEST TO THE HIGHEST. 1921. W788. 10 x 6⅞.
From Battery Park one looks north toward a group of low buildings between Greenwich Street (far left) and Washington Street (diagonally from left to right). From left to right are the Washington Building, Bowling Green Offices, Cunard Building, Singer Tower, City Investing (below and in front of the Singer), Woolworth Building, U.S. Express Company and Whitehall. The Washington Building at No. 1 Broadway, one of the first skyscrapers, was the tallest office building in the world when completed in 1884 by Cyrus W. Field, layer of the Atlantic Cable.

61. THE NEW STOCK EXCHANGE. 1921. W781. 9⅞ x 6⅞.
Shown here under construction, on the site of the old Wilks Building, is the 22-story addition to the New York Stock Exchange designed by Trowbridge and Livingston and completed in 1923. The artist was located on the northeast cor-

ner of Nassau and Wall Streets, probably on the steps of the Sub-Treasury, looking diagonally across to the new structure going up on the southwest corner. To the right (south) on Broad, is the pedimented facade of the original 1903 Stock Exchange.

62. TRINITY CHURCHYARD. 1921. W792. 9⅞ x 7.
Office workers at lunchtime relax in the seclusion of the 2¼ acres of Trinity churchyard, burial place of many prominent early Americans (Alexander Hamilton, Robert Fulton, William Bradford and others, with the earliest dated marker going back to 1681). On one of the gravestones Pennell has playfully inscribed his own signature. Towering above are Bankers Trust (stepped-pyramid roof), American Surety (alongside the spire) and Equitable (tall twin building). Across Broadway from the front of Trinity, on the southeast corner, is No. 1 Wall on a plot less than 30 x 40 feet but 18 stories (217 feet) high. On the northeast corner of Wall is the First National Bank. Bankers Trust, 39 stories high (540 feet), including eight in its roof, was one of the first skyscrapers to be topped by a "small temple" with a pyramid. It was located where the old Gillender Building had stood, on Wall Street at the northwest corner of Nassau, and a record site cost of $825 per square foot was paid. The massive new Equitable (1915, E. R. Graham, architect), 37 stories tall, encouraged adoption of the 1916 New York zoning ordinance requiring setbacks on tall buildings.

63. MADISON AVENUE, FRATERNITY HOUSE. 1923. W818. 12¼ x 9¼.
On the east side of Madison Avenue between 37th and 38th streets, the Fraternity Clubs Building (completed 1923); Murgatroyd and Ogden, architects) was built to house 16 fraternity clubs and the Cornell Club. Subsequently becoming Midston House and at present the Hotel Lancaster, it housed when new the University of Pennsylvania Club, the Mills College Club and the American Association of University Women. The building is 18 stories high (197 feet) and between the third and eleventh floors it has an H-shaped floor plan of single rooms. In this unreversed composition, we look downtown to the Metropolitan Life Insurance Tower between 24th and 25th Streets and to the Woolworth Tower beyond.

64. THE TIMES ANNEX, FROM 40TH STREET. 1923. W812. 12¼ x 9¼.
The perpetual rebuilding of New York City is forcefully presented in this contrast between towering skyscrapers ascending and an anachronistic row of two-story frame houses doomed to demolition. Originally part of a group of ten or more, these six wooden cottages, Nos. 121 to 131 (right to left, in this unreversed composition) West 40th Street, between Sixth Avenue and Broadway, were built around 1846 as choice suburban homes in pretty countryside changing from farmland to small development. They were occupied chiefly by small merchants with businesses in the lower city. The Croton Reservoir (at the present site of Bryant Park and the New York Public Library) had just been built (1843), making this an especially attractive neighborhood. Each house had seven rooms, and garden plots in front and rear. Some owners kept cows, which were free to forage around the neighborhood by day, but which at night were brought back to the backyards through a passageway on 41st Street. As the city moved north, and the Rialto and Tenderloin crept up Broadway (known earlier as Bloomingdale Road in this area), the frame houses lost their middle-class respectability and small businesses and craftsmen moved in—a car-

penter, a French launderer. Capezio, the shoemaker for ballet and theater, had a shop at No. 129. Jenny Lind is said to have lived for a while at No. 125. J. Hatfield Morton, collector of early American art and furniture, moved into one of the houses around 1900. In the basement of No. 131, obscured here by smoke, "The Old English Tea Room" was patronized by theater people, including Maude Adams and William Gillette. A reproducer of antique ornamental iron and brasses, William H. Pries, had his shop at Nos. 121–123. In the late 1880s No. 119 was torn down for the building of Beethoven Hall, itself torn down for Mendelssohn Hall (1893), which was then torn down for the 21-story Lewisohn Building, the structure at the far right decorated with massive sculptures (1913, still standing). An article in the New York Times, February 25, 1923 (from which the above information was obtained), announcing the impending loss of these historic landmarks, may have incited Pennell to do this print. In the background the tower of the Times Annex (north side of West 43rd Street, between Times Square and Eighth Avenue) bristles with scaffolding.

65. MADISON AVENUE. 1923. W811. 12¼ x 9¼.
Even though a zoning law requiring setbacks went back to 1916, the Shelton Towers Hotel (34 stories, completed 1924; Arthur Loomis Harmon, architect) was one of the first setback buildings in New York City. Located at No. 527 Lexington Avenue between 48th and 49th Streets, the huge structure is shown here under construction as seen from Madison Avenue. Anticipating the "Skyscraper Style" of the late '20s and '30s, the architect designed the building as a "styleless," forthright composition of stacked cubic masses, rather than basing it on eclectic references to past architectural styles. Walls were slanted inward at the top to emphasize verticality and to eliminate any illusion of overhanging.

66. AN ORGY OF BUILDING. 1923. W808. 12¼ x 9¼.
In the foreground are the foundations for the Hotel Roosevelt (named for Theodore Roosevelt), at 45th Street between Madison and Vanderbilt Avenues. The tracks seen here lead to Grand Central Terminal. To the northeast is the Shelton Towers Hotel, the 16th floor of which was designed for drawing and dining rooms, a roof garden and terraces. Here the outriggers for the scaffolding have been set in several sections, so that time can be saved by building parts of the exterior curtain wall before the steelwork higher up is completed.

67. THE LATEST TOWER. 1923. W815. 12¼ x 9¼.
The Standard Oil Building, 26 Broadway, northeast corner of Beaver Street, when completed in 1922, was one of the world's costliest office buildings and one of the most imposing structures on the Manhattan skyline. Costs were approximately 35 million dollars, which included the demolition of one large office building and the incorporation of two others into the structure. In this unreversed composition, we have in the background a view of New York Bay with (on the left) Governor's Island, Buttermilk Channel and the Red Hook and Gowanus Bay areas in Brooklyn, stretching toward the Narrows (in the center), and (on the right) beyond Bedloe's Island, St. George on Staten Island and Bayonne, N.J., in the distance.

68. STANDARD OIL BUILDING. 1923. W817. 12¼ x 9¼.
From the south edge of Bowling Green, at the mouth of Broadway's canyon, one looks northward to the colossal Standard Oil Building (Carrère & Hastings; Shreve, Lamb &

Blake) under construction. To the far left, at the corner of Cass Gilbert's Custom House (completed 1907), can be seen *Africa*, one of four Daniel Chester French sculpture groups, symbolizing the continents, which decorate its facade. The two dark buildings beyond are the Produce Exchange (corner visible behind *Africa*) and the Produce Exchange Bank (1905). The Woolworth Tower, Adams Express (with balustrated cornice) and the Bowling Green Building (near picture edge) line up at the right.

69. REBUILDING BROADWAY, STANDARD OIL BUILDING. 1923. W814. Aquatint. 12¼ x 9¼.
Freely adapting the previous print to aquatint, Pennell created here an unreversed expressionist variation of his Wonder of Work theme. He called these tonal works ''printed paintings.''

70. THE FOUNDATIONS AT THE CATHEDRAL, SAKS BUILDING. 1923. Etching and drypoint. W820. 12¼ x 9¼.
In 1923 construction began on Saks Fifth Avenue, first of the big exclusive stores on upper Fifth Avenue. Located just south of St. Patrick's Cathedral, the building occupies the entire block front between 49th and 50th Streets. Night work saved time in the schedule for the construction of a building. Any time lost meant a loss in profits to be earned during the limited life span of a very expensive building.

71. CAISSONS ON VESEY STREET. 1924. W854. 14 x 19½.
The foundation of the New York Telephone Company skyscraper (1923–26); Voorhees, Gmelin & Walker, architects), occupying the block bounded by West, Washington, Barclay and Vesey Streets, required excavations totaling 137,925 cubic yards and 22 caissons, each 40 feet long and eight feet thick, sunk 55 to 75 feet deep. The beginnings of the largest telephone building in the world, and the first in the Art Deco style, are overshadowed by the Woolworth tower several blocks to the east.

72. THE TELEPHONE AND TELEGRAPH FOUNDATION. 1924. W827. 12⅞ x 8⅞.
Looking eastward across Washington Street from the Barclay-Vesey Building's foundations, one sees in a row to the south (right) of the Woolworth, in this unreversed composition, the Park Row Building (under the inclined crane), the St. Paul Building and the steeple of St. Paul's Chapel.

73. GENERAL OFFICE BUILDING, BROOKLYN EDISON CO. 1923. W805. 12 x 10.
This and the next print belong to a group of six etchings made by Pennell in 1923 for the Brooklyn Edison Company (in 1945 merged into Con Edison). Probably because they were commissioned, the compositions in this set are not reversed. This view of the General Office Building (now not owned by Con Edison), located at Pearl and Willoughby Streets, is from the east end of Remsen Street. One looks across Court Street, past Borough Hall with its Ionic portico and cascade of steps facing north to Borough Hall Park, and beyond the old Fulton Street Elevated Railroad. On the northwest corner of Remsen and Court is the Garfield Building, one of Brooklyn's earliest large office buildings. An eight-story red-brick structure, its octagonal tower was originally covered by a lantern-topped cupola, probably removed because of vibrations from the subways underneath. The cornice at the upper right belongs to the Brooklyn Union Gas Company (now St. Francis College), and the spire below it is a decorative detail on the ''Old First'' Presbyterian Church at the corner of Clinton and Remsen Streets.

74. HUDSON AVENUE UNDER CONSTRUCTION, BROOKLYN EDISON CO. 1923. W810. 10 x 12.
Under construction here is the Hudson Avenue Generating Station of the Brooklyn Edison Company. At a point north of the Manhattan Bridge and just south of Wallabout Channel, overlooking Hudson Avenue to the left below, the artist looks up the East River to Williamsburg Bridge (1903). Beyond, on the left, in Manhattan, rises the 700-foot Metropolitan Life Tower at 23rd Street and Madison Avenue. At the base of the Brooklyn pier of the bridge cluster the sugar refineries established by Henry O. Havemeyer, who left his important collection of French Impressionist paintings to the Metropolitan Museum. On the right a ship heads into Wallabout Channel to the old Brooklyn Navy Yard, which was a major defense facility for the construction and repair of ships in the U.S. fleet from 1801 to 1966.

75. THE BAY, NEW YORK. Aquatint. 1922. W793. 7½ x 8⅞.
One of Pennell's most broadly conceived prints, this aquatint vividly dramatizes New York Bay at sunset. It was probably executed directly from a window in his apartment at the Hotel Margaret on Brooklyn Heights. Piers and warehouses along the East River comprise the dark mass in the lower right-hand corner of the print.

THE BROOKLYN HEIGHTS SERIES, 1923–24 (Plates 76–89)

The following 14 prints are selected from about 25 with Brooklyn Heights subject matter, including views from the Heights of the waterfront and Manhattan. In direct contrast with Pennell's concurrent Wonder of Work subjects drawn in Manhattan, these have a calm, personal quality, even when they represent shipping and the docks below. In their detachment from the dynamics of the metropolis across the river, they capture the mood of this lovely old residential district. Their intimacy and emphasis on the human aspect are reminiscent of the artist's London and Paris prints of the 1890s, when he had shown people casually enjoying themselves, skating and dancing and sitting at sidewalk cafés.

76. COLUMBIA HEIGHTS, FROM FULTON FERRY. 1924. W849. 9⅞ x 7⅞.
The Fulton Ferry was established in 1814 with the first steam ferry, Robert Fulton's *Nassau*, and continued to operate until 1924, even though Brooklyn was made progressively more accessible by bridges and subways. The ferry landing in Brooklyn was at the foot of Fulton Street, in the shadow of the east pier of the Brooklyn Bridge, just north of the Brooklyn Heights bluffs. The slip on the other side of the river was further downstream at the foot of Fulton Street in Manhattan. Here we see across the East River the Hotel Margaret, 95–97 Columbia Heights, the tall building to the right, where Joseph Pennell lived from 1921 until his death in 1926.

77. THE TUNNEL, MONTAGUE TERRACE. 1924. W845. 9¼ x 9⅛.
This 1855 viaduct, with its inclined plane and stone archway designed by Minard Lafever, was a continuation of Montague Street leading down to the foot of the Brooklyn Heights promontory. At what is now Pier 4, from 1845 until 1912, one could take the Wall Street Ferry to the foot of Wall Street in Manhattan. The arches of the old South Brooklyn Ferry can be seen directly across the river. At the foot of the ramp a locomotive shifts freight. The tall masts of vessels at the piers below merge into the trees and gaslight

posts above. A terrace with benches on top of the tunnel provided a splendid public overlook of the Upper Bay and the East River. A cast-iron footbridge, "Penny Bridge," spanned the viaduct to connect Pierrepont Place (left) and Montague Terrace. To the far right, at No. 2 Montague Terrace, can be seen the porticoed entrance to the Edward H. Litchfield residence (no longer standing), one of the grand houses on the Heights.

78. THE DOCKS, FROM COLUMBIA HEIGHTS. 1924. W831. 7 x 9¾.
Drawn from the overlook atop the Wall Street Ferry viaduct tunnel (and not from Columbia Heights, as the title would indicate), this print shows the traffic on the continuation of the ramp leading down to Furman Street and the site of the old Wall Street Ferry, now occupied by a New York Dock Company pier. In composing this view, Pennell took the artistic liberty to push the Statue of Liberty over closer to the South Brooklyn Ferry terminal.

79. PIERREPONT PLACE, MONTAGUE TERRACE. 1924. W839. 6⅞ x 9⅞.
Reminiscent of Pennell's London views, this etching evokes the remote exclusivity still enjoyed in 1924 by some wealthy residents of Brooklyn Heights. Here we look south from the very north end of Pierrepont Place, across the Penny Bridge, through Montague Terrace, to the brownstones on Remsen Street. In this reversed composition, Manhattan is to the left. Beginning on the far left, we see the edge of the Renaissance Revival residence of Henry Evelyn Pierrepont (demolished in 1946, in favor of a children's playground), with its masonry enclosure, at No. 1 Pierrepont Place. Two outstanding Italianate mansions adjoin at Nos. 2 and 3, the Alexander M. White and Abiel Abbott Low houses (1857, Frederick A. Peterson, architect). Abiel Abbot Low was a merchant in the China trade and father of Seth Low, mayor of Brooklyn, president of Columbia University and mayor of Greater New York. Beyond Penny Bridge and the open space of the sunken ferry ramp, we see on the right Nos. 1–13 of Montague Terrace, a group of elegant brownstone mansions from around 1886, which make this a "terrace" in the English sense of a set of row houses.

80. MONTAGUE TERRACE, CHILDREN SKATING. 1924. W832. 8 x 9⅞.
This juxtaposition of the Low mansion on the left and the Litchfield mansion at No. 2 Montague Terrace (right) with the Woolworth tower quietly contrasts the old wealth of Brooklyn Heights with the new entrepreneurial money of Manhattan. In peaceable security a stroller, children roller skating, mothers and nurses are detached from even the workaday world flowing through the viaduct beneath them.

81. NEW YORK, FROM GRACE COURT. 1924. W836. 7⅜ x 8⅞.
The uncrowded spaciousness of this tranquil corner of the clamorous metropolis is a world away from its backdrop of river traffic and Lower Manhattan skyscrapers. At the other end of Grace Court, behind the artist and facing the intersection with Hicks Street, is Richard Upjohn's Grace Church (1847). On the left here are iron fences of the deep backyards belonging to the brownstones on Remsen Street. This print exemplifies the artistic liberties Pennell would sometimes take. Not only is the scale of figures diminished, but the scene is a composite from at least two vantage points on Grace Court, with Lower Manhattan shifted over to the left for a more impressive effect. Nonetheless, the lively and ac-

curate depiction of individual objects is amazing when one can make comparisons with old photographs or actual buildings.

82. WILLOW STREET, BROOKLYN. 1924. W840. 9⅞ x 6⅞.
In a view looking north toward the Brooklyn Bridge, the picturesqueness of the Heights and the atmosphere of nostalgia for its aristocratic past are suggested by this shady street lined with Federal row houses, pedimented porticos of Greek Revival doorways, and railings of decorative cast ironwork.

83. PINEAPPLE STREET. 1924. W837. 9⅞ x 6⅞.
According to one story, Cranberry, Orange, Pineapple, Poplar and Willow Streets originally had other names, those of prominent Brooklyn Heights families. A cantankerous Miss Middagh from one of the old families so persisted in tearing down street signs bearing names of neighbors whom she disliked that a city resolution was passed to use instead the botanical names which she had insisted upon. The name for Middagh Street remained, though. Another, no more credible, explanation is that Orange Street and Nassau Street (its continuation on the other side of Fulton Street) were named after the houses of Orange and Nassau, and that when the streets adjacent to Orange were named, this was not understood and they were named Cranberry and Pineapple. The location in this print is between Hicks Street and the harbor, with a view of the Brooklyn piers and Bankers Trust in Manhattan awaiting at the end of Pineapple.

84. ORANGE STREET, BROOKLYN. 1924. W847. 9⅞ x 6⅞.
Quiet, open spaces at the foot of many of the east-west streets on Brooklyn Heights were pleasant neighborhood spots with benches to relax on. Like the Esplanade today, these spaces were Brooklyn's front porch, with one of the greatest views in the world. Capping the skyline in this print, left to right, are the Singer Tower, Equitable Building and Bankers Trust. Until its disastrous fire in early 1980, the Hotel Margaret was located at the northeast corner of Orange Street and Columbia Heights, just beyond the left margin of this print.

85. FROM CLARK STREET TO WALL STREET. 1924. W842. 8⅞ x 7½.
A fountain plays in a shallow garden at the foot of Clark Street, from which there is an uninterrupted view directly up Wall Street to Trinity Church. Terraces with trees and plantings project out over the mercantile warehouses below. This is the site of Fort Stirling, built on the bluff in 1776 as one of a chain of redoubts used in the Battle of Long Island.

86. FALL RIVER BOATS GOING OUT. 1924. W846. 5⅛ x 10.
From Brooklyn Heights, Pennell drew these Fall River Line steamers heading up the East River to Hell Gate for their overnight passage through Long Island Sound to the Massachusetts cotton-manufacturing town of Fall River, where there were direct train connections to Boston. Established in 1847, the Fall River Line operated until 1938, competing with other Sound boats run by the Hartford and New Haven Line; New London, Newport and Norwich Line; Providence Line; and Stonington Line. Its terminal was at the foot of Fulton Street, near the Cortlandt Street ferry on West Street in Manhattan. A pioneer in marine design and safety, the Fall River Line maintained a fleet of safe (only one accidental passenger death during its 90-year history), comfortable and efficient boats, which were the preferred alternative to the arduous overland route. Operating year round, there were

sometimes four boats at once carrying as many as 4000 passengers. The *Metropolis*, one of the early sidewheelers, made the 180-mile run from Fall River to New York in eight hours and 41 minutes. Possibly among the ones shown here is the *Priscilla* (1894–1938), a palatial liner with 361 staterooms, bunks for 1500 persons and a cruise speed of 22 miles per hour (Braynard, *Famous American Ships,* pp. 75, 77, 116). The line closed out because of competition from trains (the long tidal estuaries extending inland had been bridged, cutting down the overland time); the automobile, truck, and bus; and the Cape Cod Canal (Hill, *Sidewheeler Saga,* pp. 194, 236).

87. SHIPPING, FROM COLUMBIA HEIGHTS. 1924. W834. 6⅞ x 9¾.

The Pennells' apartment in the Hotel Margaret overlooked the busiest waterfront in the world. Across the East River was the congestion of shipping on South Street. Beyond lay New York Harbor. Directly beneath them on the Brooklyn side, they could see part of the extensive wharfage of piers, stores and great warehouses which extended for miles south from the Brooklyn Bridge to Red Hook and beyond. At those piers began some of the longest sea voyages out of New York—6200 miles to Rio de Janeiro, 8000 to Buenos Aires.

"This place is in its way as fine as Adelphi Terrace—and the view from the Ocean to upper Manhattan with New York across the river—ten times more wonderful and if the country was not dry* . . . things would be all right, for this town is absolutely unspoiled—it is old Brooklyn and like—in a way Bloomsbury with German bands—and cats meat men —and brown stone houses—and dam respectability—and I overlook and look over that—and this Sunday morning the chimes of Trinity ring across the river and save the far away wail of the steamers—we see them come in—this Sunday morning, save the Brooklyn birds—is absolutely quiet—and if it had not been for the fool war I would have had this place

*Prohibition was in effect.

and Adelphi Terrace too . . .'' (E. R. Pennell, *Life*, II, p. 239).

88. OUT OF MY BROOKLYN WINDOW. 1923. W813. 9¼ x 12¼.

This view from a bay window of his apartment in the Hotel Margaret was a constant inspiration for Joseph Pennell.

"I look out the window and the steam wreaths wrap the town in glory in the day and the fairy boats float by in the night—and the colour in the morning is more lovely than Venice down the bay, and up the river at night more magic than London, and that is why I stay—and shall stay as long as I can—for though it is a noisy hell in New York here it is a quiet haven—and if I hate the mongrels who have overrun it, New York from Brooklyn is the most wonderful city in the world.''

"Friends thought we went to Brooklyn because we could not afford New York. We were there because it was the one place where he wanted to be, with the Unbelievable City, the City Beautiful, the City that he loved, out of his windows . . . that he could look out of and forget how rottenly asinine the world has become'' (E. R. Pennell, *Life,* II, pp. 246; 237–38).

89. THE DESERTED FERRY. 1924. W838. 7⅞ x 9⅞.

The Fulton Ferry stopped running in 1924, the year Pennell etched this empty ferry house on the Brooklyn side. The spot had been a ferry landing since 1642. General Washington had used it in 1776 as the point of egress for his troops during the Battle of Long Island. Even though the Fulton Ferry operated for 40 years after the Brooklyn Bridge opened in 1883, the automobile and rapid transit eventually made its service obsolete. In a similar way, Pennell's style had already been superseded by such American "modernists" as John Marin, Joseph Stella, Arthur G. Dove, Georgia O'Keeffe and Stuart Davis.

And now I am home, but not in my own home, not in the land I left and knew and loved and dreamed of coming home to. I am still in it, though I am not allowed to do anything for it. I have been given every thing the country gives. I am here and shall stay here till the end, which may come any day, any hour. I would not stay a minute if I could not sit with E. and look out of our windows on the most beautiful thing left in the world, and that is going too, ruined by fools, business men to puff themselves and their shops, to make money, their god, their aim, their idol, which is no good to them when they have got it and so they give it away, most of them to advertise themselves. We are of it, but not in it, the world. But we see it, see it passing, for in a little while it will be no more and we shall be no more, the world we loved and laid up treasures in—it is gone and they are gone. The view from our windows is the last of our world, for all else has gone—we have seen it go—and we are going and it is going. But it is good to have lived, to have adventured, to have known, and to remember (Joseph Pennell, The Adventures of an Illustrator, *p. 361).*

Bibliography

JOSEPH PENNELL

Keppel, Frederick. *The Golden Age of Engraving.* New York: The Baker and Taylor Company, 1910.

——*Joseph Pennell, Etcher, Illustrator, Author.* New York: Frederick Keppell & Company, 1907. (Reprinted from *The Outlook,* September 23, 1905.)

Masheck, Joseph. "The Panama Canal and Some Other Wonders of Work." *Artforum,* Volume 9, May 1971, pp. 38–41.

Pennell, Elizabeth Robins. *The Life and Letters of Joseph Pennell* (2 volumes). Boston: Little, Brown, and Company, 1929.

Pennell, Joseph. *The Adventures of an Illustrator.* Boston: Little, Brown, and Company, 1925.

——*Etchers and Etching.* New York: The Macmillan Company, 1919.

——*The Graphic Arts, Modern Men and Modern Methods.* Chicago: University of Chicago Press, 1921.

——*Pen Drawing and Pen Draughtsmen.* New York: The Macmillan Company, 1920.

——"The Pictorial Possibilities of Work." *Journal of the Royal Society of Arts,* Volume 61, 1912–13, pp. 111–26.

——"The Wonder of Work." *Scribner's Magazine,* Volume 58, December 1915, pp. 775–78. (This is a reprint of "The Pictorial Possibilities of Work," above.)

——"The Wonder of Work in the Northwest." *Harper's,* Volume 132, March 1916, pp. 591–600.

"Pennell's Masterly Etchings of the American Scene." *Current Literature,* Volume 47, September 1909, pp. 286 ff.

Singer, Hans W. "On Some of Mr. Joseph Pennell's Recent Etching." *International Studio,* Volume 30, February 1907, pp. 312–19.

Tinker, Edward Larocque. Joseph Pennell entry in *Dictionary of American Biography* (Volume 7, Part 2, pp. 437–41). New York: Charles Scribner's Sons, 1934.

U.S. Library of Congress. *American Prints in the Library of Congress: A Catalogue of the Collection* (introduction by Alan Fern). Baltimore: Published for the Library of Congress by the Johns Hopkins Press, 1970.

Wuerth, Louis A. *Catalogue of the Etchings of Joseph Pennell.* Boston: Little, Brown, and Company, 1928.

——*Catalogue of the Lithographs of Joseph Pennell.* Boston: Little, Brown, and Company, 1931.

Young, Mahonri Sharp. "The Remarkable Joseph Pennell." *American Art Journal,* Volume 2, No. 1, Spring 1970, pp. 81–91.

NEW YORK CITY

Abbott, Berenice, and Elizabeth McCausland. *Changing New York.* New York: E. P. Dutton and Company, Inc., 1939. (Reprinted by Dover as *New York in the Thirties.*)

Braynard, Frank O. *Famous American Ships.* New York: Hastings House, 1956.

Burnham, Alan. *New York Landmarks.* Middletown, Conn.: Wesleyan University Press, 1963.

Callender, James H. *Yesterdays on Brooklyn Heights.* New York: The Dorland Press, 1927.

Goldberger, Paul. *The City Observed: New York/A Guide to the Architecture of Manhattan.* New York: Random House (Vintage Books), 1979.

Goldstone, Harmon H., and Martha Dalrymple. *History Preserved: A Guide to New York City Landmarks and Historic Districts.* New York: Simon and Schuster, 1974.

Hill, Ralph Nading. *Sidewheeler Saga.* New York: Rinehart and Co., 1953.

King, Moses. *King's Views of New York, 1896–1915, and Brooklyn, 1905.* New York: Arno Press, 1977. (Reprint of the 1974 edition published by Benjamin Blom, Inc., New York.)

Kouwenhoven, John A. *The Columbia Historical Portrait of New York.* New York: Doubleday and Company, Inc., 1953.

Mujica, Francisco. *History of the Skyscraper.* New York: Da Capo Press, 1977. (Reprint of 1929 edition published by Archeology and Architecture Press, Paris & New York.)

New York City Guide: A Comprehensive Guide to the Five Boroughs of the Metropolis. (American Guide Series, Federal Writers' Project, W.P.A.). New York: Random House, 1939.

New York Panorama (American Guide Series, Federal Writers' Project, W.P.A.). New York: Random House, 1938.

Schultz, Earle, and Walter Simmons. *Offices in the Sky.* Indianapolis: Bobbs-Merril Company, Inc., 1959.

Silver, Nathan. *Lost New York.* Boston: Houghton Mifflin Company, 1967.

Starrett, W. A. *Skyscrapers and the Men Who Built Them.* New York: Charles Scribner's Sons, 1928.

Stokes, Isaac Newton Phelps. *The Iconography of Manhattan Island* (6 volumes). New York: Robert H. Dood, 1915–28.

Van Dyke, John C. *The New New York.* New York: The Macmillan Company, 1909.

Watson, Edward B. Contemporary photographs by Edmund V. Gillon, Jr. *New York Then and Now.* New York: Dover Publications, Inc., 1976.

White, Norval, and Elliot Willensky. *AIA Guide to New York City* (New York Chapter, American Institute of Architects). Revised edition. New York: Collier Books, 1978.

Whitehouse, Roger. *New York: Sunshine and Shadow.* New York: Harper and Row, Publishers, 1974.